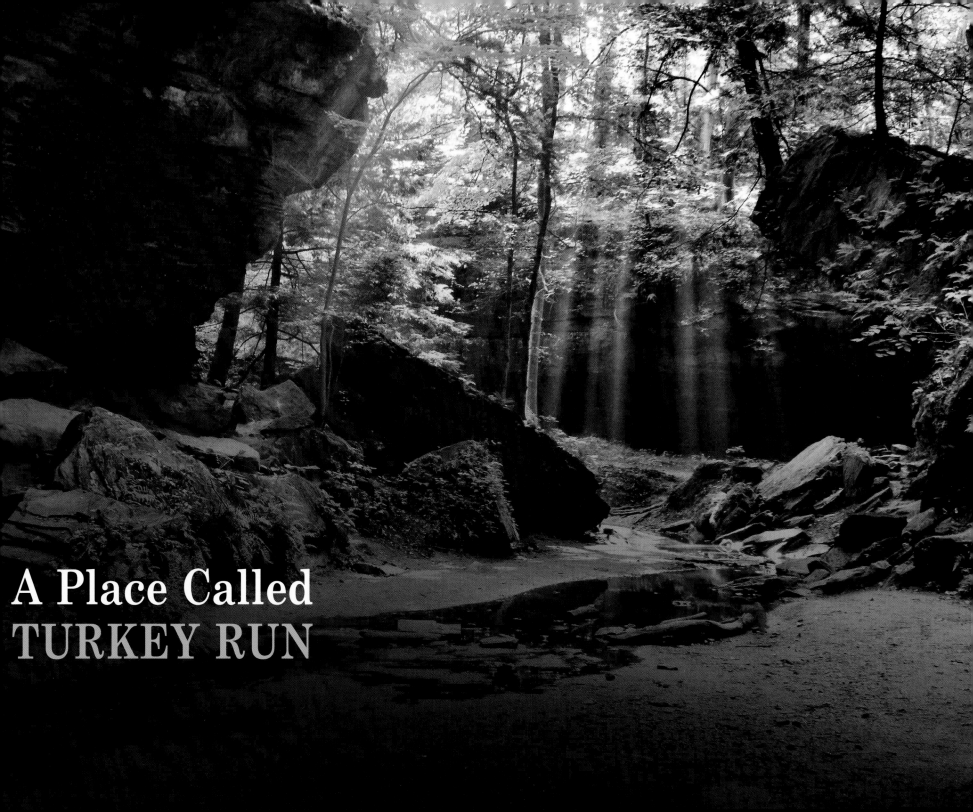

A Place Called
TURKEY RUN

A Place Called TURKEY RUN

A Celebration of Indiana's Second State Park in Photographs and Words

Daniel P. Shepardson

Purdue University Press
West Lafayette, Indiana

Library of Congress Cataloging-in-Publication Data

Names: Shepardson, Daniel P., author.
Title: A place called Turkey Run : a celebration of Indiana's second state
 park in photographs and words / by Daniel P. Shepardson, Department of
 Curriculum and Instruction and Department of Earth, Atmospheric, and
 Planetary Sciences, Purdue University.
Description: West Lafayette, Indiana : Purdue University Press, [2016]
Identifiers: LCCN 2016013432 | ISBN 9781557537560 (cloth : alk. paper)
Subjects: LCSH: Turkey Run State Park (Ind.)—History. | Turkey Run State
 Park (Ind.)—Pictorial works. | Parks—Indiana—Parke County.
Classification: LCC F532.T8 S54 2016 | DDC 977.2/465—dc23 LC record available at http://lccn.loc.gov/2016013432

Dedication

To my parents, Mary and Phil, who instilled in me an appreciation for all places wild. And to Susan Britsch, a good friend, colleague, and companion, who provided suggestions and edits for formatting and writing this book, and who critiqued some of the images shown here. Finally, to Turkey Run, for all of its natural beauty and for providing me the opportunity to hike, explore, and photograph nature.

About the Author

Daniel P. Shepardson is a professor of geoenvironmental and science education at Purdue University. He holds a joint appointment in the Department of Curriculum and Instruction and the Department of Earth, Atmospheric, and Planetary Sciences. Shepardson is a nationally recognized nature photographer and author. He teaches introductory environmental science and environmental education courses at Purdue. He received his PhD in science education from the University of Iowa and both his MSEd in science education and BS in wildlife science from Utah State University. Shepardson is an avid nature lover, who spends his free time hiking and photographing nature in Indiana's state parks and local nature preserves. He spends several weeks every summer in Yellowstone and Glacier National Parks.

Contents

Foreword

As a child, I often roamed the canyons and creek beds all across the great state of Indiana. Like so many Hoosier children, I grew to love the outdoors and all nature has created for our enjoyment. Of all the state parks that Hoosiers call their own, not one invokes the magical memories of exploring the natural world like Indiana's second state park.

Turkey Run is one of the Hoosier state's most treasured natural areas. The uniqueness found in the flora and fauna of this special place bring tranquility to the spirit.

Generations of Hoosiers and our guests have walked these trails and experienced firsthand the splendor of this special place. It is important, if we are to fully understand and embrace the natural world, to view it across a wide range of spectrums.

The book you have in your hands does just that. It offers you a glimpse of what visitors can experience if they choose to seek it out.

Daniel Shepardson has created a masterpiece of stunning photography coupled with a narrative which explains the natural history of one of Indiana's most beloved parks.

I hope it sparks in you a curiosity and desire to experience Turkey Run State Park as so many have done before.

Daniel W. Bortner, SPHR, SHRM-SCP
Director
Indiana State Parks

Acknowledgments

I would like to thank the following individuals who reviewed draft versions of this book: Susan Britsch, Professor, Department of Curriculum and Instruction, Purdue University; Mary Cutler, Naturalist, Tippecanoe County Parks and Recreation Department; Jon Harbor, Professor, Department of Earth, Atmospheric, and Planetary Sciences, Purdue University; Ginger Murphy, Deputy Director for Stewardship, Indiana State Parks; and Ken Ridgway, Professor, Department of Earth, Atmospheric, and Planetary Sciences, Purdue University. Their feedback was valuable in finalizing the images and text found in this book. Their time and effort is greatly appreciated.

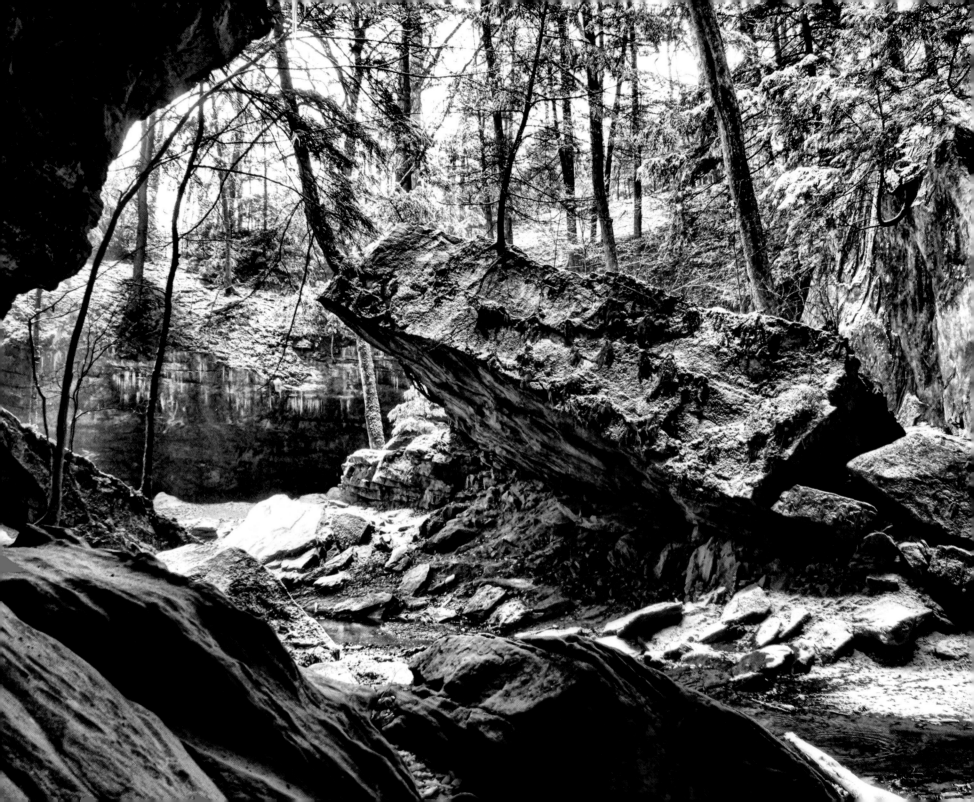

INTRODUCTION

In 1916, Turkey Run was established as Indiana's second state park. Within its boundaries lie some of the more rugged and stunning landscapes found in Indiana. Its sandstone bluffs and canyons, created by the erosive force of melting glaciers and flowing water, provide outstanding landforms and landscapes that support an array of plant and animal life. Since moving to Indiana in 1990, I have had many opportunities to hike, explore, and photograph the natural splendor that is Turkey Run. Because of these experiences and my appreciation for the natural beauty of this park, I have created this book in celebration of its one hundredth anniversary. It is my attempt to honor the natural beauty of Turkey Run through image and text.

I have hiked and photographed the park at different times of the day, different times of the year, and under different lighting and meteorological conditions. I have hiked the park during rain and snow events, and I have photographed the park in ways that capture its unique beauty, all of which give a different perspective on the park's landscapes and way of life. I have photographed sandstone bluffs from afar and ferns up close. My photographs have captured the environmental conditions of the park over the years in thousands of images that I reviewed for this book. It was a difficult selection process, but I focused on images that provide different perspectives of nature—images that give the reader a different view of the park, its sandstone, plant communities, wildlife, and seasons.

I have organized this book around six topics or chapters that provide different perspectives of the park, while overlapping: "Sandstone," "Bluffs and Canyons," "Flowing Water," "Snow and Ice," "Tall Trees," and "Flowers, Ferns, and Fungi." Each chapter helps readers visualize an important and unique natural aspect of the park. Many of the images were taken from designated trails; these views are accessible to the reader. I challenge the reader to identify the different locations along the park's trails. Some are easier to find than others.

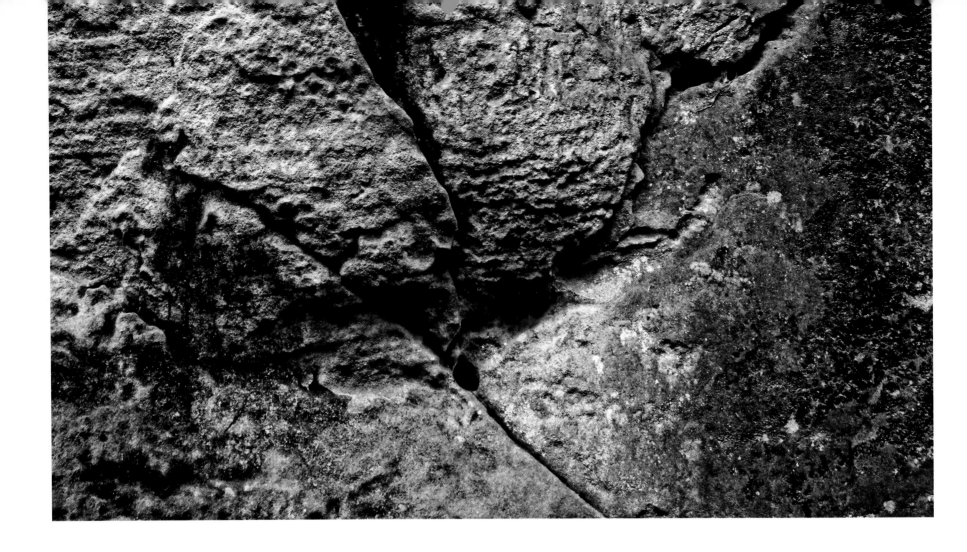

Chapter 1, "Sandstone," takes us on an up-close tour of the rock that makes up the Turkey Run landscape. The colors, textures, shapes, and patterns of the Mansfield sandstone—revealed through weathering, erosion, and mass wasting—are captured in the images of this chapter. How are these geological processes shown in the sandstone of Turkey Run?

Chapter 2, "Bluffs and Canyons," explores the impressive landforms and landscapes that make Turkey Run attractive to so many visitors. These landforms and landscapes were carved by melting glaciers and have been slowly deepened and widened by flowing water. Think about how the bluff faces and canyon walls have changed over time and how they will continue to change. How might light and rain change the way we see the bluffs and canyons of Turkey Run?

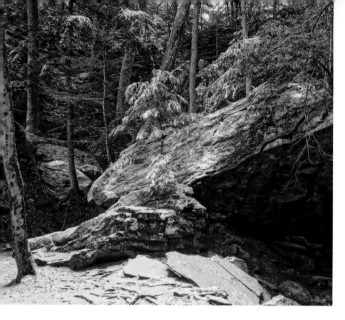

In chapter 3, "Flowing Water," the geological processes of weathering and erosion are captured in time and space. The many faces of Sugar Creek show the fluvial processes that transport and deposit sediments, forming sand and gravel bars. What signs do you see of its work?

Chapter 4, "Snow and Ice," takes a special look at how water, "frozen" in time, shapes the landscape and gives Turkey Run a different look and feel. In what ways do snow and ice change the Turkey Run landscape?

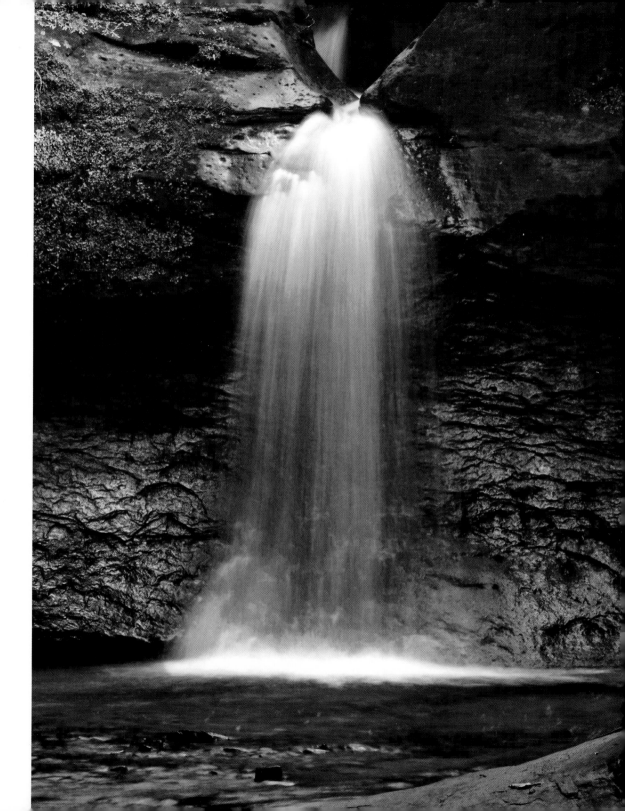

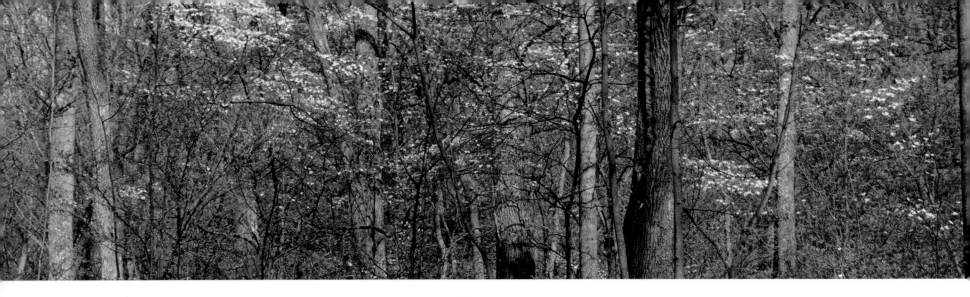

Chapter 5, "Tall Trees," takes readers on a hike through the deciduous forest of the park, foregrounding it's importance and relationship to life in the park. Next time you visit, look closely at the trees in the park. How does the land influence where the tall trees of Turkey Run grow?

Chapter 6, "Flowers, Ferns, and Fungi," provides a look at the many life forms that make up the forest floor or cling to sandstone cliffs for life. These often go unnoticed by visitors, yet play an important role in the park's ecology. The spring flowers create a landscape awash with brilliant and subtle colors that draw our attention. The ferns and fungi, however, have their own appeal and place if we look more closely.

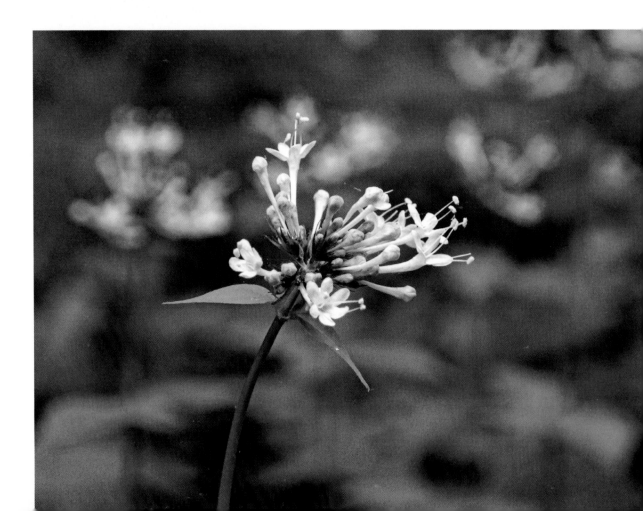

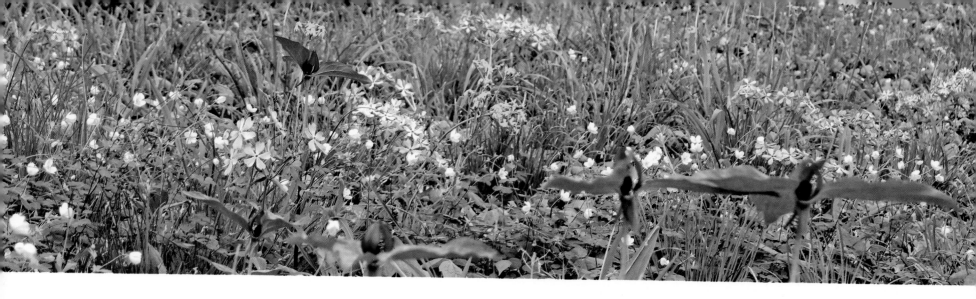

For me, the joy of photographing Turkey Run over the years is divided into two parts. First, the hike—experiencing nature's beauty, its wildness, and its freedom of place—is rewarding in its own right. Like all visitors, I have my favorite trails and locations, such as Wedge Rock, Gypsy Gulch, and the hemlock grove on Trail 7. Next comes the immersion into nature as I frame each shot and set the exposure. The images shown in this book also reflect the challenges in photographing nature: poor lighting conditions and natural obstructions, to name two. It is always a challenge to take the chaos or randomness of nature and compose an image that shows structure and pattern such that it is pleasing to the viewer's eye.

The photographs in this book reflect my many experiences with Turkey Run, and my efforts to capture its majesty, its power, and its mystique. I attempt to convey a similar experience to readers through the images in the chapters that follow. I present this book not only as a legacy to Turkey Run, but also as an inspiration to readers who may appreciate the precious few natural places that remain in Indiana. Lastly, I hope this work motivates readers to explore Turkey Run from a different perspective, to capture nature with a camera, and to share their representations with others.

Daniel P. Shepardson

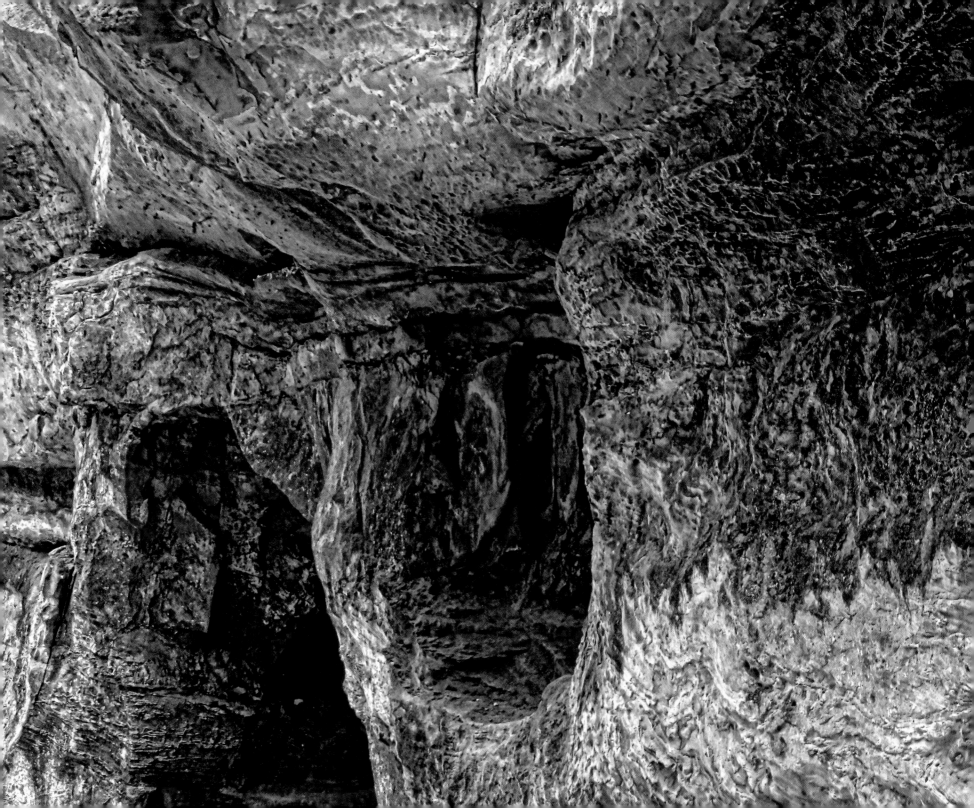

CHAPTER 1

Sandstone

The best way to start our exploration of Turkey Run is by looking at the rock that makes up the park. Have you ever looked closely at the rock? Have you ever noticed its shape, texture, or color? Have you ever wondered why we see this rock in the first place? The foundation, or bedrock, of Turkey Run is Mansfield sandstone, a sedimentary rock formed about 300 to 350 million years ago. Sedimentary rocks are formed from rock fragments or sediments of clay, silt, sand, and gravel that were transported and deposited by wind, water, and glaciers. These deposited sediments later cemented together to form rock.

In Turkey Run, sand was transported and deposited primarily by ancient rivers during the Carboniferous Period. This sand was deposited in loose, unconsolidated layers that were "stacked" one on top of the other. Over time, the buried sand was compacted by pressure and cemented (lithified) into the sandstone found today. The "stacking" of sediment layers forms a bedding sequence, with the oldest layer on the bottom. Variation in the course, flow, and sediment load of the ancient rivers resulted in differences in the deposition of the sand, giving us the different layers, or strata, we can see throughout the park. In some locations, the sand was deposited at an angle or incline. This resulted in a tilted layer or stratum known as a cross-bed. If you look closely at the bluff faces and canyon walls, you can see the different layers of sandstone. Also during this period, dead, swampy vegetation accumulated and was buried, eventually forming a small, thin layer of coal. This coal layer can be seen in several locations in the park.

Why do we see this sandstone today? Over geologic time, erosion brought the sandstone layers to the surface, exposing them to the eye. In Turkey Run, the melting Pleistocene glaciers served as the primary force that shaped the park's landscape, creating the sandstone bluffs and canyons that we see today (see chapter 2, "Bluffs and Canyons," for a more detailed explanation). The exposed sandstone was, and still is, physically and chemically weathered. Physical weathering breaks down rock through direct contact with water, wind, ice, and pressure, disintegrating the rock into fragments, grains, and particles with no chemical change. Chemical weathering, on the other hand, involves the disintegration of rock through changes in its chemical composition, dissolving and oxidizing rock material. Water is the principle agent here, starting as rain or snow. These earth processes sculpt the sandstone, creating the interesting textures, colors, patterns, and shapes that we see in the park.

Our journey explores the sandstone that makes up the park's bluffs and canyon walls. The images in this chapter capture the colors, textures, and patterns found in the sandstone. Most of the photographs were taken from Trails 2, 3, and 6. If you look carefully on your next hike, you will be able to see similar characteristics in the park's sandstone. You might even be able to identify the location of several of the photographs.

1

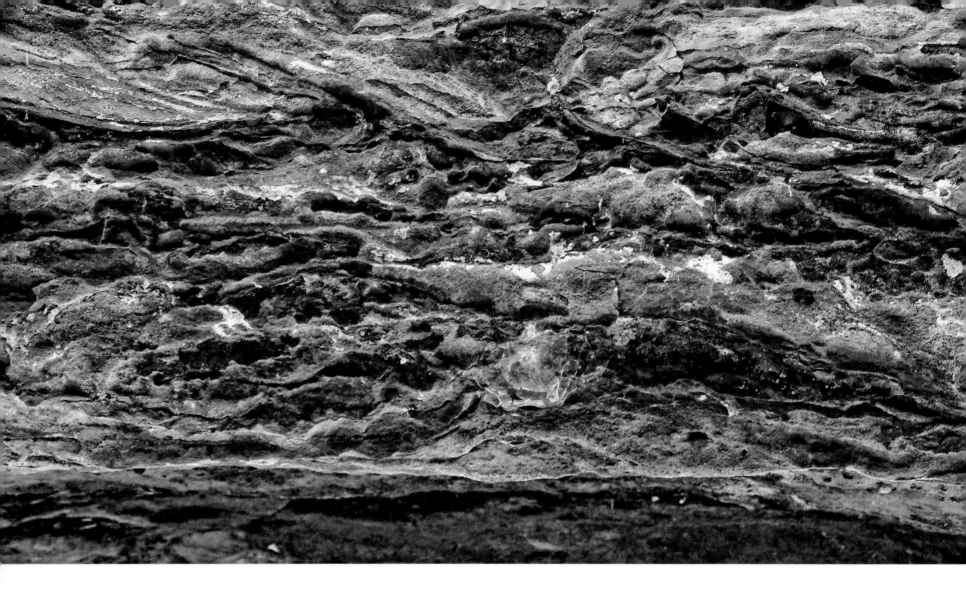

In geologic terms, the "sand" in sandstone refers to the size of the particles that make up the rock, not to its composition. Sandstones are composed of many different types of sand grains, with quartz being the most abundant. You will find few fossils in Turkey Run's sandstone because the organisms that died and fell into the ancient rivers were either broken into tiny pieces or were washed away by the flowing water. On the other hand, you might see iron concretions that formed when iron precipitated out and filled the space between the sand deposits (the darkish red bands seen in the image). Here, the iron precipitated along the bedding plane (horizontal layers).

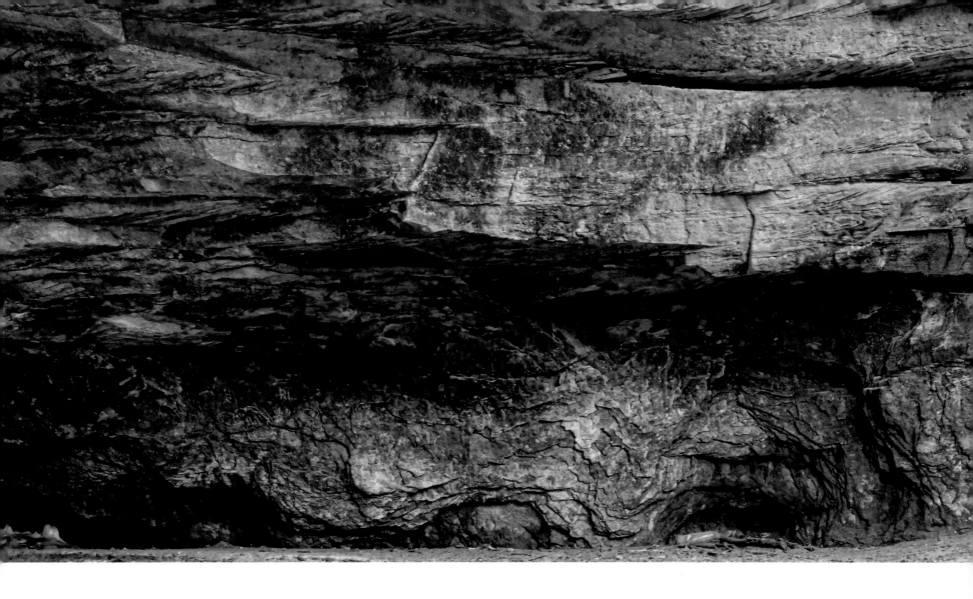

The "stacking" of different sediment layers forms a bedding sequence based on the composition and depositional pattern of the deposited sediment. This photograph shows sandstone rock layers (beds) that have been exposed as a result of glacial meltwater and stream erosion. When I hike and photograph the park, I always stop and look backward to take a different perspective of the landscape. This image, for instance, appeared to me as I turned to look back. Had I not turned, I would have missed this shot.

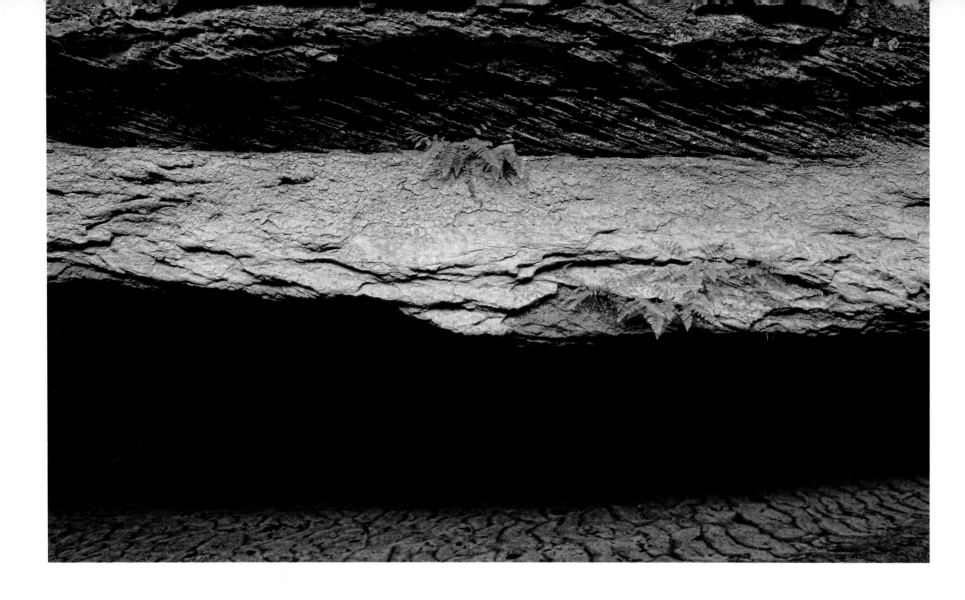

Cross-bedding is the deposition of sediments at an angle, or incline, resulting in a tilted layer or stratum known as a cross-bed. Erosion brings the rock layers to the surface, exposing the sandstone to chemical and physical weathering. Today, stream erosion continues to erode the sandstone, undercutting the sandstone wall. Ferns take root where shade and moisture provide a favorable environment. This image juxtaposes the sandstone formed from ancient river deposits with the sand ripples deposited in the flowing stream. The splash of color provided by the ferns contrasts with the nonliving sandstone.

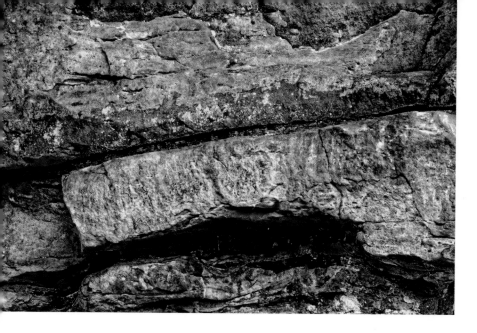

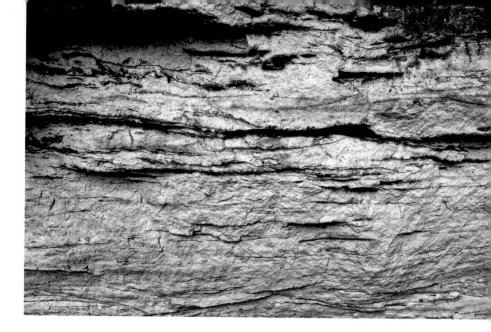

During the Carboniferous Period, large scaly trees and giant rushes and ferns grew in the Turkey Run area. This lush vegetation was buried by sediments, and over time was partially compacted and transformed into coal. The coal, sandwiched between sandstone layers, gave rise to thin coal seams that can be seen in several locations throughout the park.

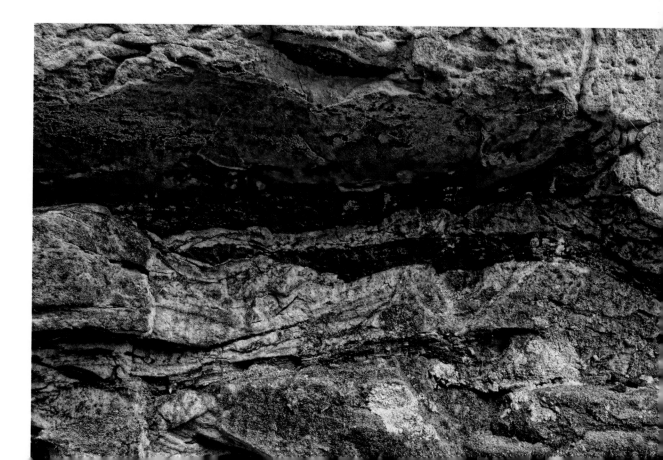

All rocks have zones of weakness along which they crack or fracture. The joints or cracks in the sandstone shown in the top right image indicate that the zones of weakness lie along the bedding plane formed by the layering of sediments. Erosion brings the sandstone to the surface, which opens the fractures and exposes the sandstone to chemical and physical weathering. Water percolating through the sandstone leaches out minerals, which are exposed to air and water and oxidized, creating colorful tapestries. The tan and yellow hues are provided by a blend of quartz and feldspar, while the reds and browns result from the presence of iron. The greens and blues are from lichens and mosses that have taken up residence on the sandstone. The image on the facing page illustrates the use of light and shadow to enhance the texture and color of the fractured sandstone.

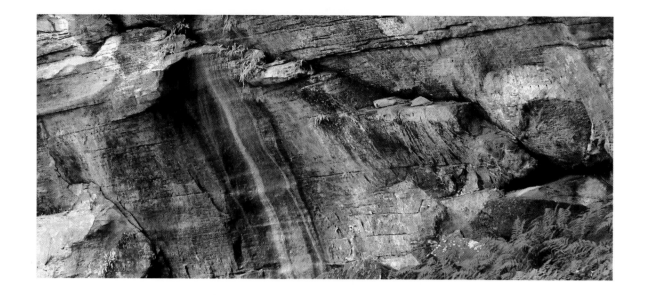

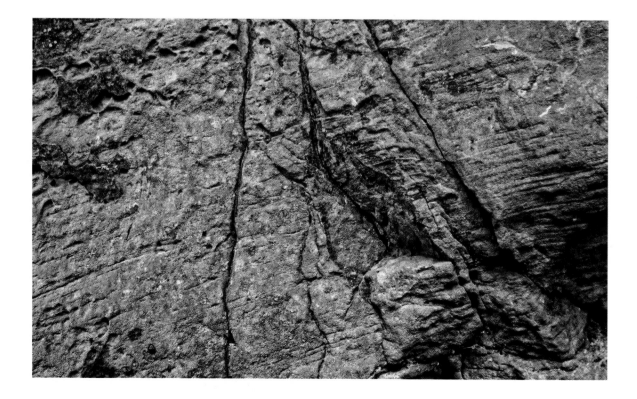

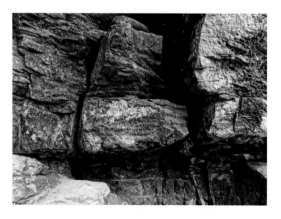

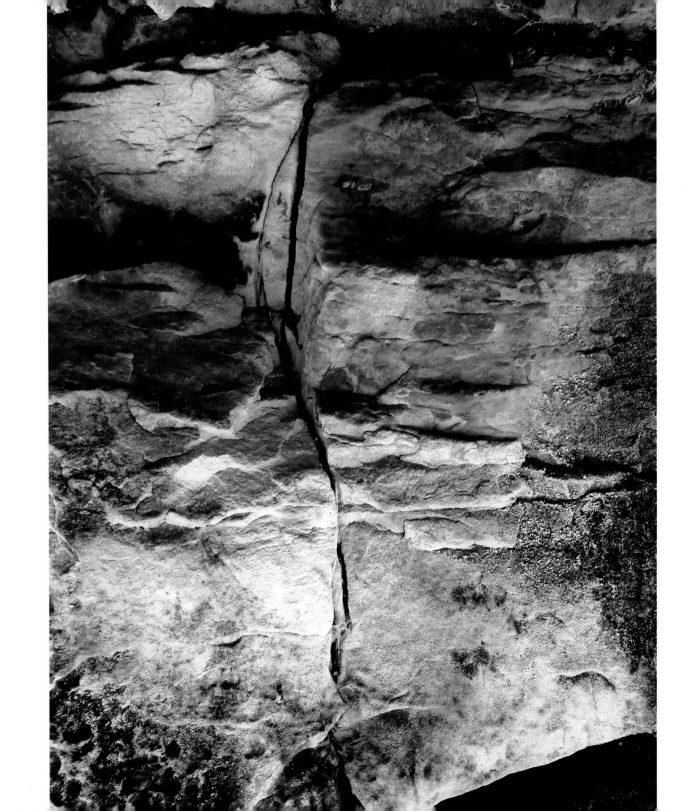

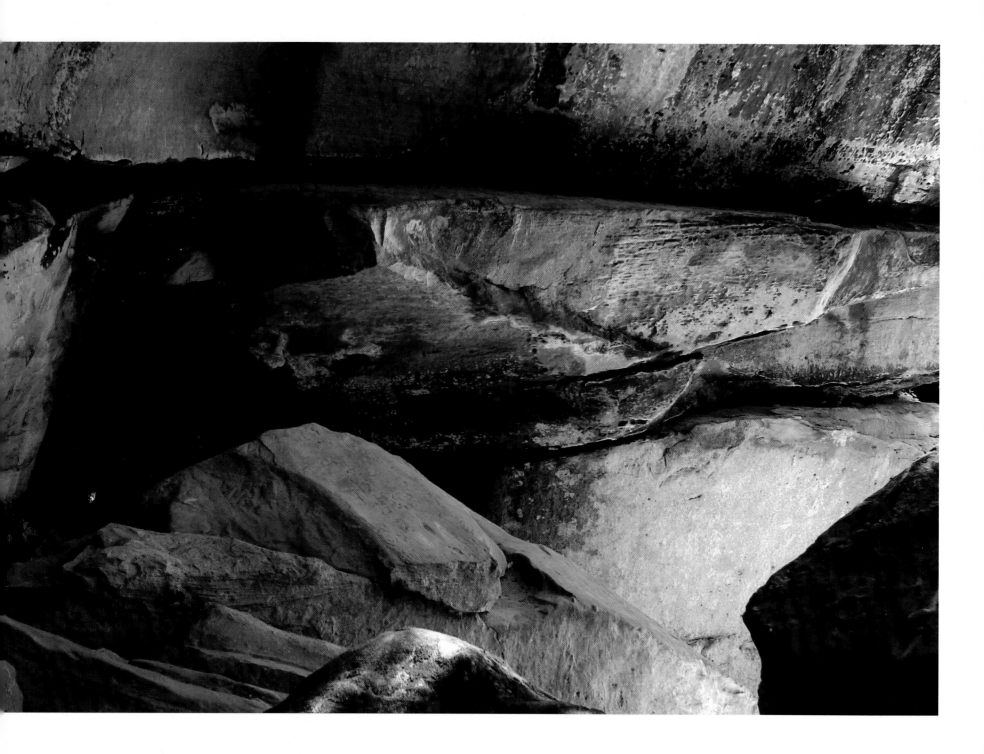

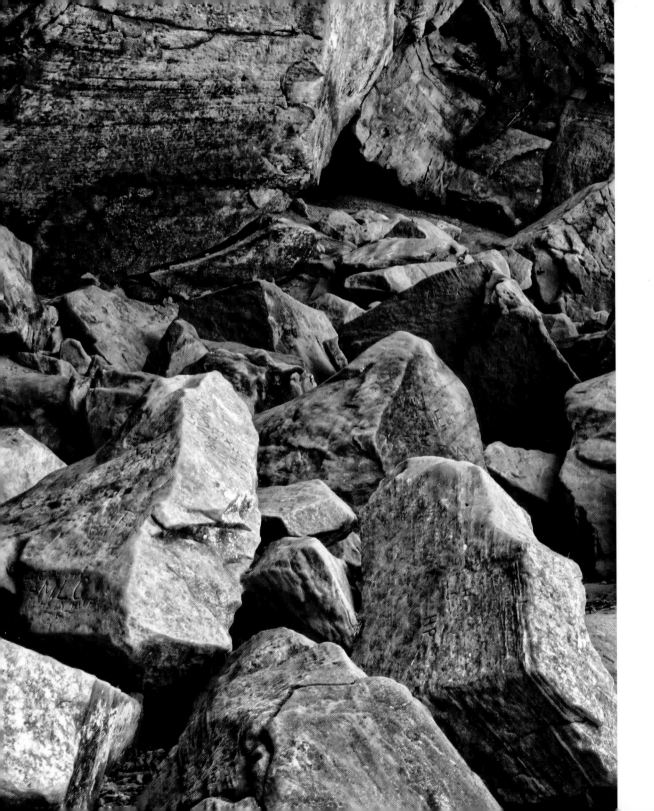

We do not often think of ice as a change agent. Yet in seasonal climates like Turkey Run, where moisture is available and temperatures fluctuate above and below freezing, this freeze-thaw process breaks down rock. This frost wedging is an extremely efficient process for weathering the park's sandstone. Moisture that seeps into cracks and fractures in the sandstone expands when it freezes. This force pushes outward, creating a wedge that further cracks and fractures the sandstone. This repeated freeze-thaw cycle splits the sandstone so that blocks of sandstone detach and fall due to the pull of gravity—this is known as mass wasting. I call the image on the facing page "Calm Chaos" because in "human time" it appears calm, changing very slowly. Yet in geologic time, it has changed drastically. This sandstone bluff is disintegrating toward chaos.

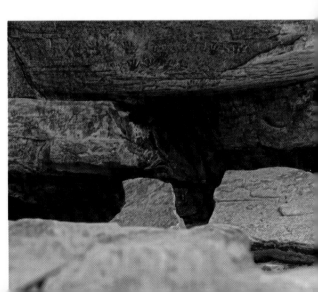

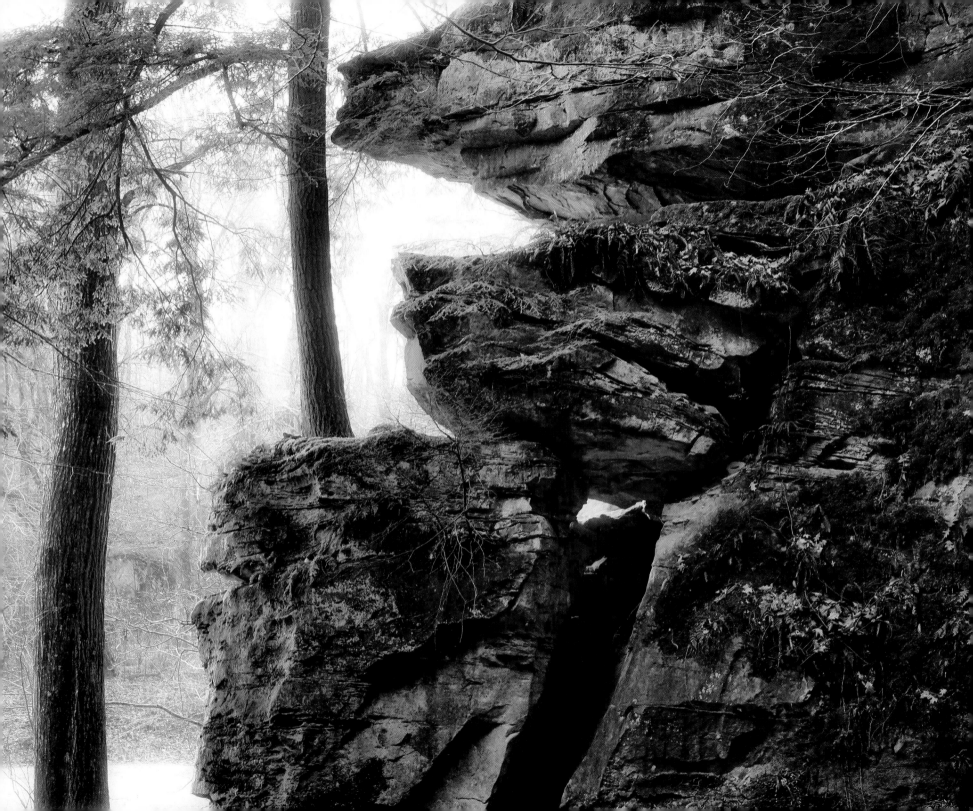

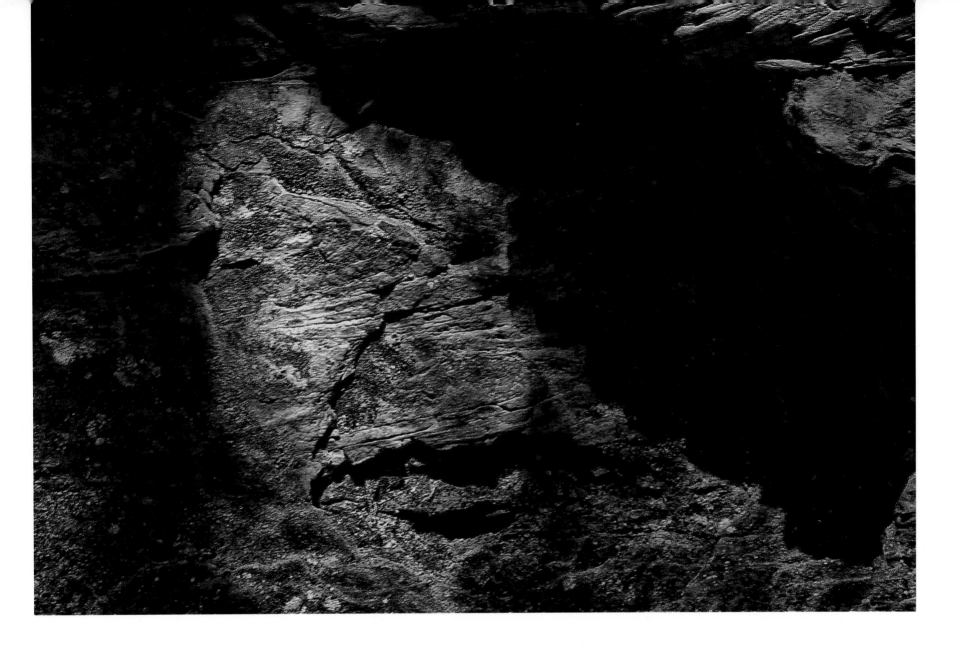

Although we did not see the formation of Turkey Run's sandstone, we can see its destruction. The weathering process will eventually cause the sandstone blocks to collapse at the joint, reshaping the canyon wall (image on facing page). Because of temperature changes caused by the sun, sandstone expands and contracts unevenly. This causes flat sheets of sandstone to fracture and detach from the canyon wall, forming an uneven surface (image above).

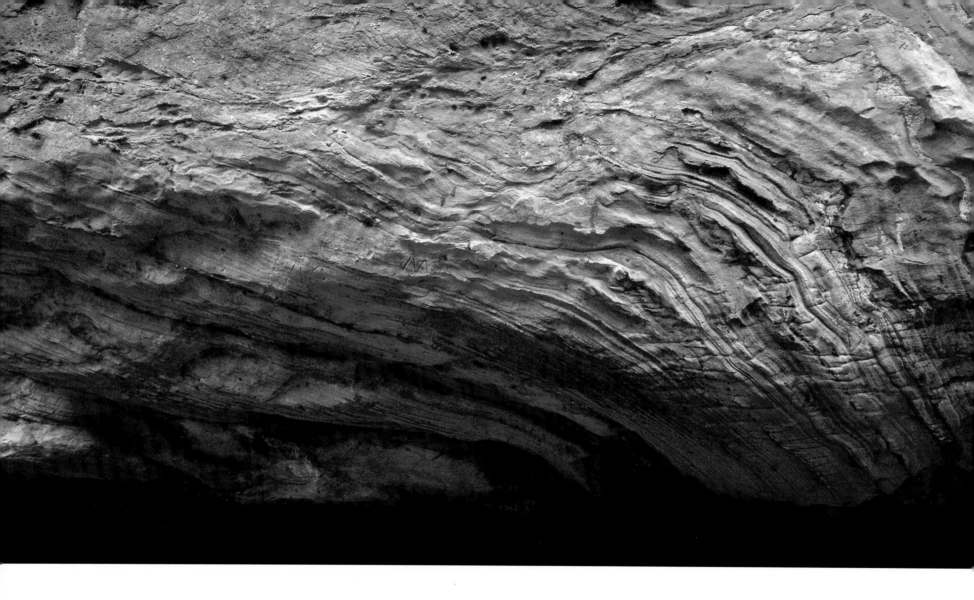

The rate at which sandstone is weathered depends on its mineral composition and structure and on the length of time it is exposed to the atmosphere. Thus, the sandstone of Turkey Run weathers at different rates and in different ways, as seen in the images on this page and on the facing page. In the image above, flowing water has eroded the sandstone at a faster rate along its bedding plane. This has created channels that funnel the water over the sandstone, further eroding the channels and producing the rippled effect. The "Face" image (facing page) displays a different weathering pattern. Here, the length of exposure to the atmosphere is seen in the color differences. The dull, grayish surface has been exposed to the atmosphere longer than the burnt orange surface.

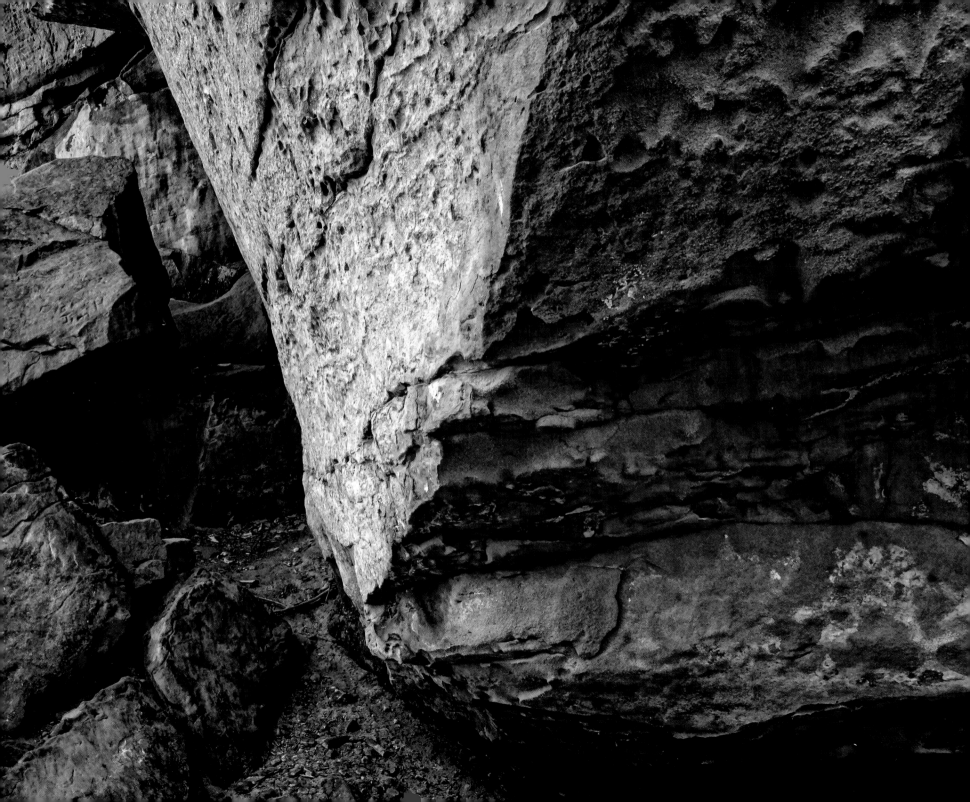

Biological weathering involves both physical and chemical processes. Lichens and mosses (top image) that grow on sandstone create moist, humid environments that chemically weather the sandstone. At the same time, their attachment to the sandstone physically disintegrates it. The trees, shrubs, and ferns in the images here take root along ledges and fractures in the sandstone. As the plant roots enlarge, they exert an outward force, expanding the fracture and further cracking the sandstone. The roots also furnish a pathway through which moisture infiltrates, chemically weathering the sandstone from the inside out. This weathering of rock gives us soil.

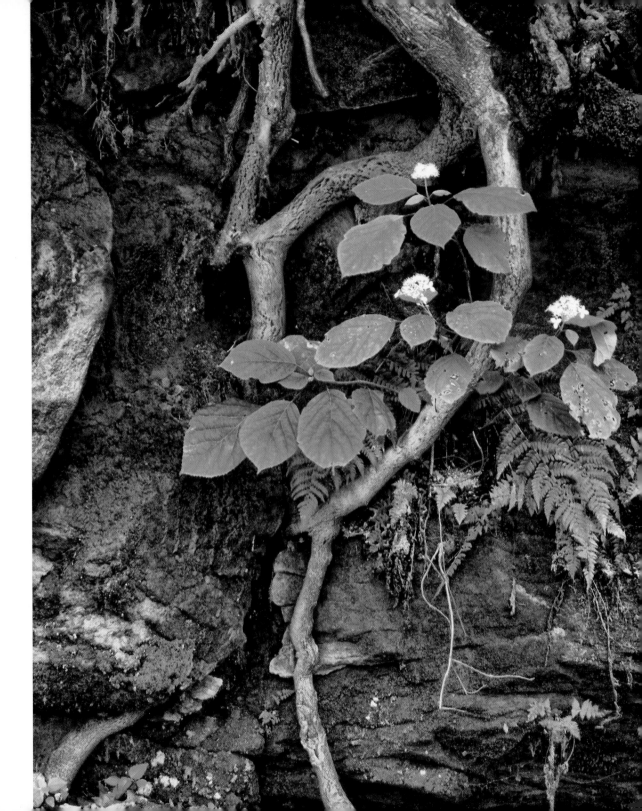

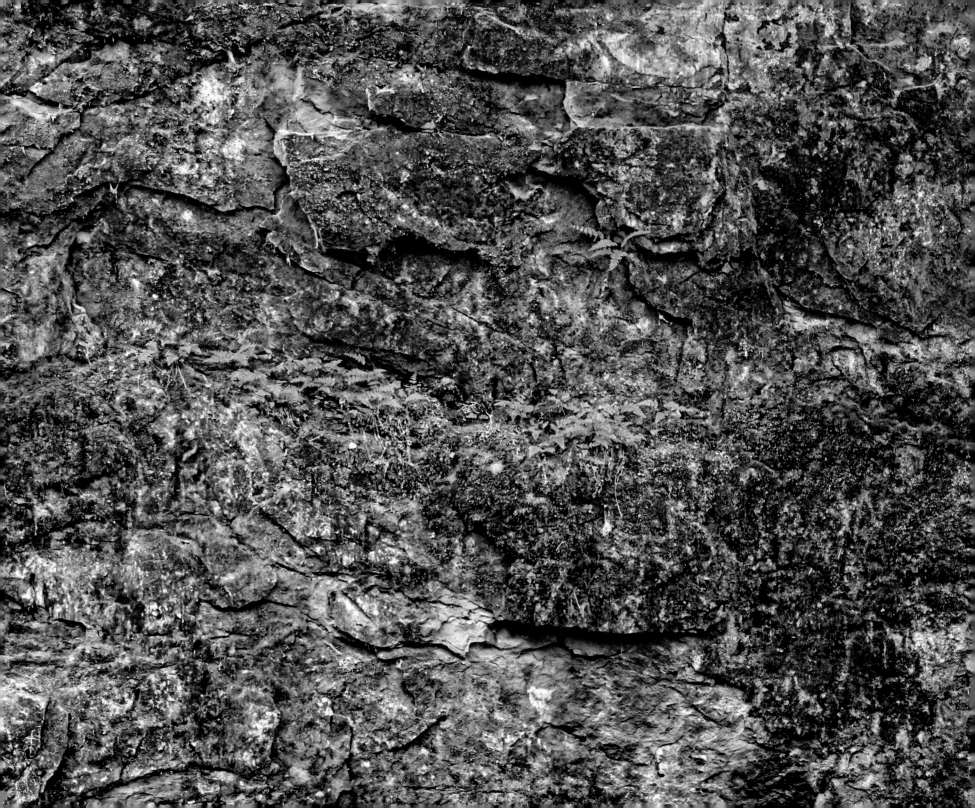

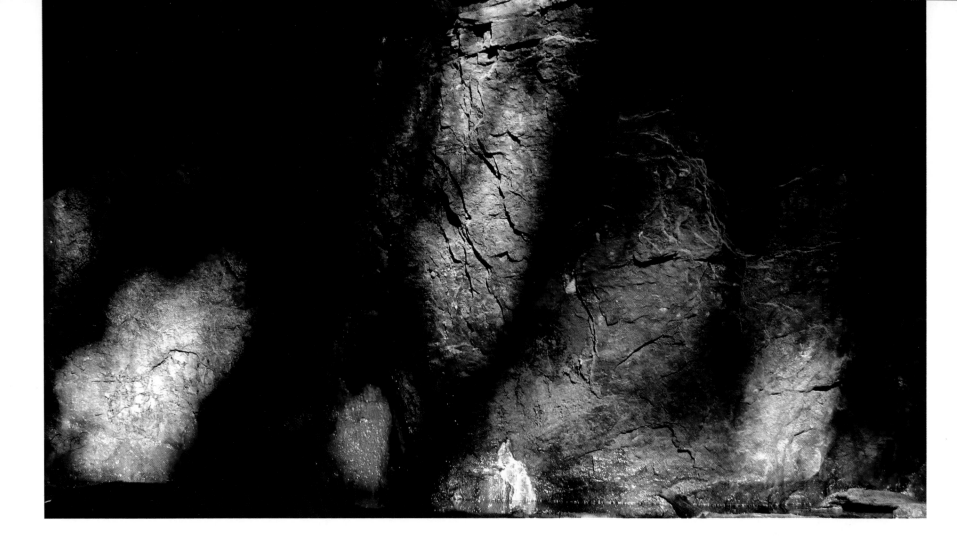

I often photograph the patterns of light and shadow that dance on the sandstone faces. The light frames the colors and textures of the sandstone, giving the bluffs and canyon walls a different look. The image on the facing page is a result of sunlight reflected upward, illuminating the sandstone. Next time you hike Trail 3, look closely at the canyon walls. How does light change the appearance of the sandstone?

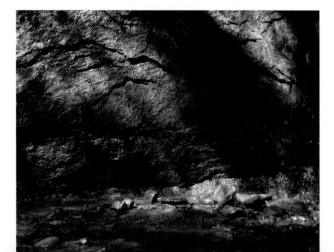

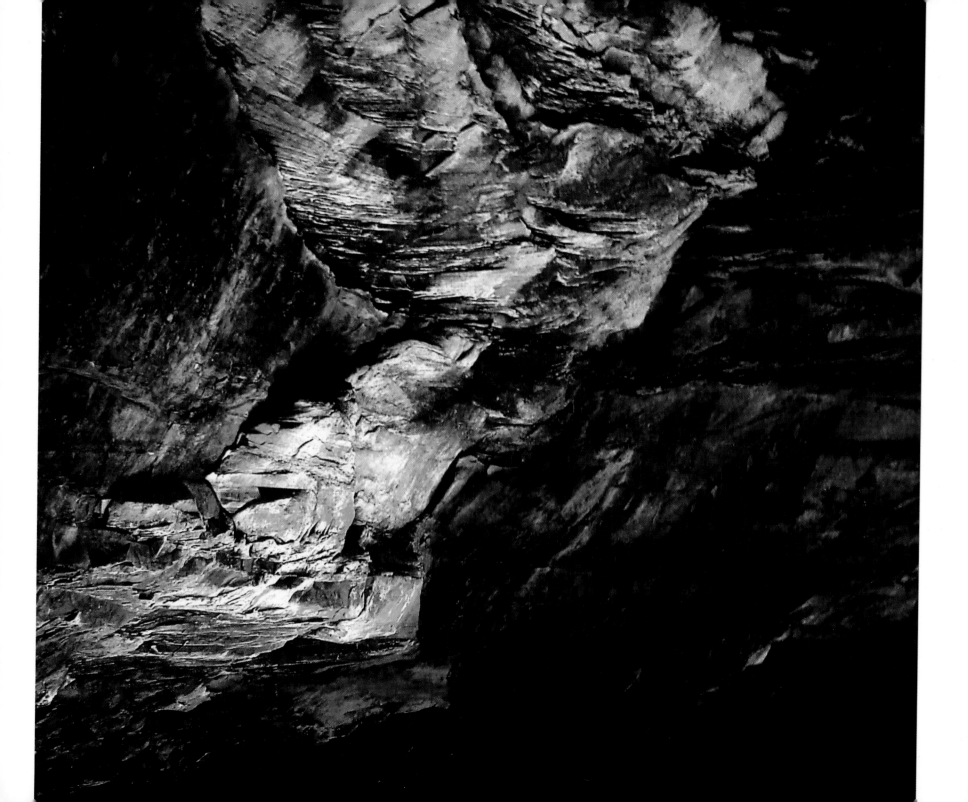

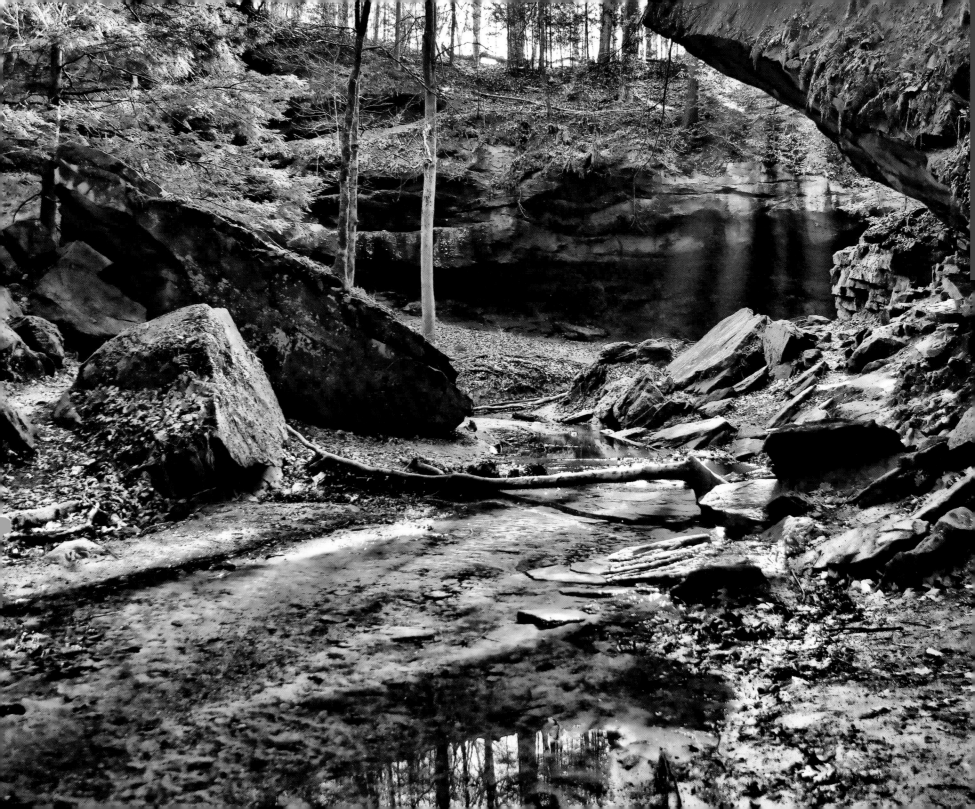

CHAPTER 2

Have you ever wondered why there are sandstone bluffs and canyons in Turkey Run? How they were formed? The Pleistocene glaciers, especially the Wisconsinan glacier, served as the primary force that shaped Turkey Run's landscape, creating the picturesque sandstone bluffs and canyons we see and hike today.

During the Pleistocene, beginning about two million years ago and ending just ten thousand years ago, the climate was much colder than it is today. This allowed snow and ice to accumulate over long periods of time, giving rise to mile-thick ice sheets or continental glaciers that flowed down from Canada. As the glaciers flowed, they eroded the land. The weight of the flowing glaciers fractured the bedrock and lifted blocks of rock up into the ice, where they became part of the glacier. As the glaciers continued to flow forward, they gouged out the land. They stripped Canada of its bedrock and transported and deposited it as far south as Indiana.

These sheets of ice melted, retreated, and advanced several times during the Pleistocene. The Wisconsinan glacier was the last to advance, reaching central Indiana before it began to melt and retreat some twenty thousand years ago, leaving its mark on Turkey Run in two ways. First, as the glacier melted, it deposited unsorted earth material, or till. This glacial till consisted of earth materials of various sizes, from finely ground silt, to stones, to large boulders. These stones and boulders consisted of igneous and metamorphic rock, including granite, basalt, and gneiss, transported from Canada. Today, these rocks are transported by flowing water that washes them from the land and into the ravines and canyons found throughout the park. Second, the tremendous amount of glacial meltwater not only transported and deposited the till, but also eroded the earth's surface. This carved out the canyons found today in Turkey Run and formed the channel that became Sugar Creek. As glacial meltwater flowed, it gouged the land deeper and wider, exposing the sandstone bedrock and forming the river bluffs seen today. Today, water is the principle erosive agent, starting as rain or snow. This water continues to weather and erode the sandstone bluffs and canyons, and cuts ravines into the land, transporting the earth material toward Sugar Creek.

It is the sandstone bluffs and canyons that make Turkey Run exceptional. They add topography to the land, giving us the scenic beauty we enjoy. The bluffs and canyons also create distinctive areas in the park that support different plants and animals, adding to the park's biodiversity. Additionally, they provide us the opportunity to experience the geological past and to see how earth processes shape the land today. If you think about it, when you hike the canyons you are traveling back in time. You are walking on and seeing rock that was deposited as sand millions of years ago. And today, you are seeing its disintegration.

In this chapter we will look more closely at the sandstone bluffs and canyons of Turkey Run. I hope the images provide you with a new way of seeing and reading the Turkey Run landscape.

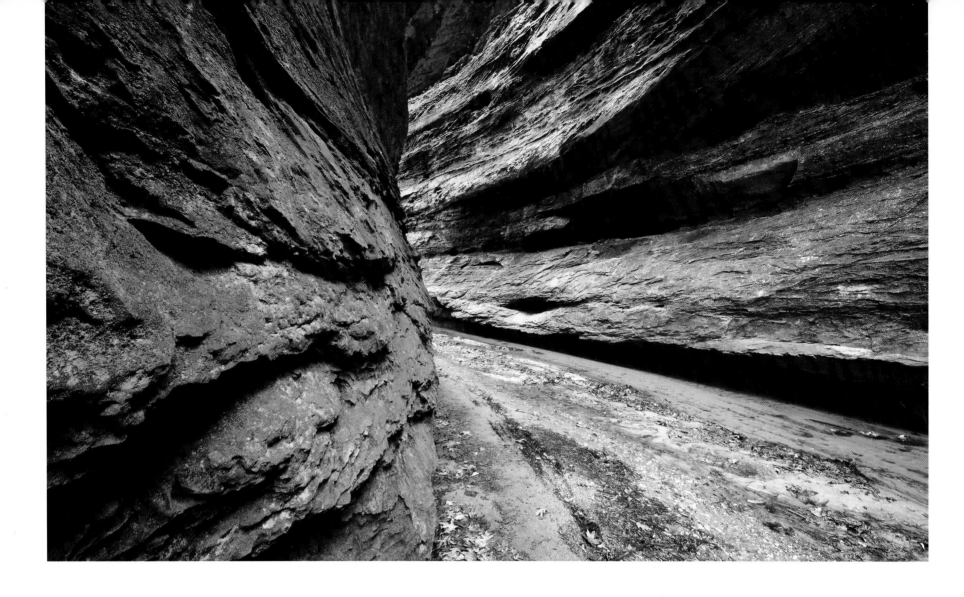

The initial advance of the Wisconsinan glacier was followed by a period of stagnation during which the glacier began to melt and retreat. This released tremendous amounts of meltwater. As a result, great outwash rivers flowed from the glacier. The huge amounts of glacial meltwater cut deep into the sandstone bedrock, eroding the land into narrow, steep-walled canyons. This exposed the layers of sandstone formed from ancient sediments deposited in rivers millions of years ago. Today, rain and snowmelt continue to erode the canyons deeper and wider. The images that follow provide many perspectives on the canyons and bluffs of Turkey Run.

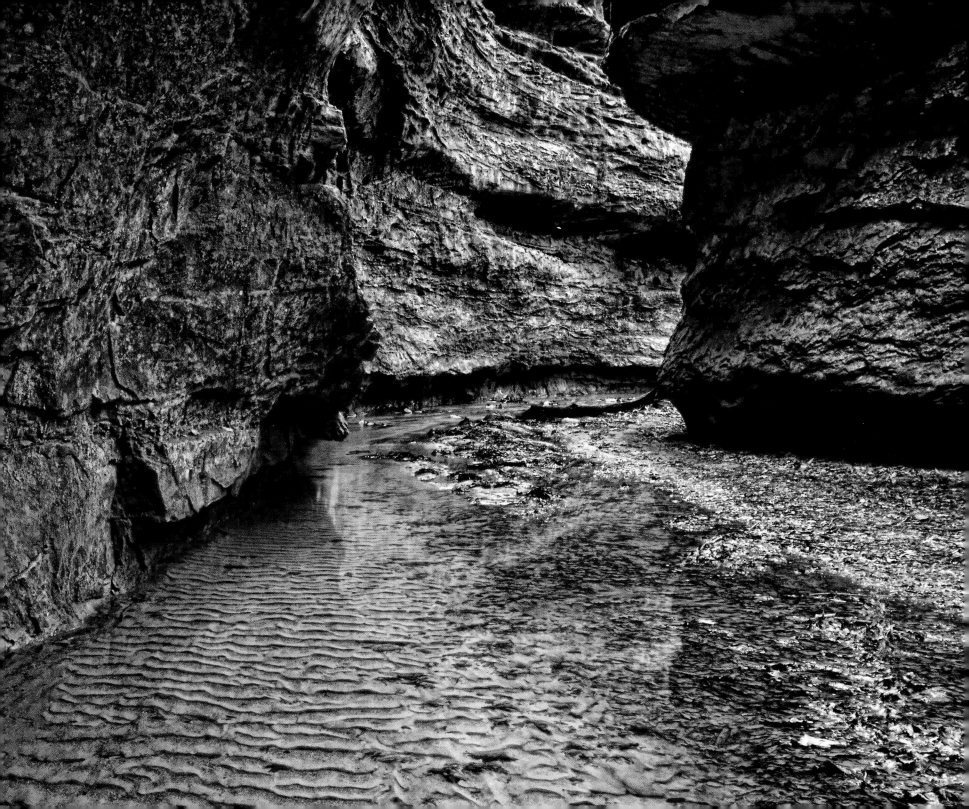

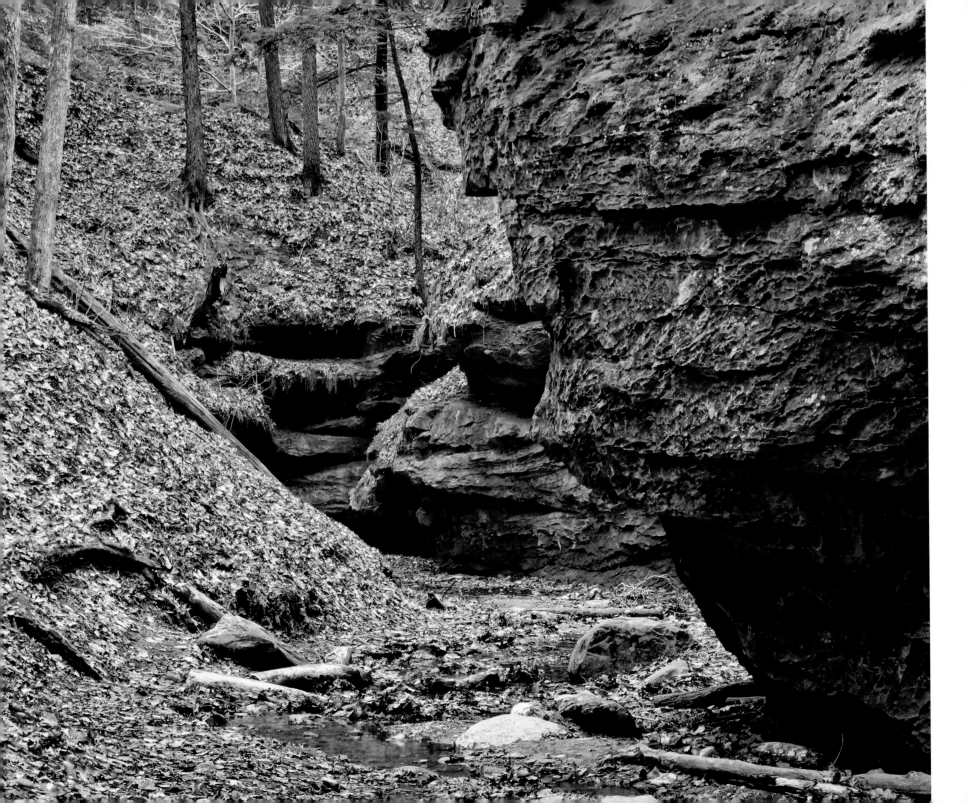

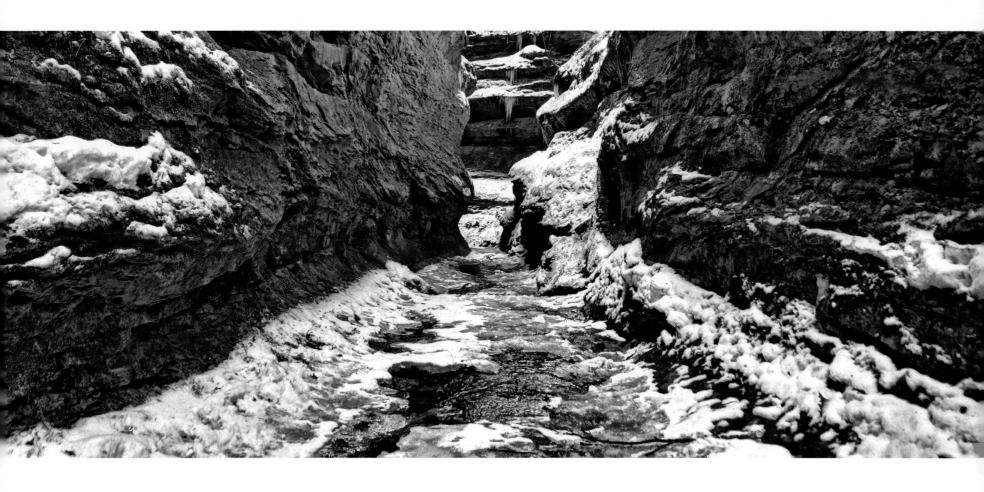

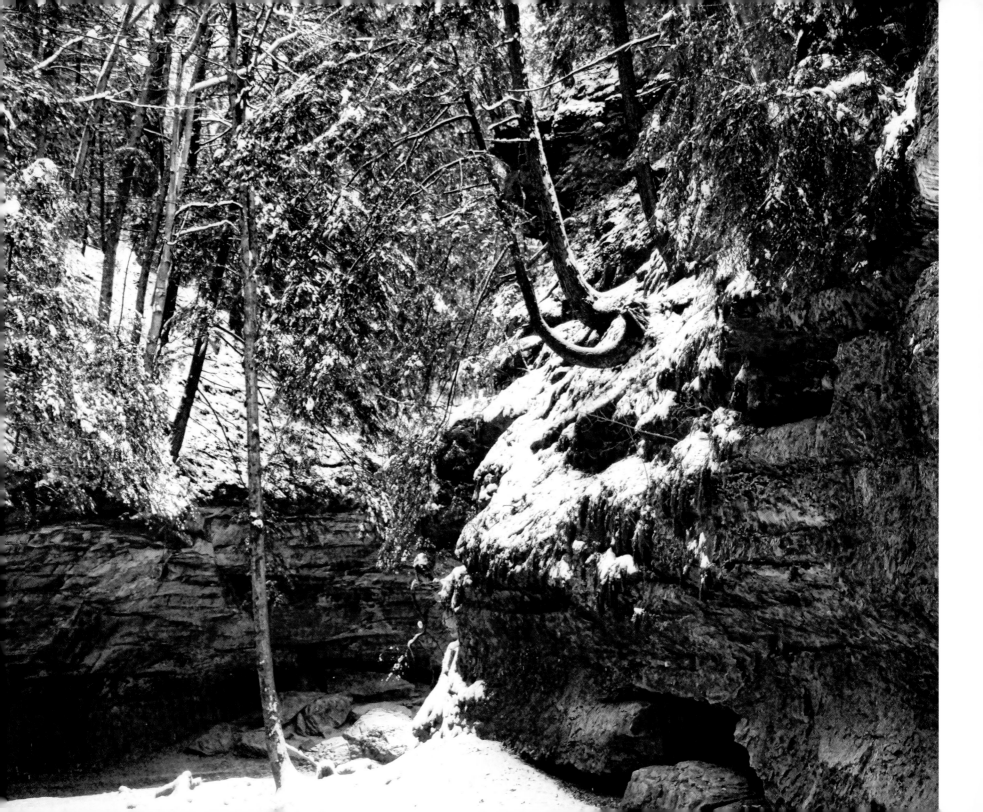

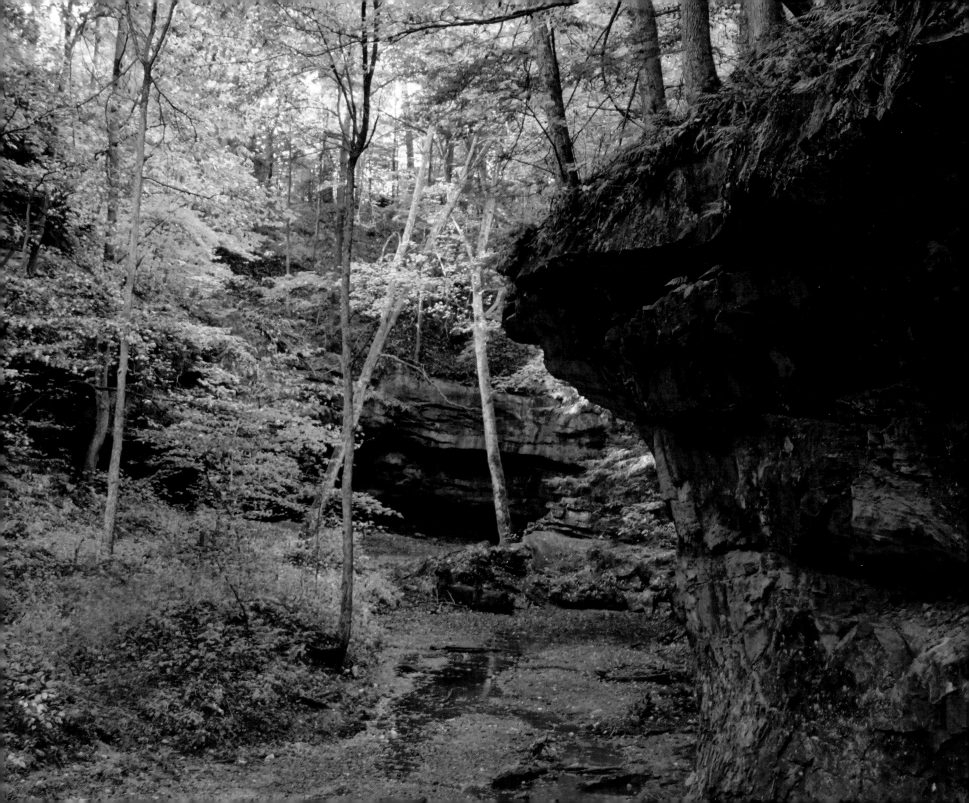

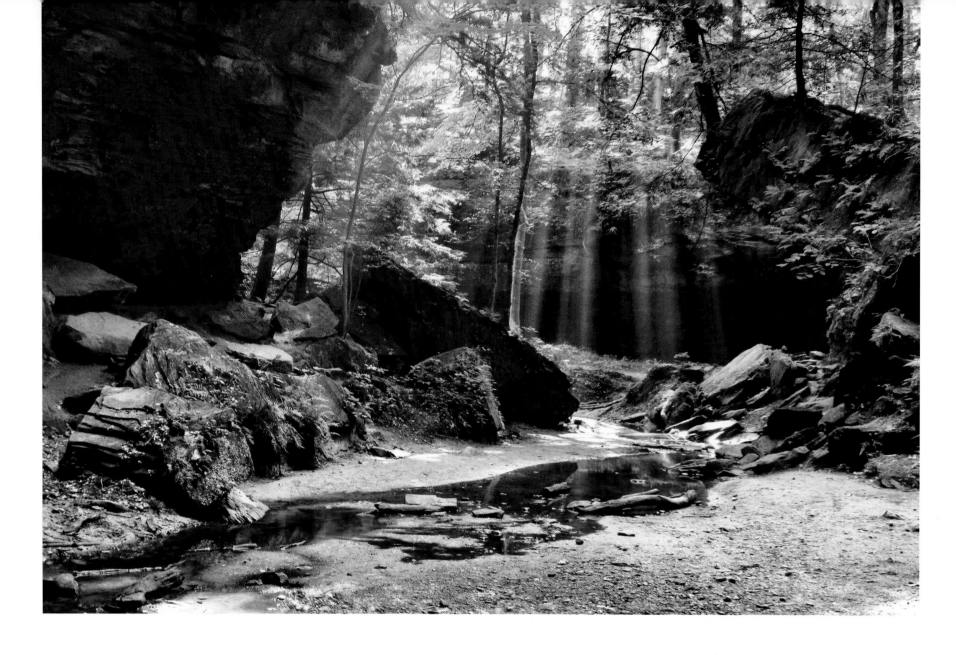

The narrow sandstone canyon on Trail 3 provides an opportunity to experience the workings of flowing water as it erodes the earth. The canyon's look and feel changes with the seasons and the time of day. Summer mornings bring cool, moist air, creating a fog that hangs between the rims and scattering light as it penetrates the trees above.

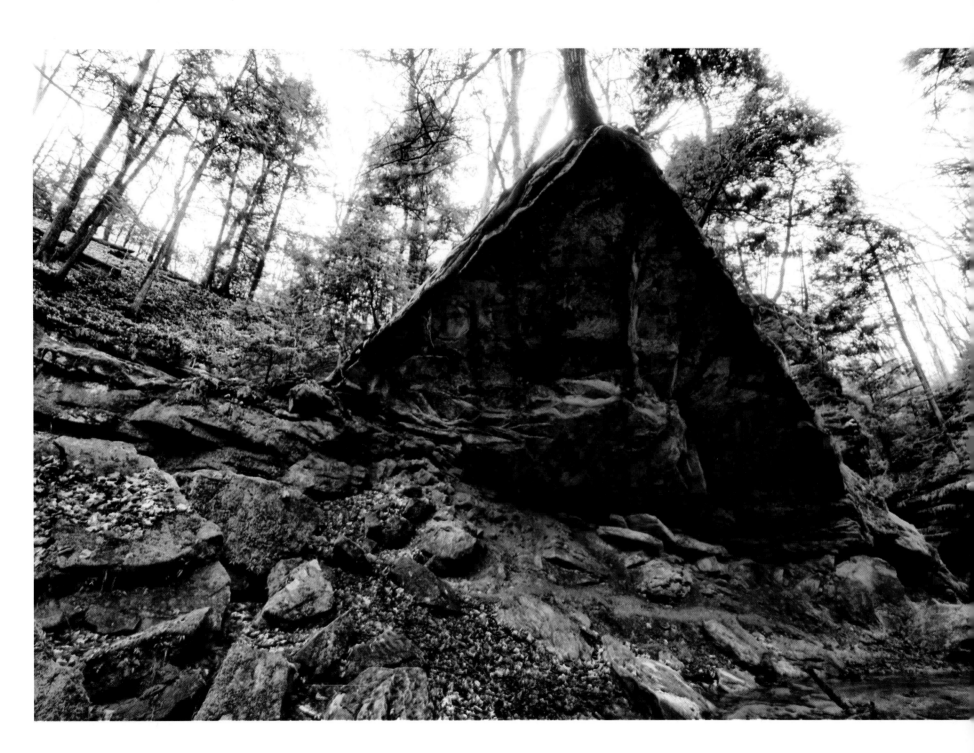

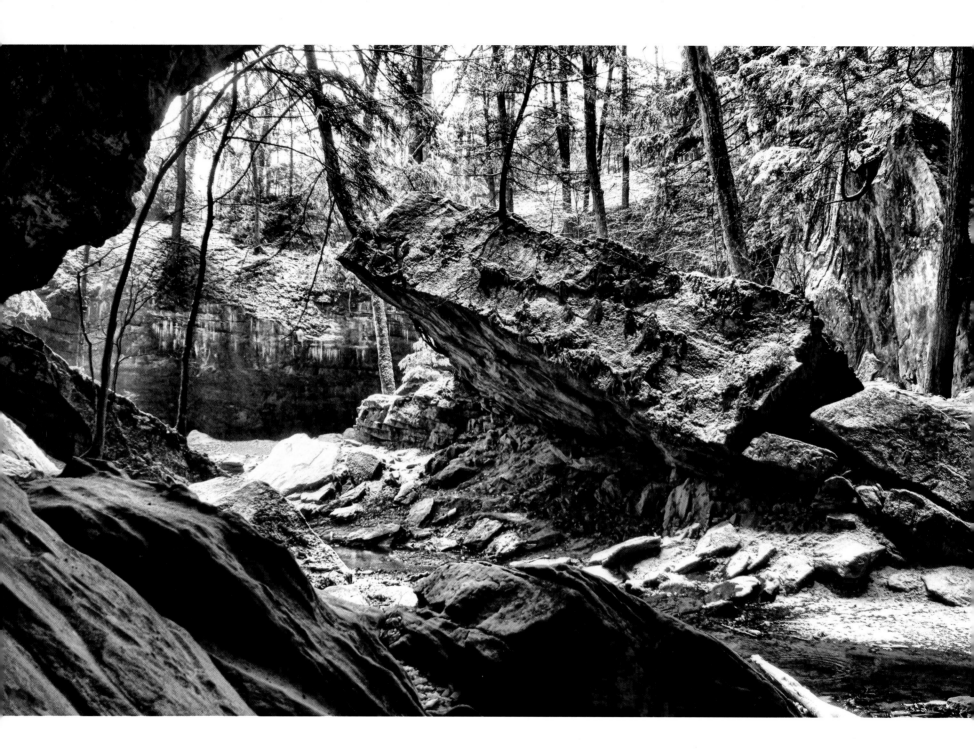

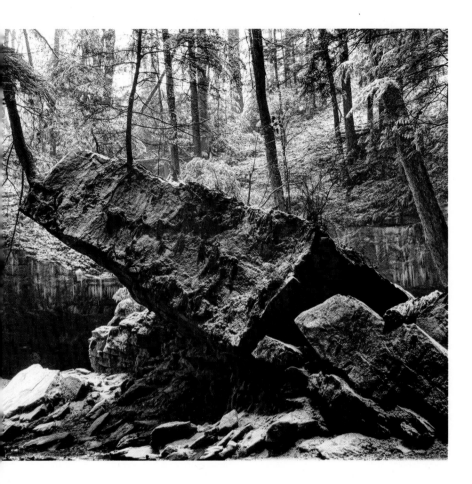 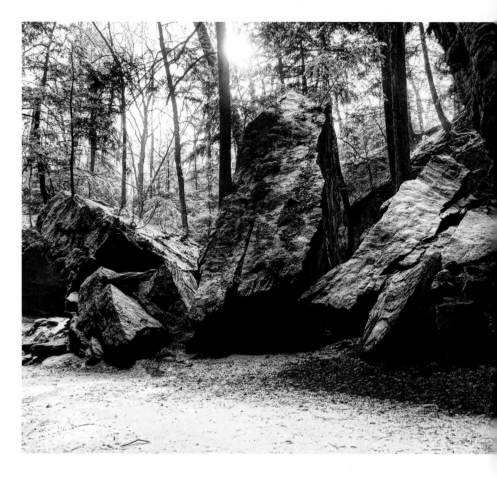

Wedge Rock is a joint block that separated from the canyon wall, unfolding like an accordion. All rocks have zones of weakness along which they crack or fracture. The joints in this sandstone show these zones. Erosion brings the rocks to the surface, which exposes the joints to chemical and physical weathering, weakening the joint and causing the sandstone block to collapse under the pull of gravity. At some point in the future, the base of the outer joint block will be eroded away, causing it to fall to the earth's surface. As seen on these pages, I was fortunate to photograph Wedge Rock with a dusting of snow on a foggy morning. The combination of the morning light and the fog and snow gives a white glow to the scene. The images on the next two pages capture Wedge Rock aglow in summer morning sunlight, reflected upward from the creek below, while the following set of images provide a touch of fall color.

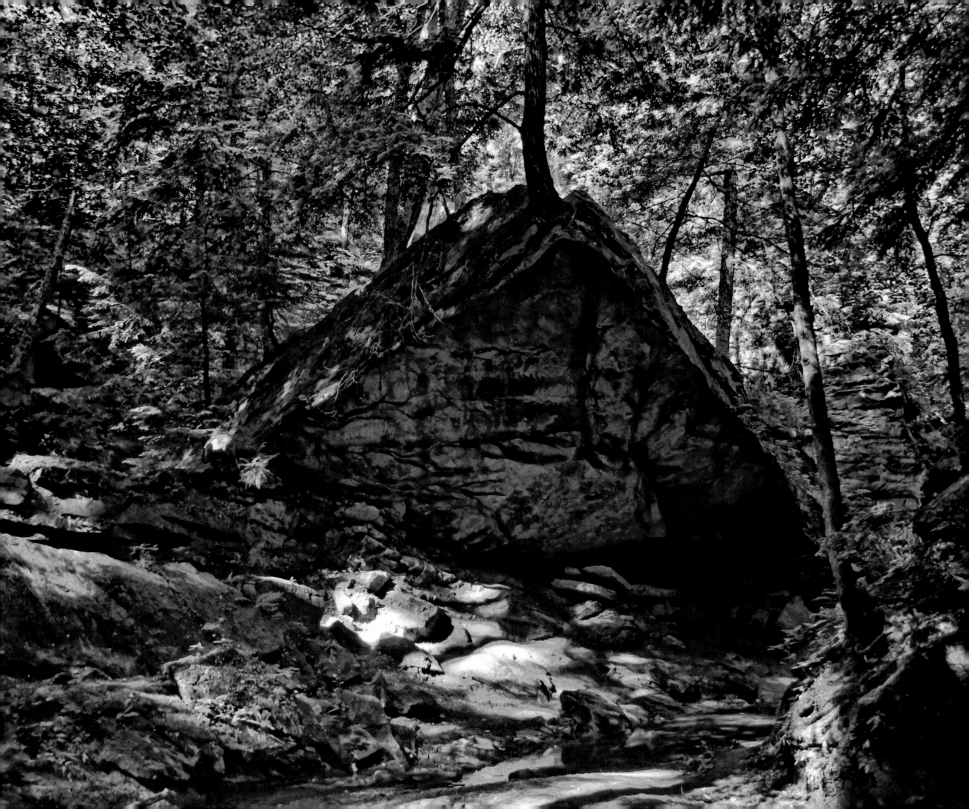

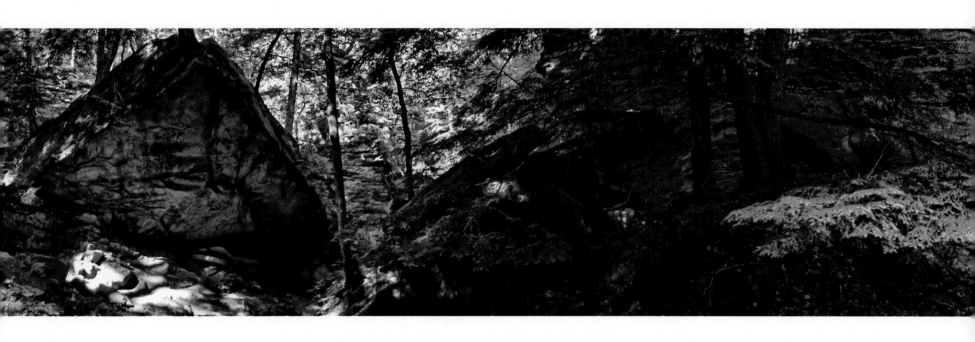

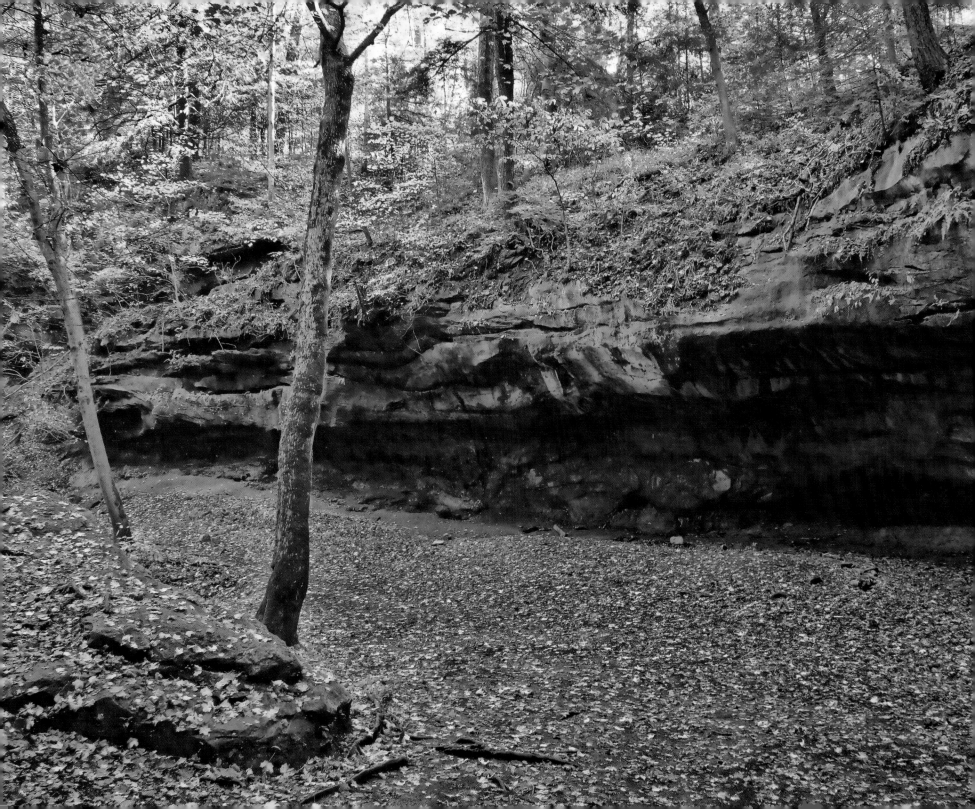

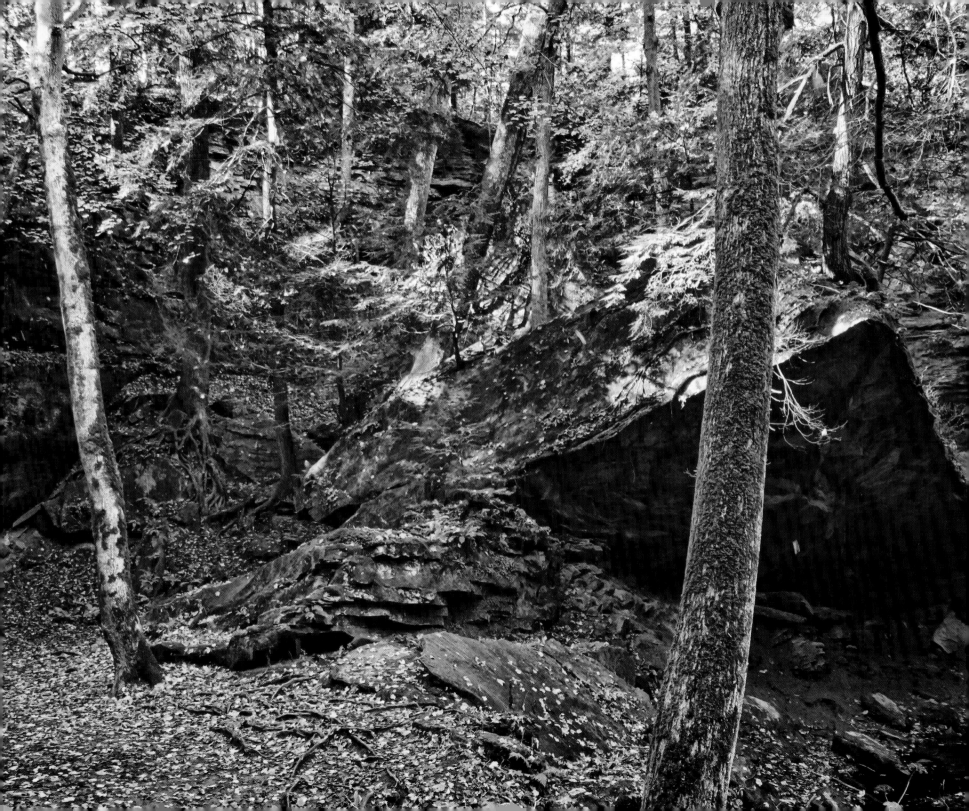

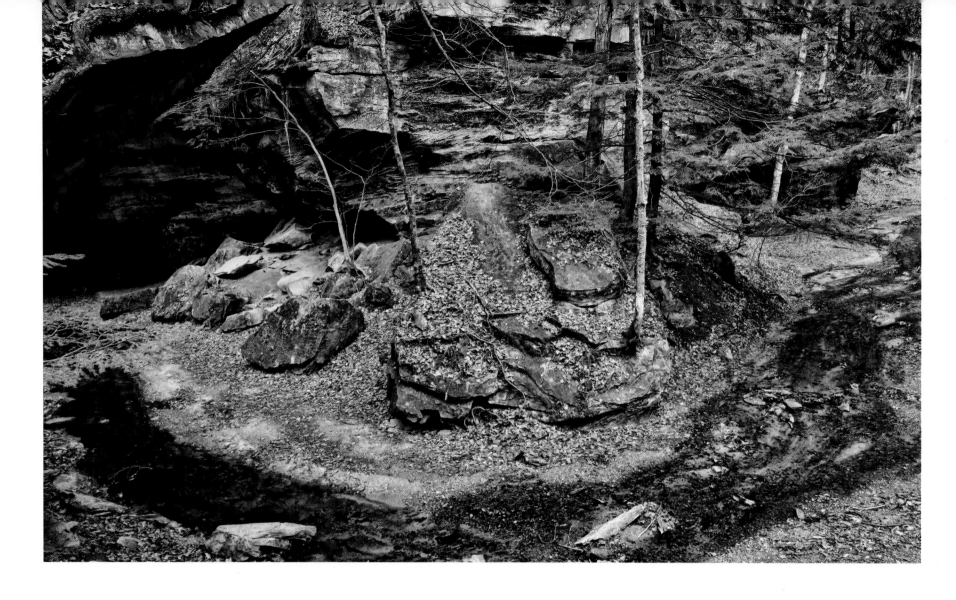

The narrow sandstone canyons of Turkey Run create microclimates. The canyon walls and trees shade the canyon from the sun, which results in cooler air that holds more moisture. This, in turn, creates a localized climate, or microclimate, suitable for eastern hemlock trees to grow. These relics are remnants of Turkey Run's past, when the climate was much cooler. Today, rain and snowmelt running off the land continue to take the path of least resistance. The flowing water will erode the sandstone until it reaches base level, the elevation at which the water no longer flows downhill.

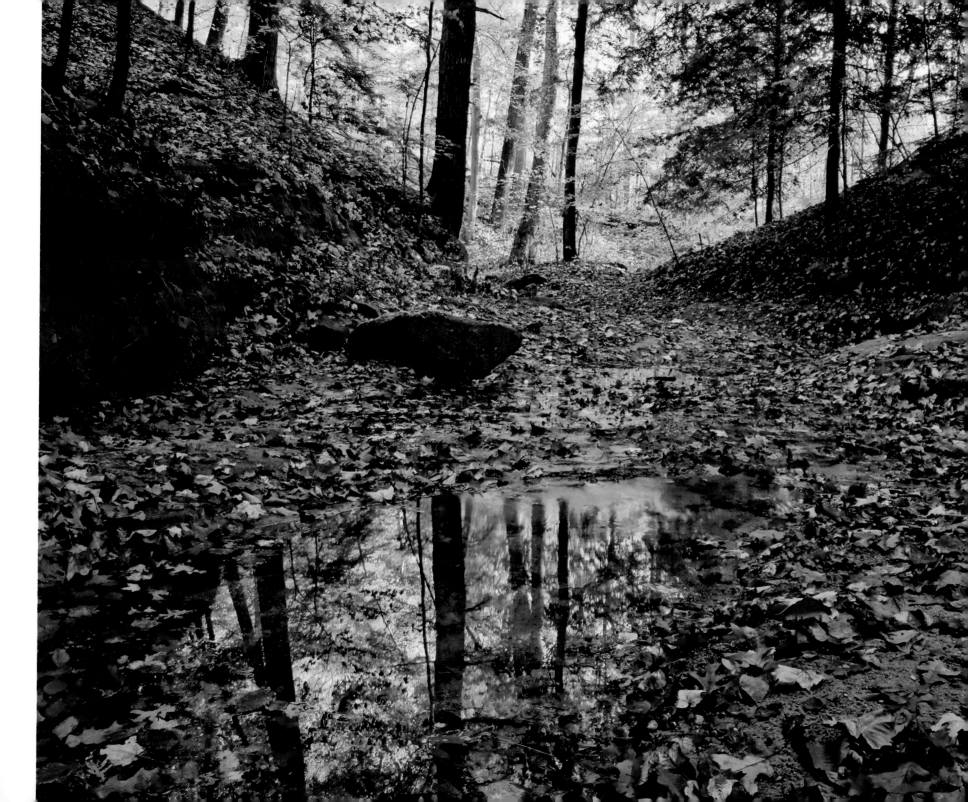

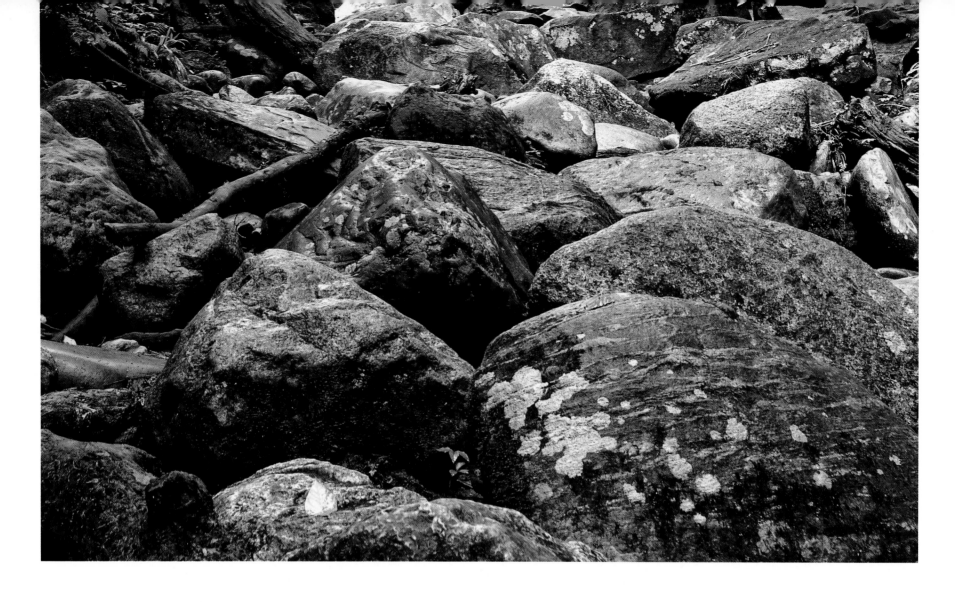

These boulders of granite, basalt, and gneiss were transported from Canada in and on glaciers and deposited by glacial meltwater. They are considered glacial erratics because they are different from the sedimentary rock (the sandstone) that makes up the foundation of Turkey Run. Eroded rock and sediment may be transported hundreds of miles before it is deposited as till.

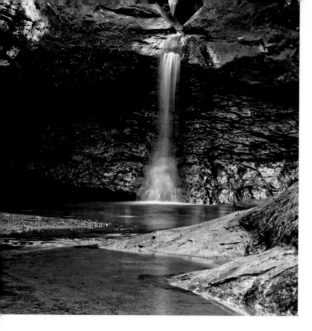

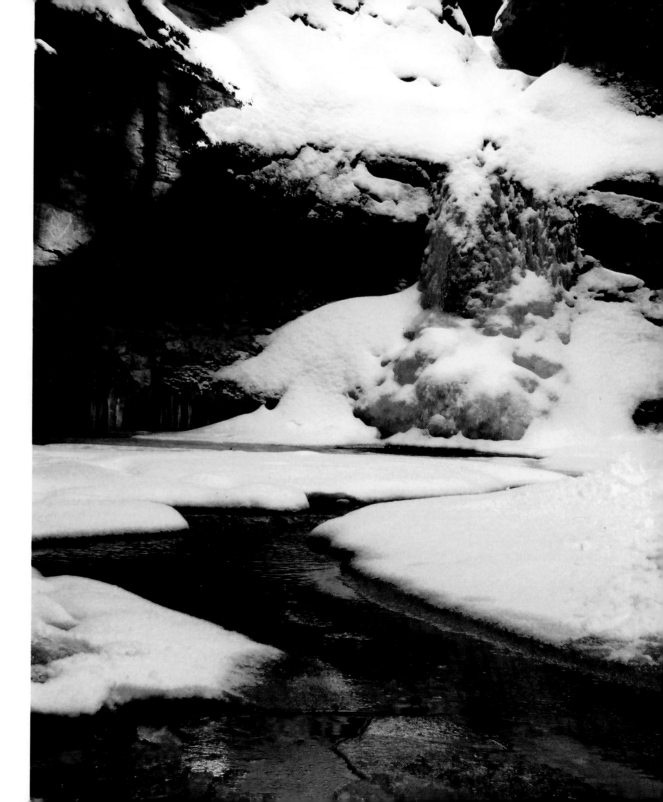

The images here, taken in summer and winter, are of the Punch Bowl. It is an ancient pothole carved into the sandstone by boulders and rock fragments swirling in glacial meltwater. Today, rain and snow-melt running off the land continue to erode the Punch Bowl. The moist air allows mosses and ferns to grow.

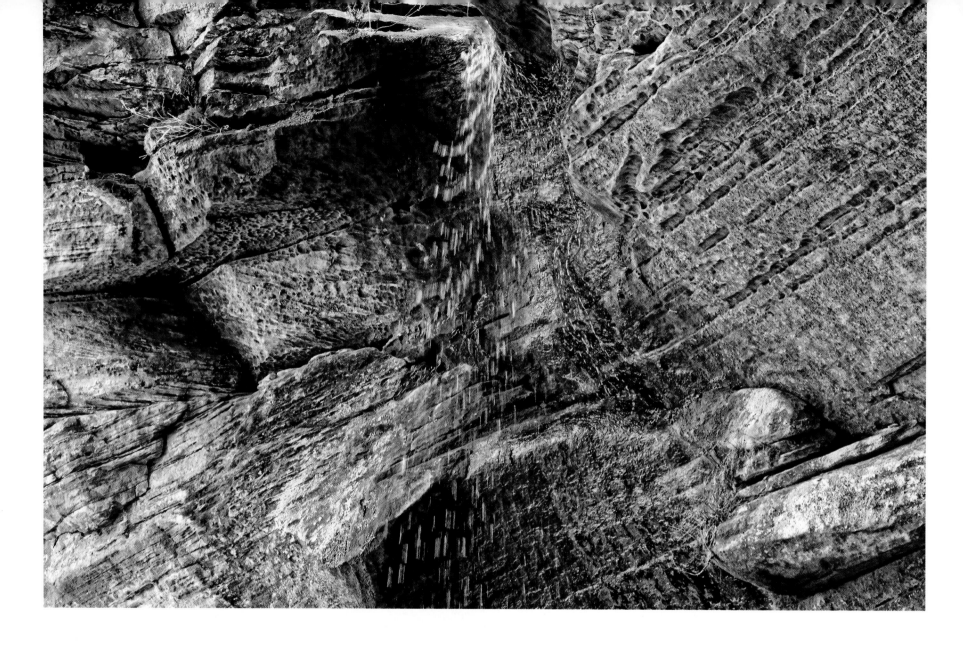

Water percolating through and flowing over the sandstone leaches out minerals that are exposed to air and water and oxidized. This creates colorful tapestries. The tan and yellow hues reflect a blend of quartz and feldspar, while the reds and browns result from the presence of iron. Greens and blues derive from lichens and mosses that have taken up residence on the rock.

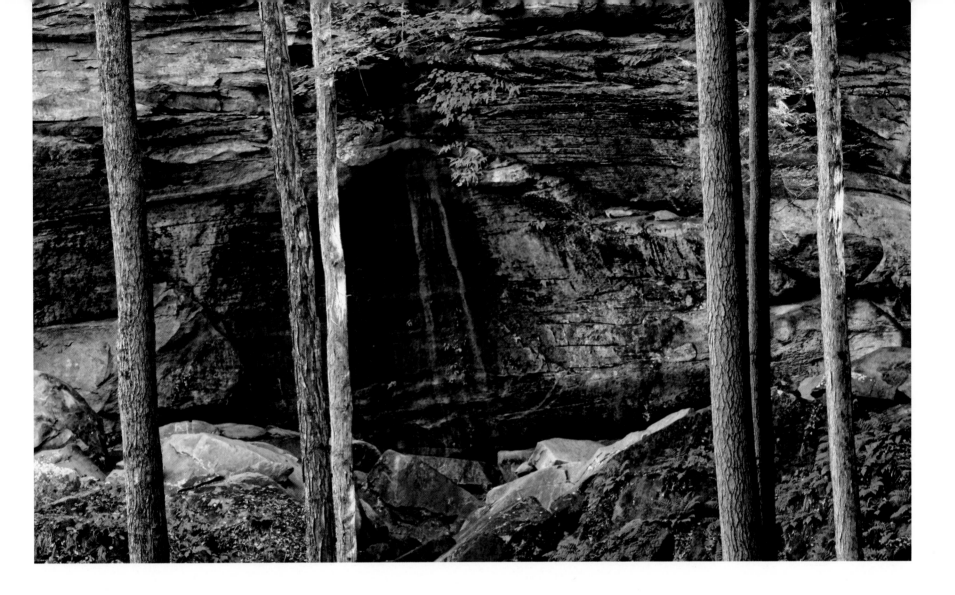

Gypsy Gulch, on Trail 2, changes with the seasons, weather, and lighting conditions, as seen in the images that follow. Carved by glacial meltwater, this bluff once stood above the flowing water of ancient Sugar Creek. Over time, the glacial meltwater subsided to the present-day channel of Sugar Creek. As the glacial meltwater flowed, it eroded the sandstone, exposing the joint or crack that we see between two different layers of sandstone. The joint in this sandstone shows that the zone of weakness lies along the bedding plane formed by the layering of sediments in an ancient river millions of years ago. Today, the exposed sandstone is chemically and physically weathered by water.

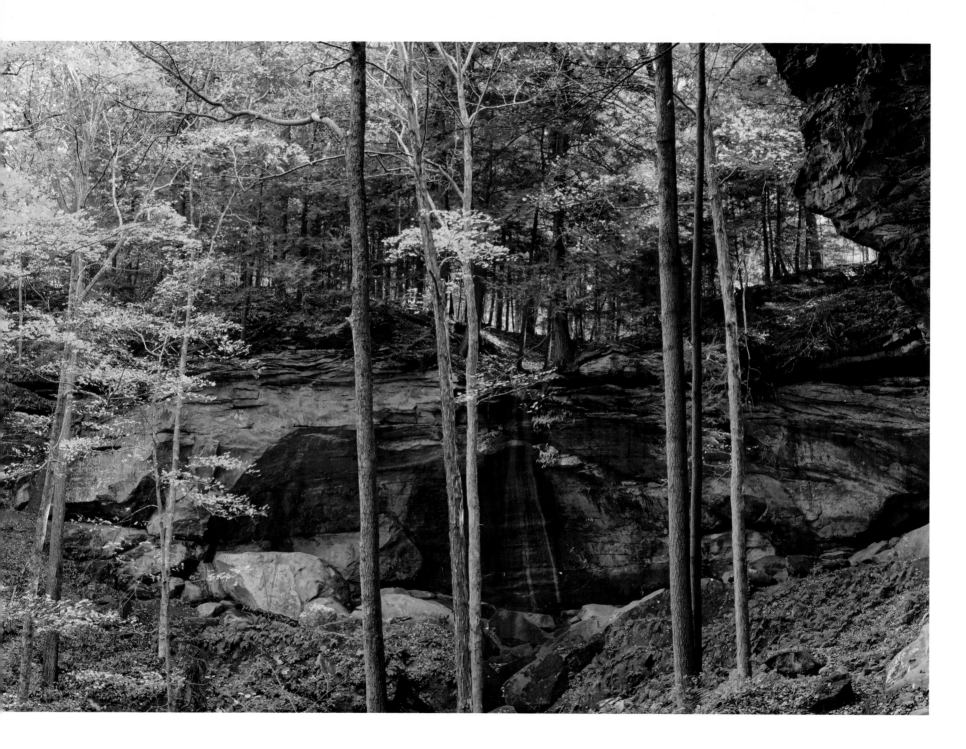

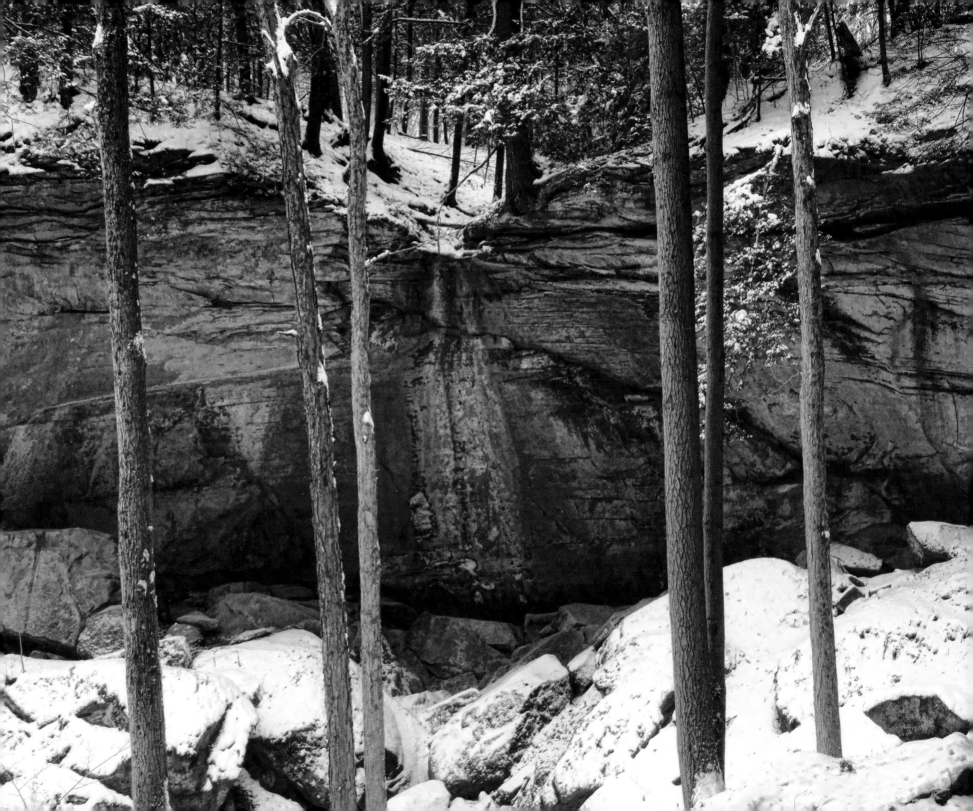

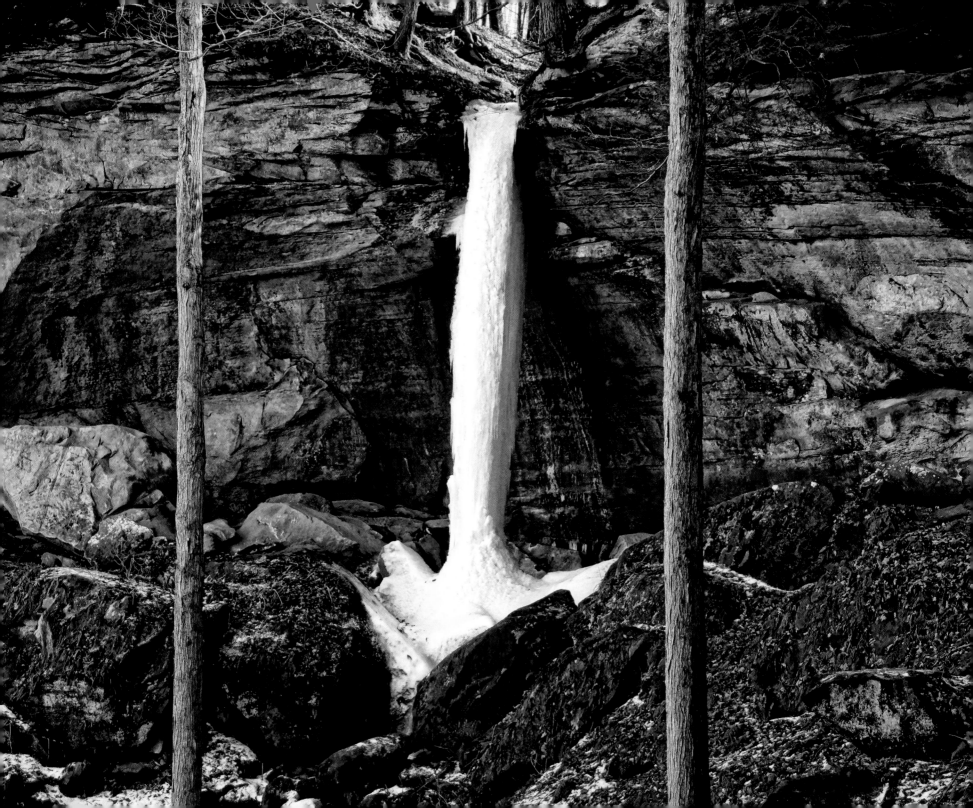

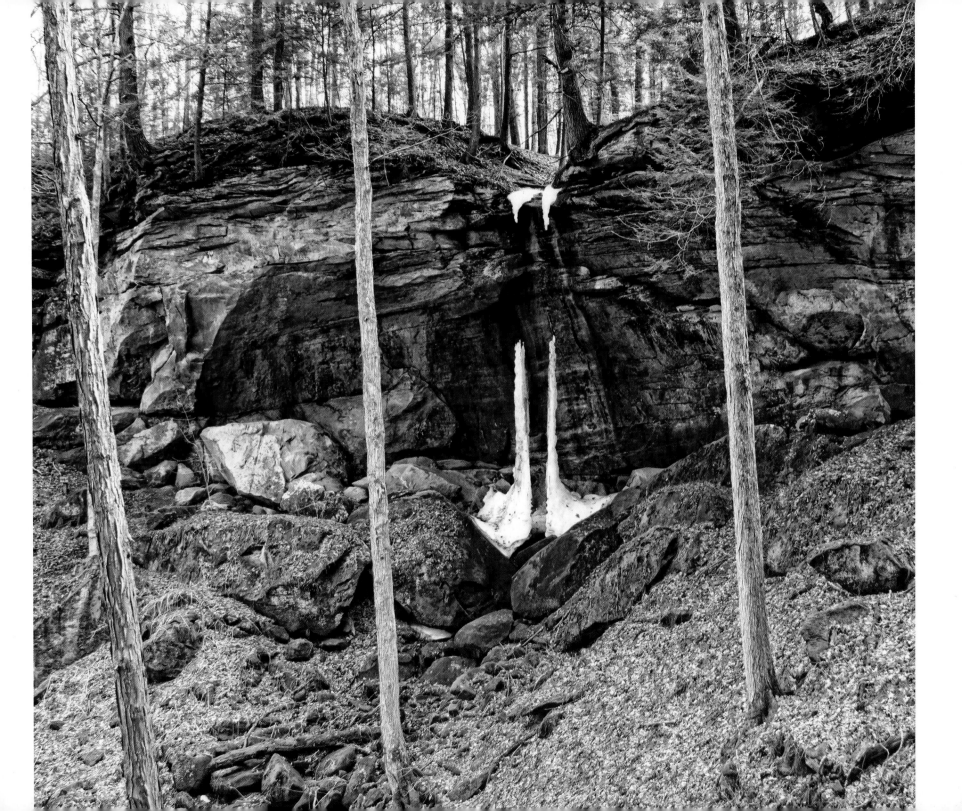

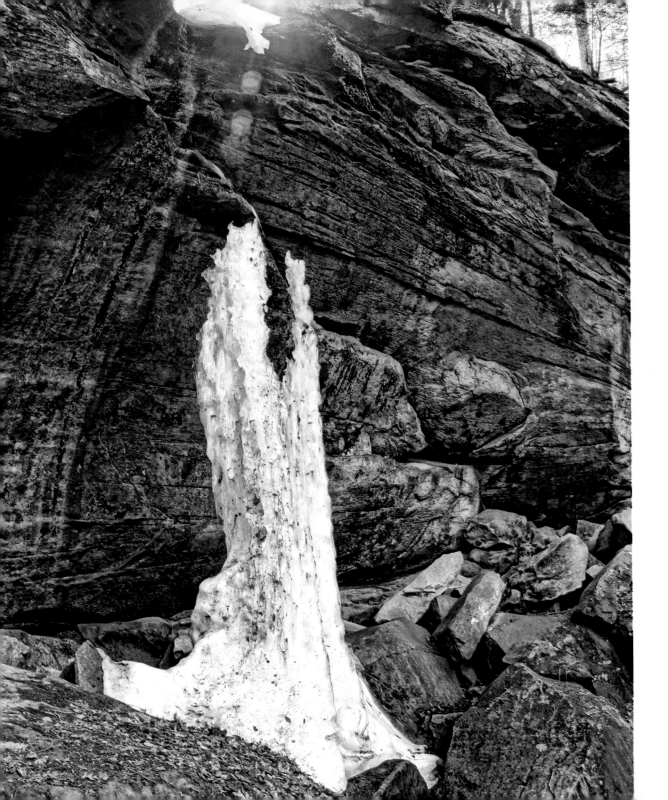

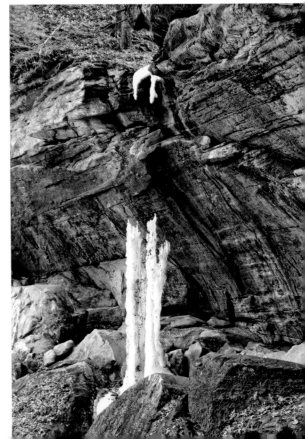

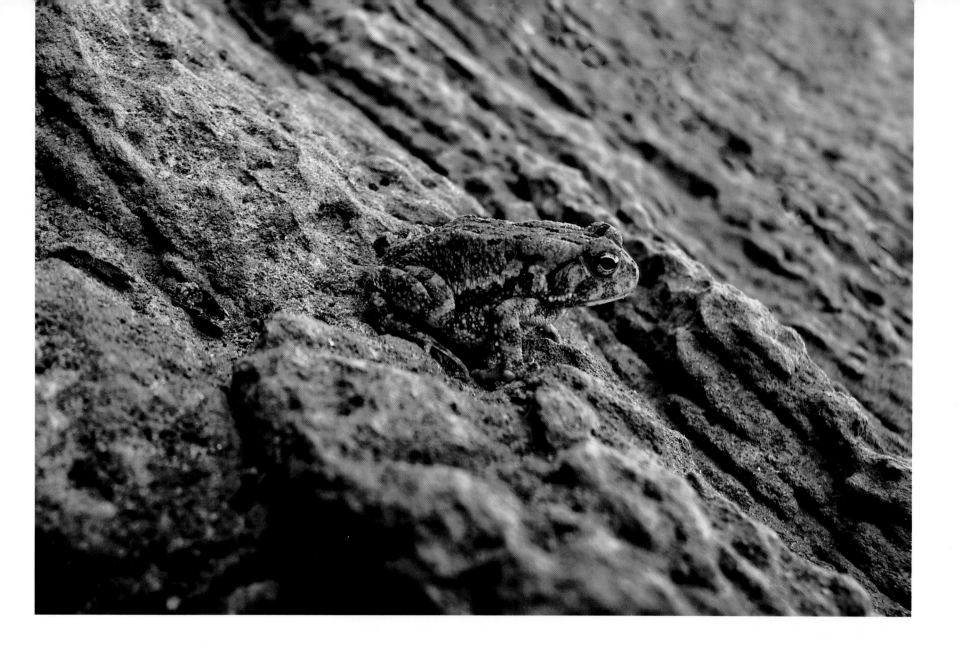

The sandstone bluffs and canyons provide habitats for toads and other animals. The cracks and joints in the sandstone provide cool, damp places for toads to live, protecting them from predators. The toad's thick skin reduces water loss, which enables it to live along the bluffs and canyons far from water. It returns to water only to mate and lay its eggs, which develop into tadpoles. Adult toads mostly eat insects.

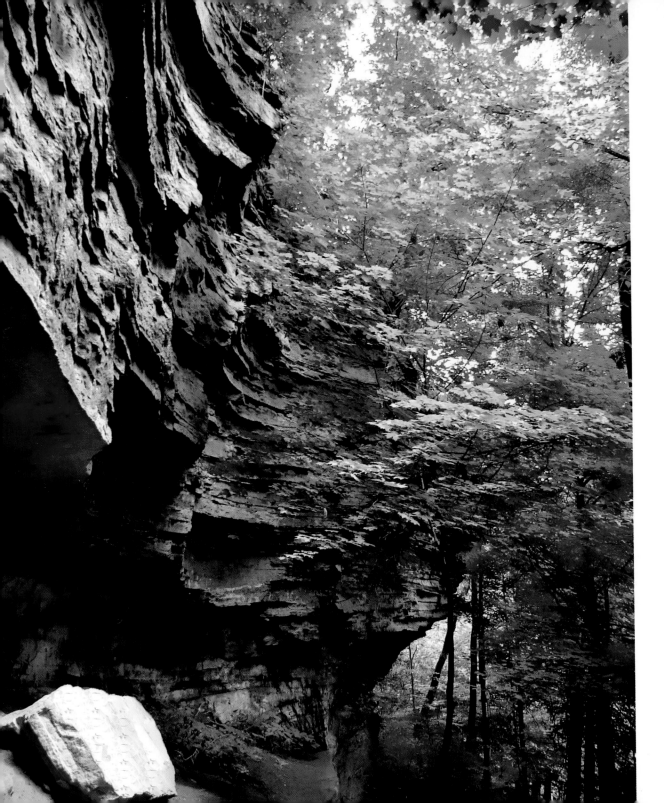

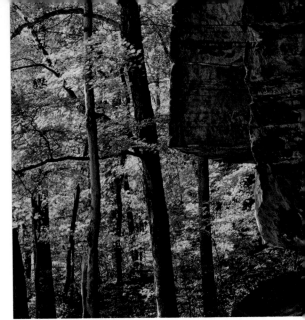

There is something about the bluffs of
Turkey Run that draws me to them. There's
a feeling of awe standing next to a sand-
stone face that is hundreds of millions of
years old. The trees that grow at the base
of the bluff suggest a harmony between
the living and the nonliving. The past and
the present are seen in the rock and the
tree, and in the green and yellow leaves
of the trees, in these images.

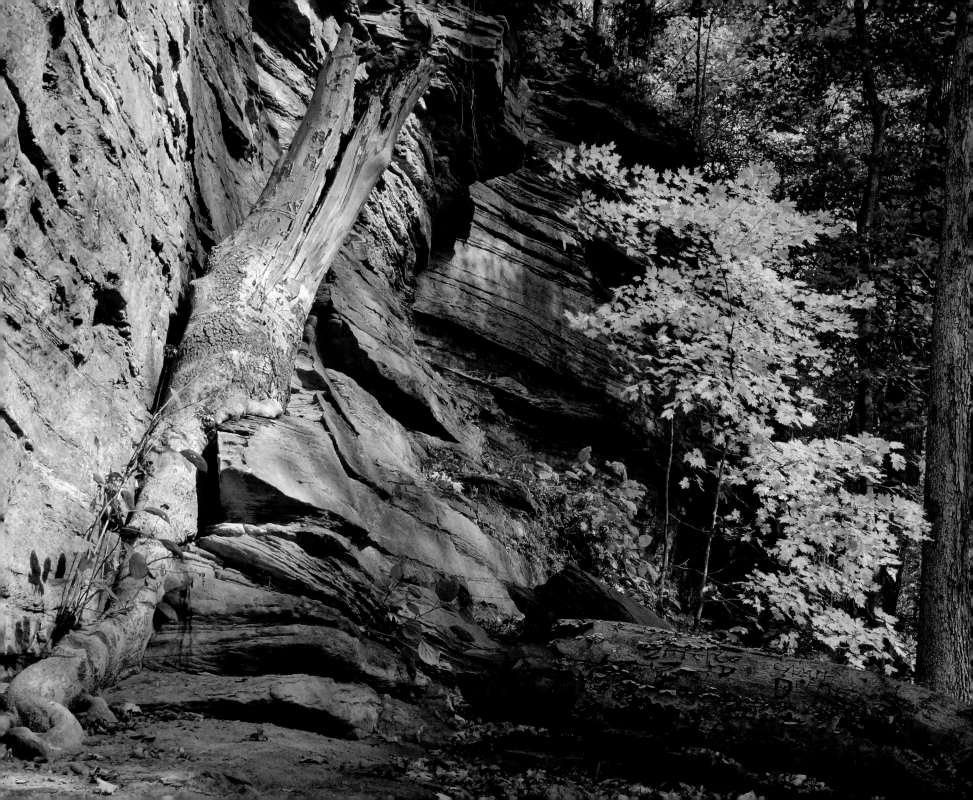

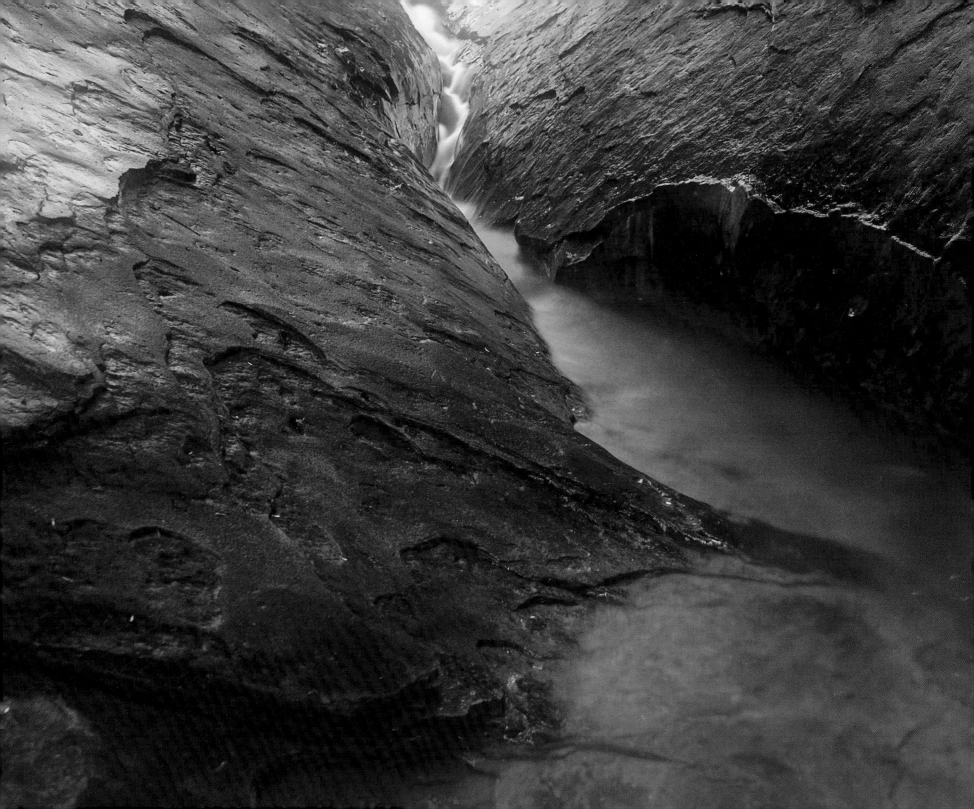

CHAPTER 3

Flowing Water

To the human eye, the Turkey Run landscape seems to change very little over time. Yet it constantly undergoes dramatic change over geologic time. The landscapes we see today have taken thousands of years to form. They are products of the earth's forces of weathering and erosion, forces that continue today to shape the park's landscape.

If we look closely at the land, we can read its clues and begin to see how the earth's forces have shaped the landscapes we see in Turkey Run. For example, the deep sandstone canyon hints at the work of glacial meltwater and stream erosion. We can see how the landscape was shaped in the past and we can imagine how weathering and erosion may sculpt it in the future.

I think of weathering and erosion as opposite sides of the same coin. Weathering breaks down rock, while erosion transports and deposits the rock pieces—the earth materials or sediments. Weathering drives erosion, for without sediments to be transported there would be no erosion or deposition. Sediments are loose earth materials that range in size, from clay, to silt, to sand, to gravel, to pebbles, to cobbles, to boulders.

Wind, water, ice (including past glaciers), and gravity are agents of erosion. They transport the sediments produced from the weathering of rock. When these agents of transport lose energy and no longer have sufficient force to overcome the weight and friction of the sediment being transported, the sediment is deposited. Deposition, then, is the geological process of adding earth material to a landscape. If we look closely, we can

see the evidence of these processes of weathering, erosion, and deposition throughout Turkey Run.

Today, the primary agent of weathering and erosion in Turkey Run is water, especially flowing water. As snowmelt and rain run off the land, it more easily erodes the softer sandstone and transports soil from the land. This differential rate of erosion then contours the land, leading to the formation of channels and ravines; it also further erodes the sandstone bluffs and canyons in the park. Flowing water always erodes downward until it reaches base level, the lowest point (elevation) to which it can flow. In Turkey Run this is Sugar Creek. Sugar Creek then transports the water and the earth materials downstream, eventually reaching the Wabash River, which flows into the Ohio River, which flows into the Mississippi River, which flows into the Gulf of Mexico.

In this chapter we explore the ways in which water, flowing over the land, gives us the beautiful landforms and landscapes found throughout the park. As the images in this chapter attest, I have hiked during and after rain events in order to photograph the rainwater gushing off the sandstone and running down the canyons and off the bluffs. I often wear rain boots instead of hiking shoes so that I can wade in the water to get a different perspective on the flow of the runoff. This chapter contains few words, but many images of flowing water. I hope they entice you to hike in the rain, to experience flowing water.

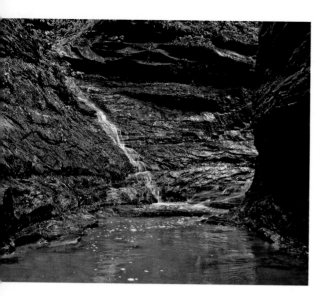

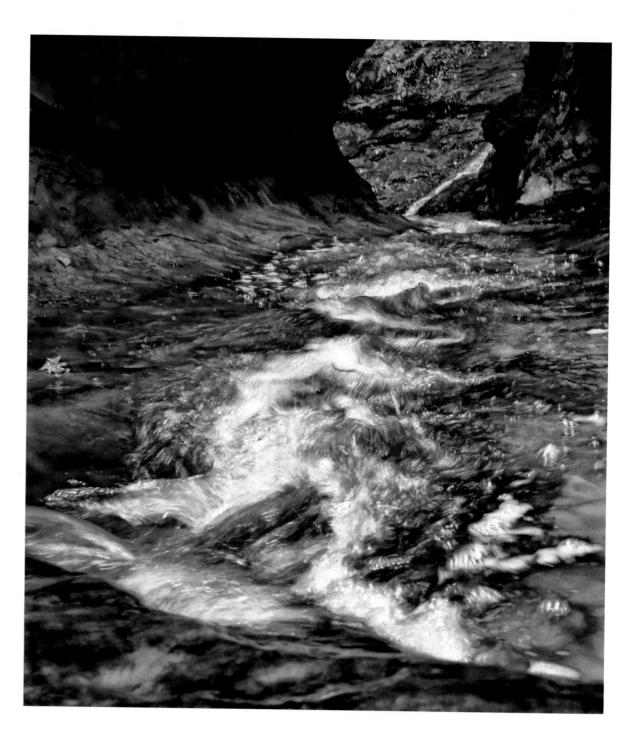

Glacial meltwater initially carved the sandstone canyons in Turkey Run. Today, water as rain and snowmelt are the principle erosive agents. Some sandstone is more easily eroded than others. As water flows, it cuts a channel into the least resistant sandstone. In landscapes where water flows rapidly, it creates erosional landforms such as V-shaped canyons. This V-shaped profile forms because the water erodes the channel downward at a faster rate than the lateral erosion of the canyon walls.

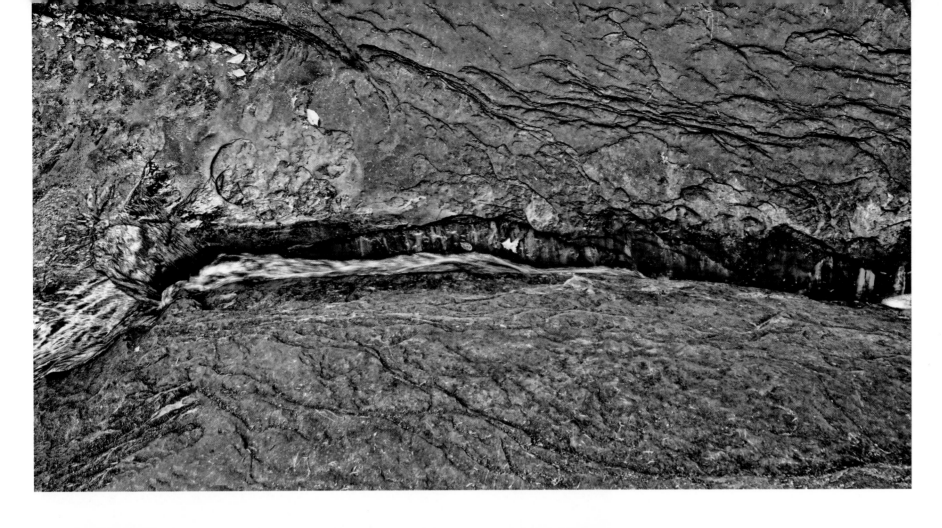

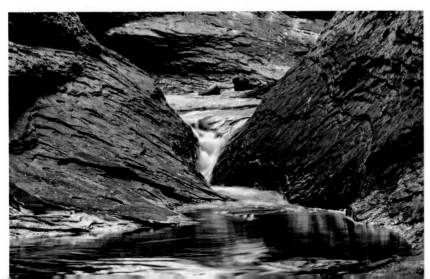

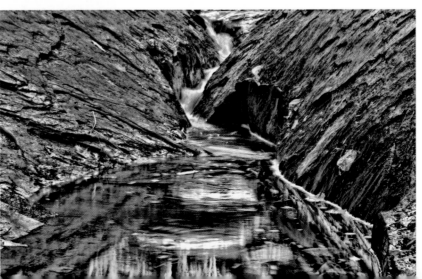

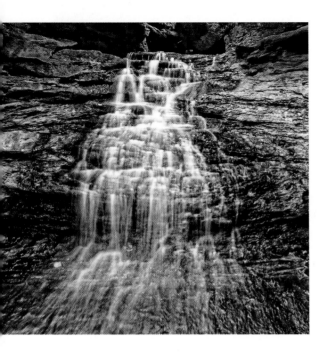

Flowing water erodes the land with an abrasive force, cutting further into the softer, less resistant sandstone. Rain and snowmelt will continue to erode the sandstone until it reaches base level, the elevation at which the water no longer flows downhill.

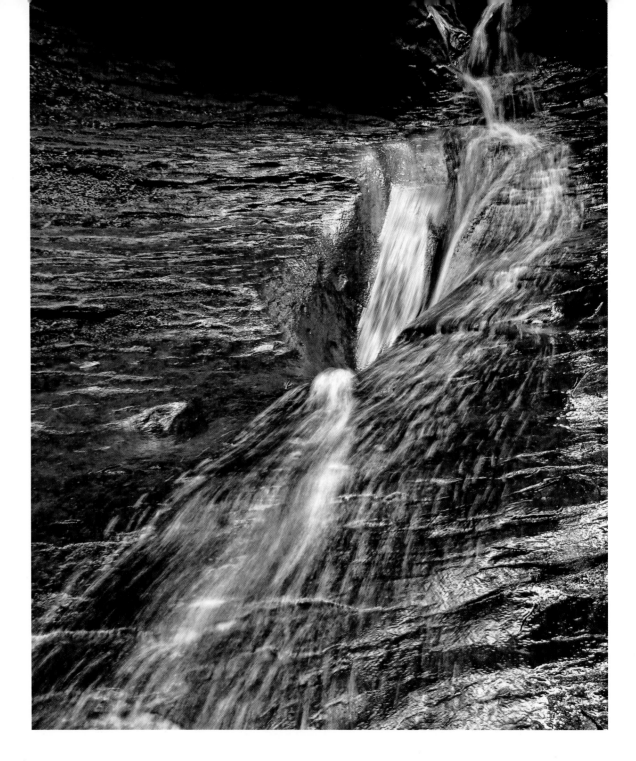

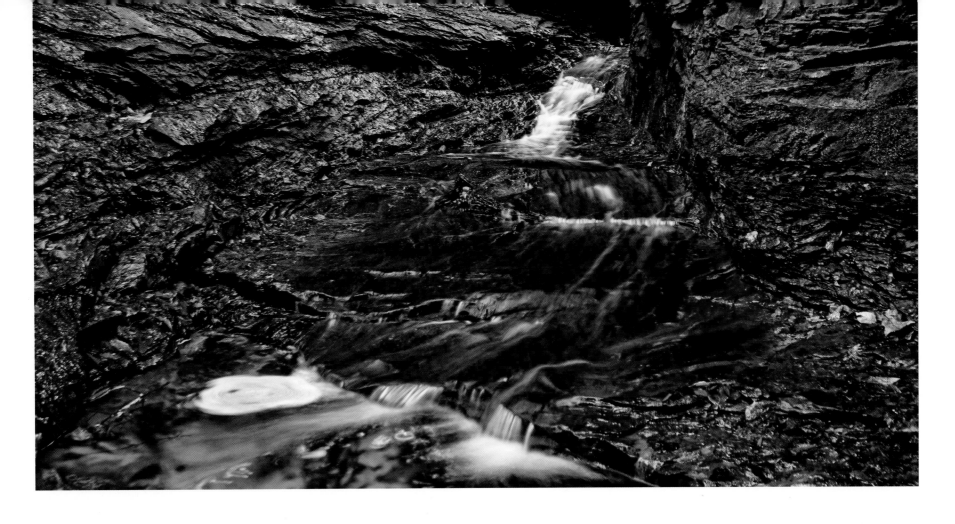

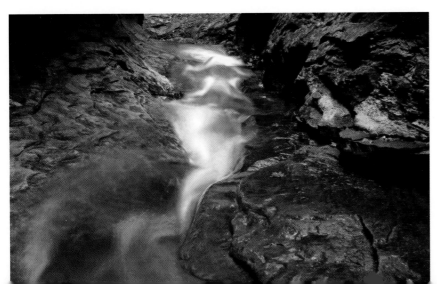

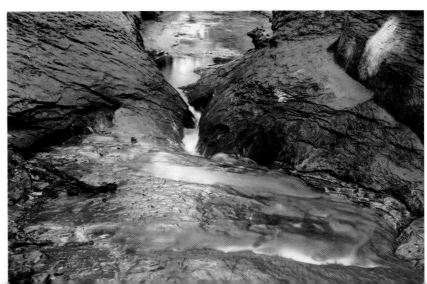

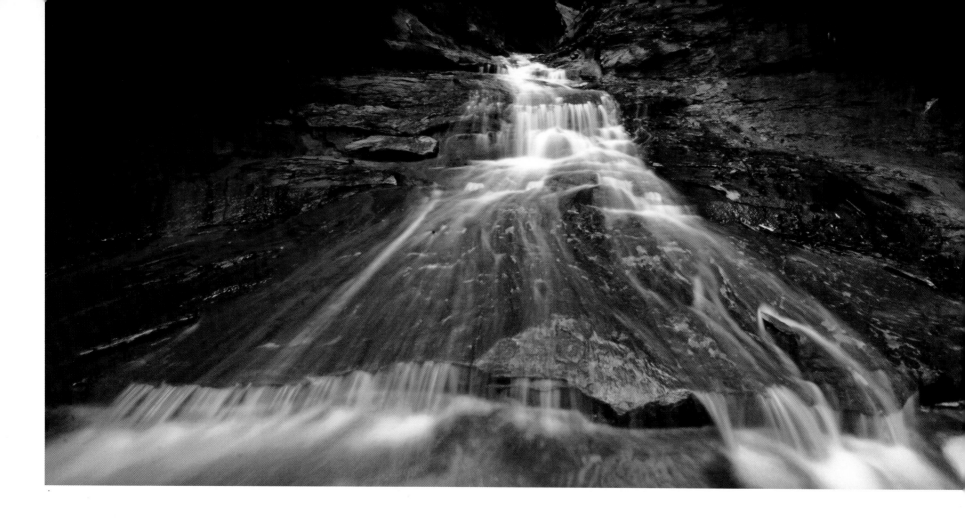
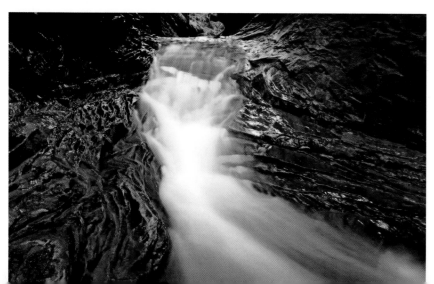
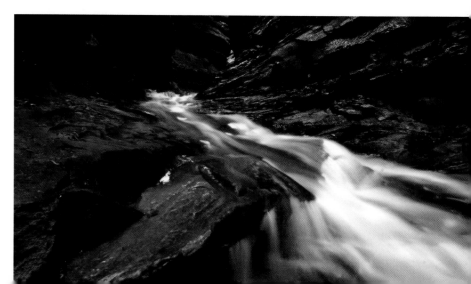

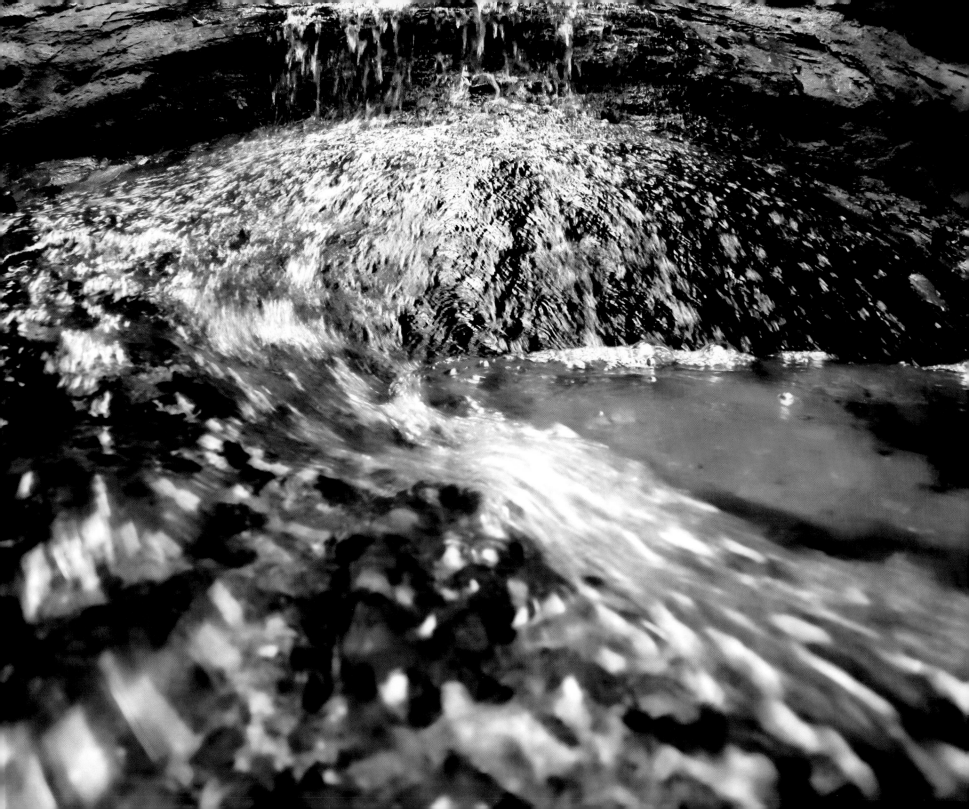

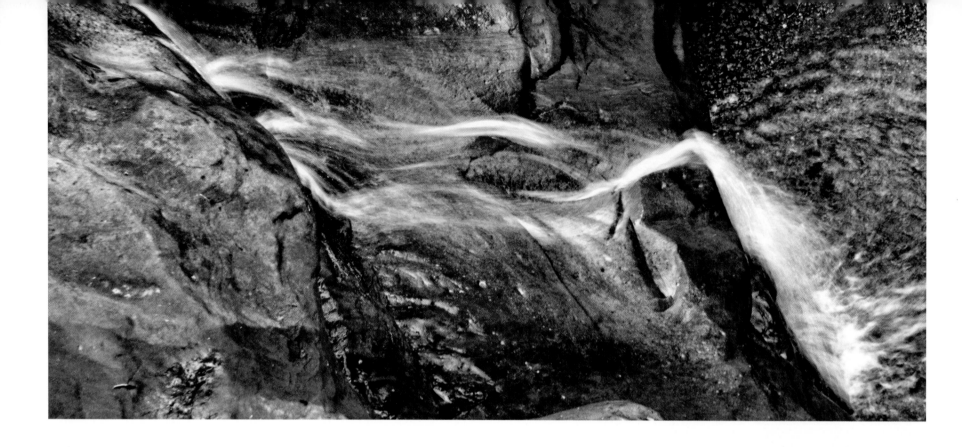

When I photograph flowing water, I take two photographs at different shutter speeds, one fast and one slow. This creates different effects on the images, such as freezing water in place (bottom image) and blurring the trace of flowing water (top image).

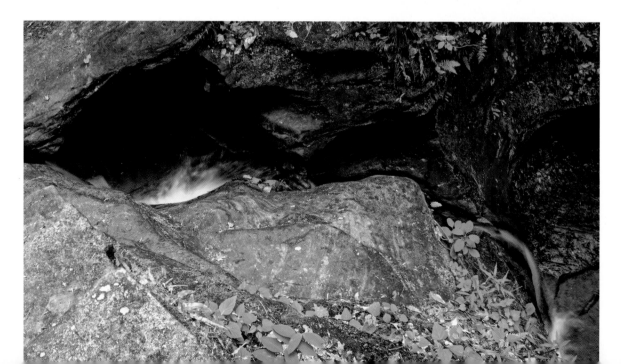

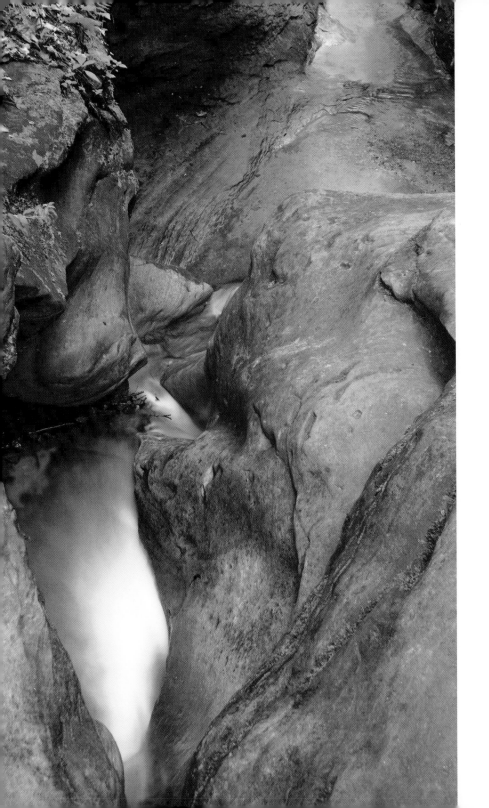
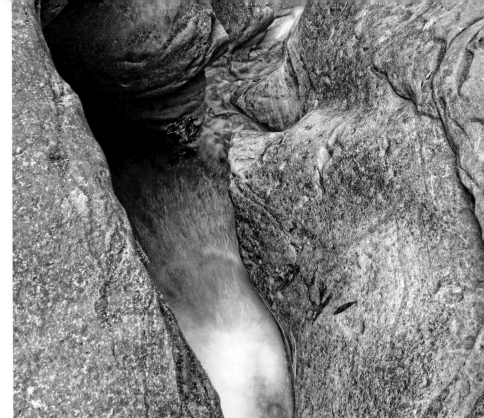
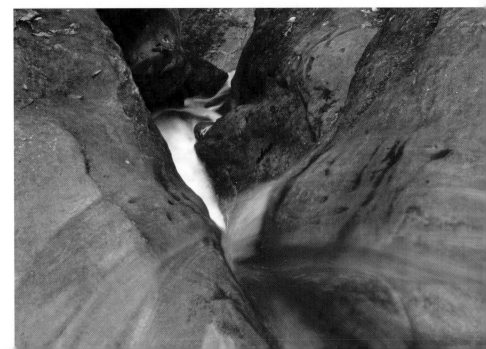

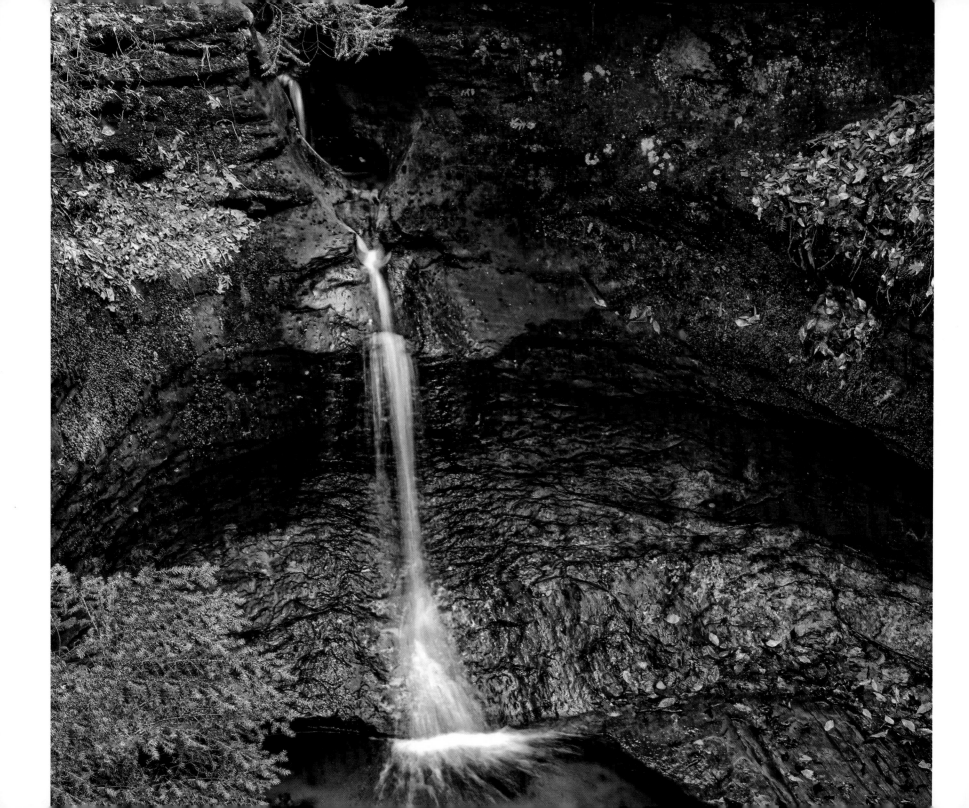

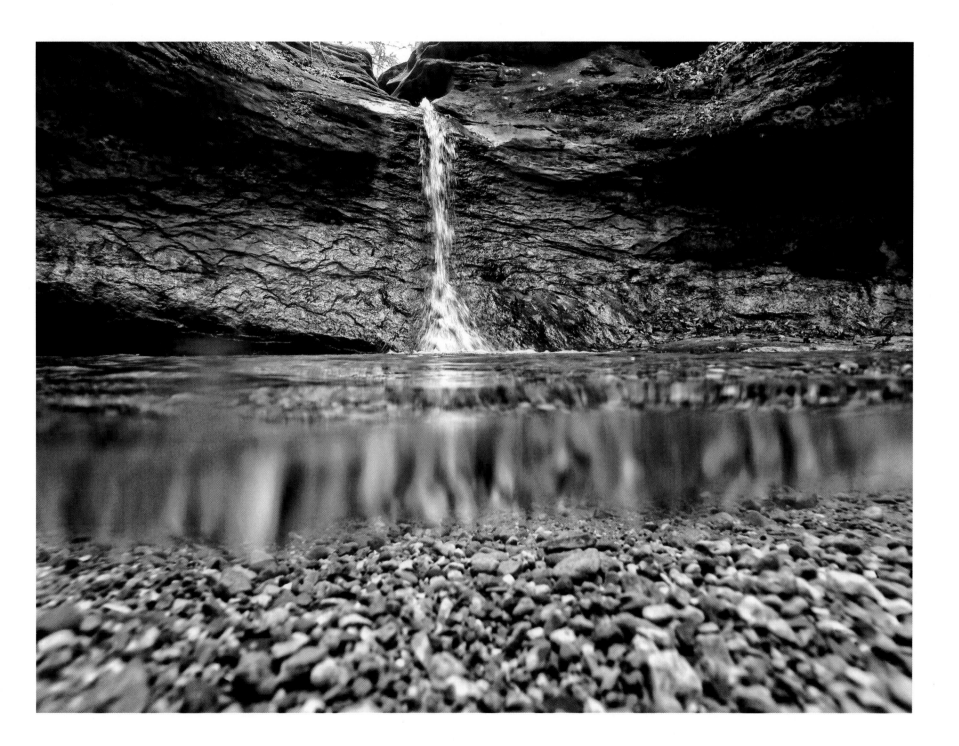

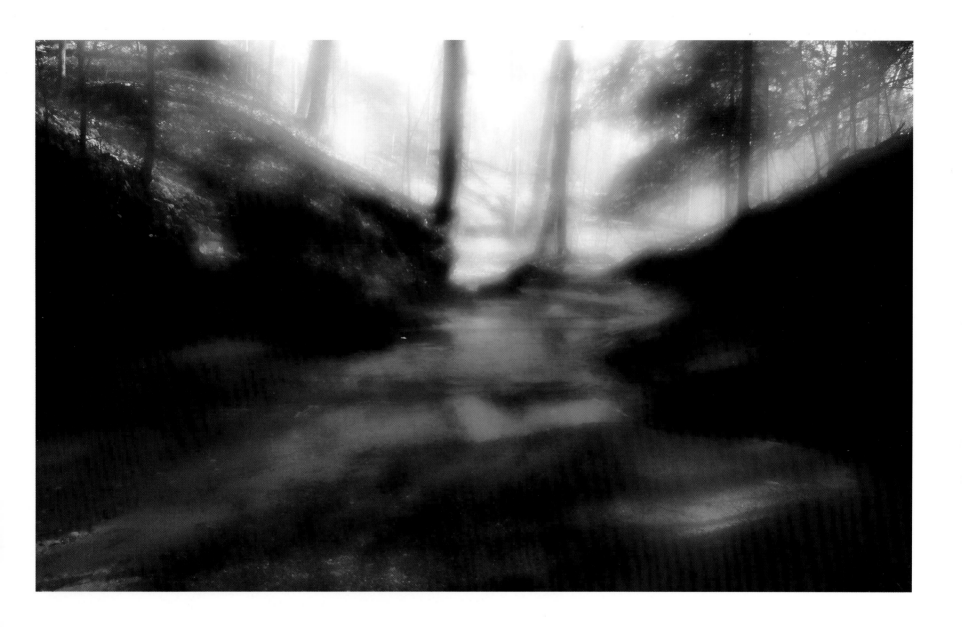

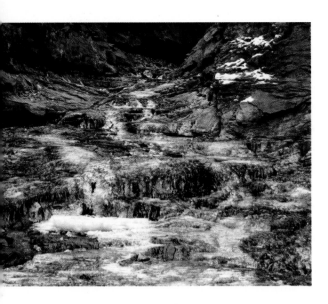

Even in winter, water flows through the park, adding a different look and feel to the canyons and bluffs. Fast-flowing water runs free, eroding the sandstone and transporting sediments as it moves down toward Sugar Creek. The image of the Punch Bowl on the facing page captures the trace of flowing water encased in a cocoon of ice.

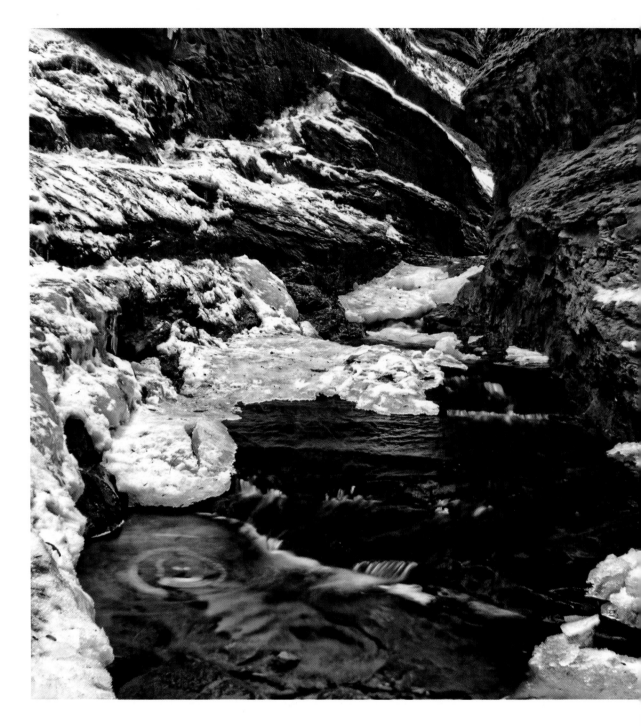

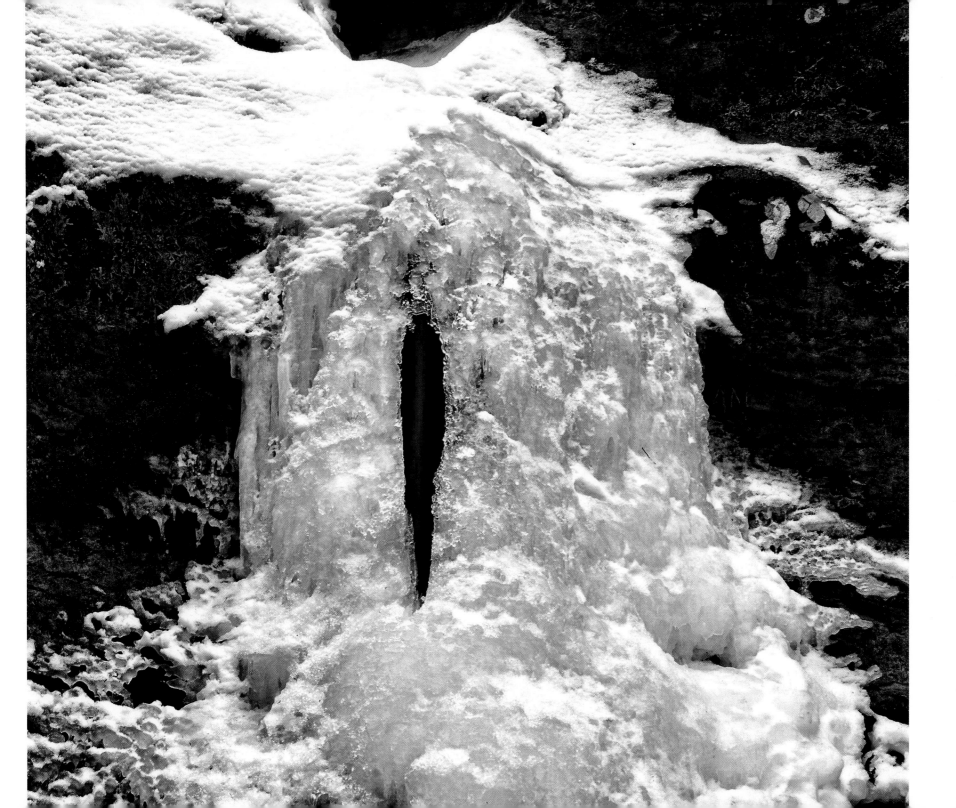

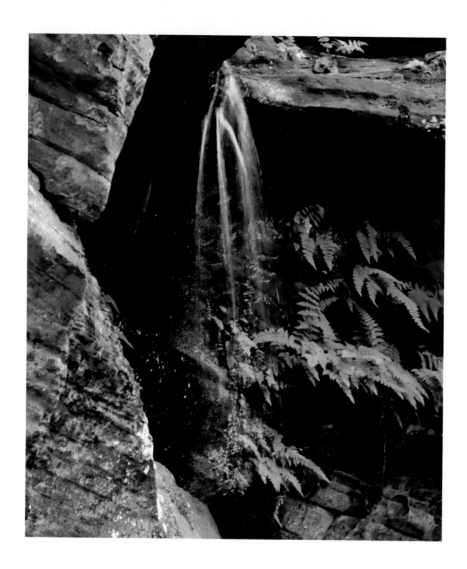

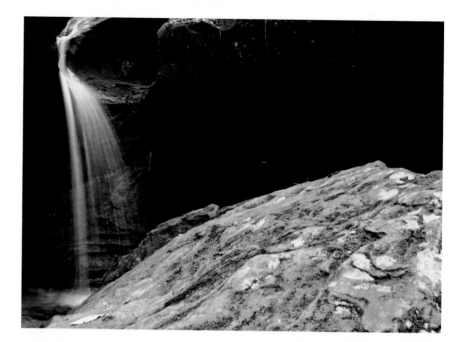

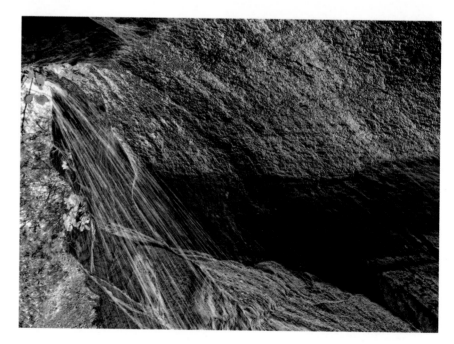

Water flowing from bluffs and cliffs in the park erodes the sandstone and creates dramatic waterfalls that come and go with the seasons. The flowing water provides a moist environment that allows mosses and ferns to take up residence on the sandstone, providing a splash of color.

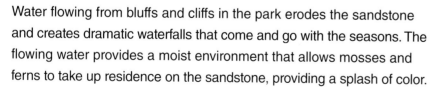

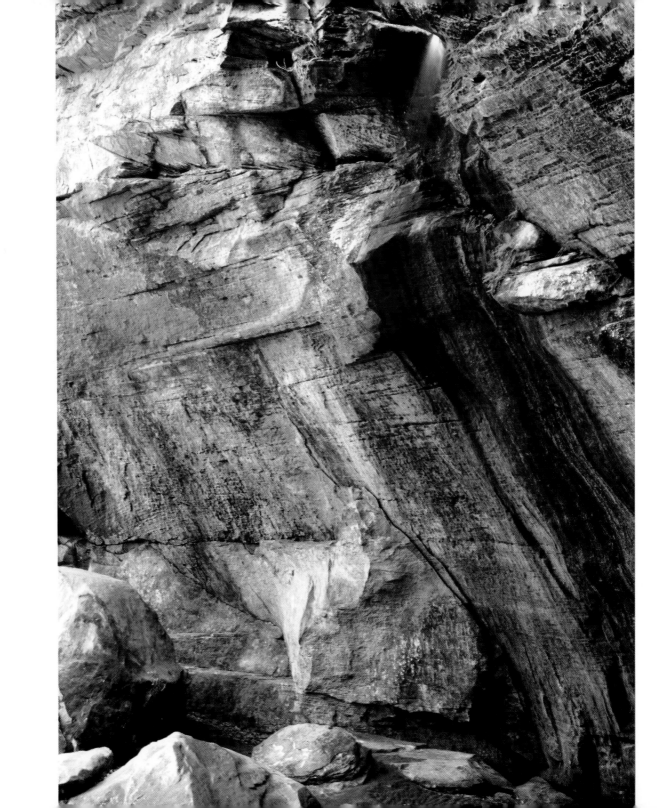

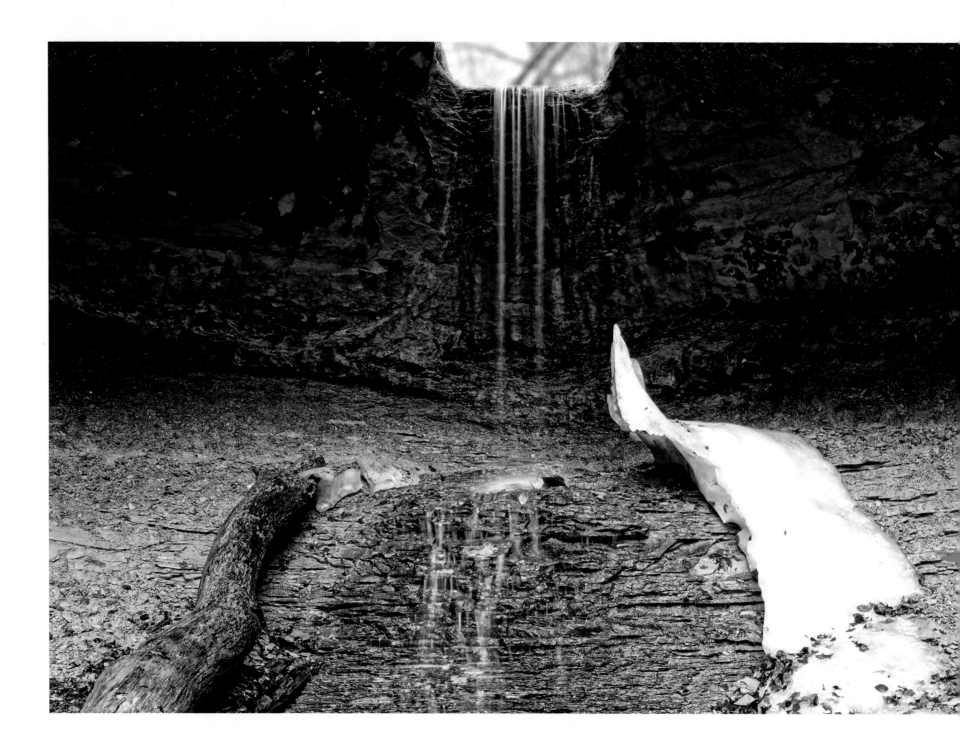

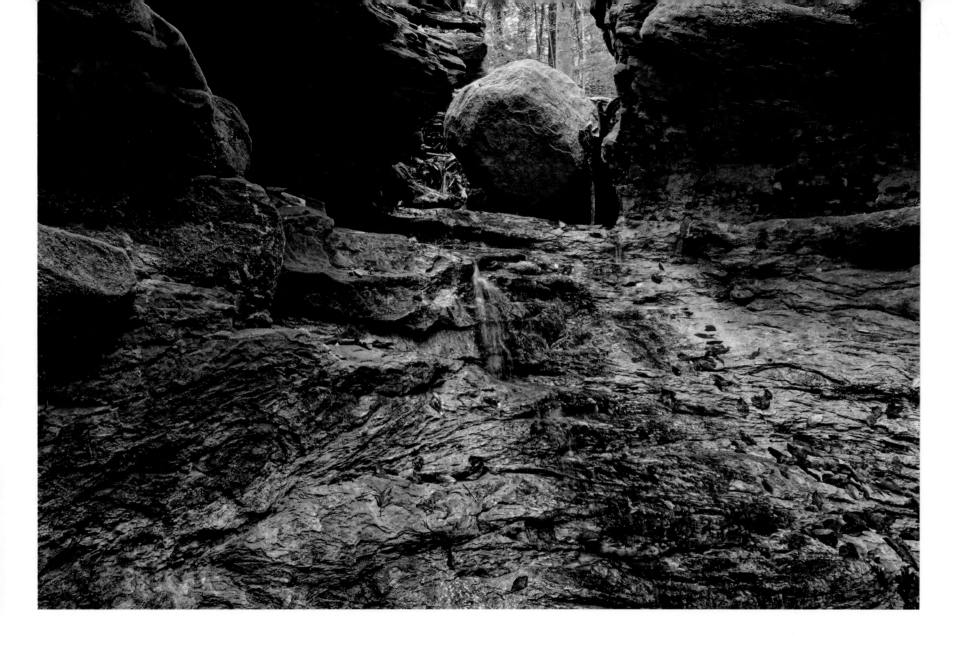

Flowing water erodes the sandstone and transports sediments as it moves down toward Sugar Creek. Here, a granite boulder (a glacial erratic) is slowly being moved as the channel is cut deeper by the flowing water. It will eventually tumble to the canyon floor.

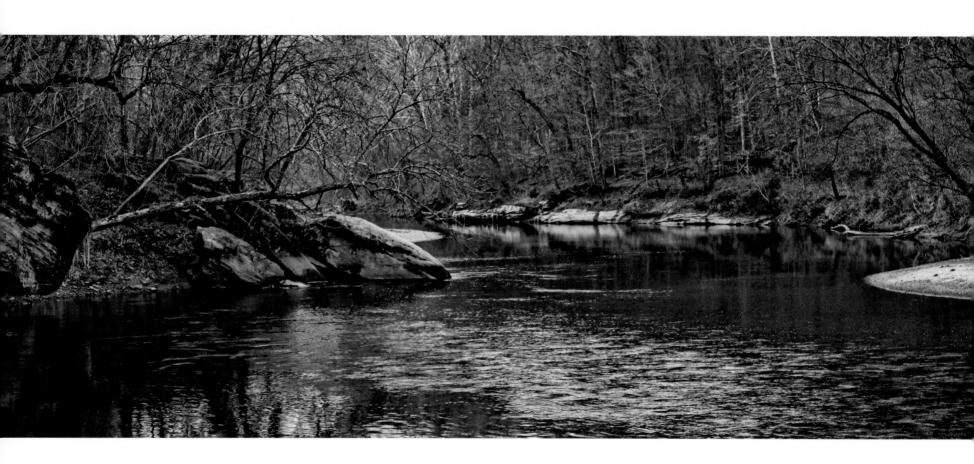

When the Wisconsinan glacier retreated some twenty thousand years ago, glacial meltwater eroded the land, forming the channel that became Sugar Creek. In Turkey Run, Sugar Creek cuts through the sandstone, forming the scenic bluffs seen along the river. As Sugar Creek flows, it also erodes its bank and undercuts the sandstone bluffs.

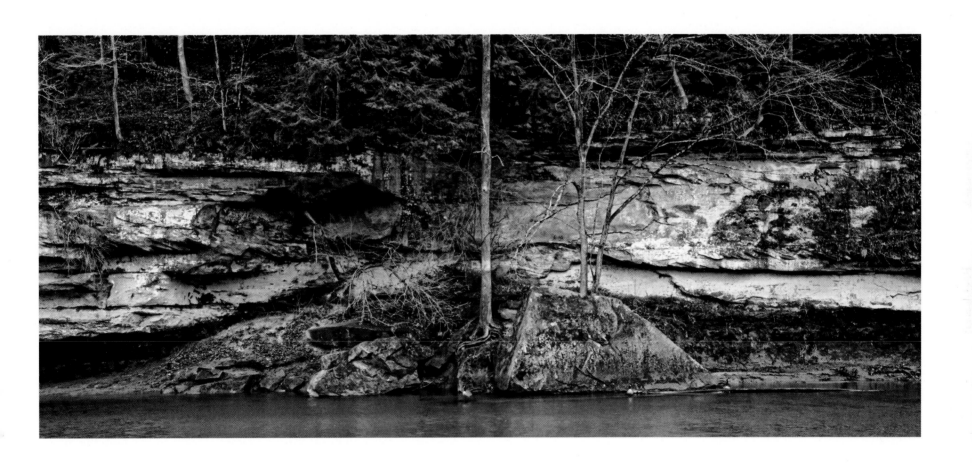

69

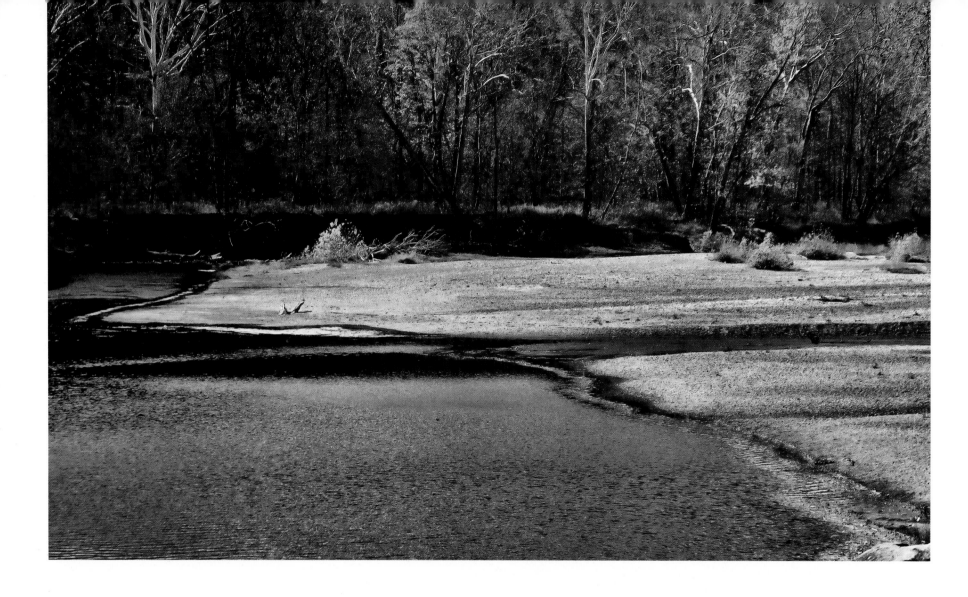

Water that flows from the land finds its way to Sugar Creek. This flowing water transports the weathered pieces of sandstone and soil from the land and deposits them in Sugar Creek. Sugar Creek then transports these sediments as it flows toward the Wabash River. These geologic processes associated with rivers are described as "fluvial"—pertaining to a river.

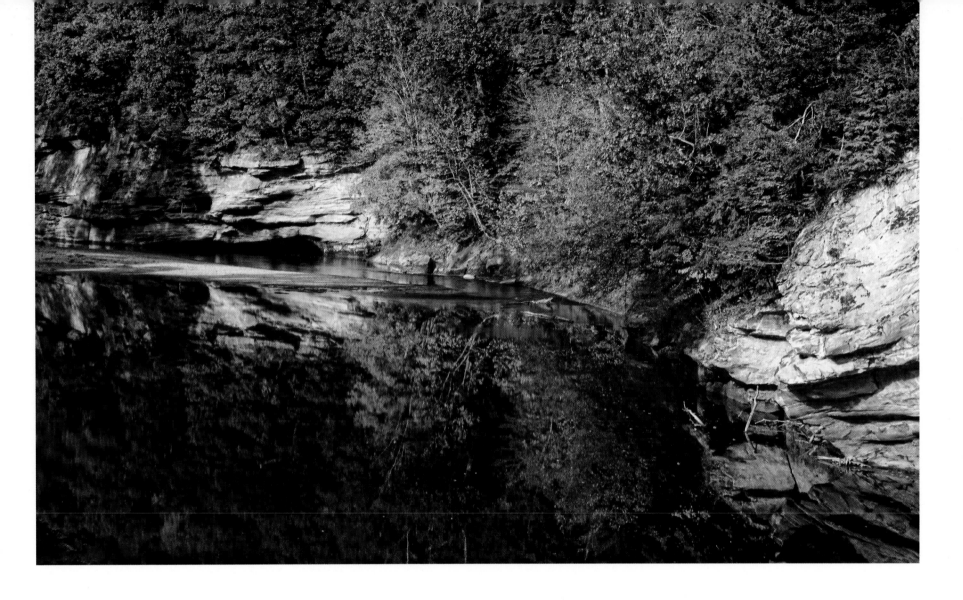

Sand, mud, and gravel bars develop in Sugar Creek, where the water's velocity slows and sediment deposition occurs. Over time, the river may erode the channel downward around a bar. Alternatively, additional sediment may be deposited on the bar to elevate it above the river. If high-flow events occur, the bar may be completely eroded away and washed downriver. If the bar remains in place for a period of time, grasses, shrubs, and thickets may grow there.

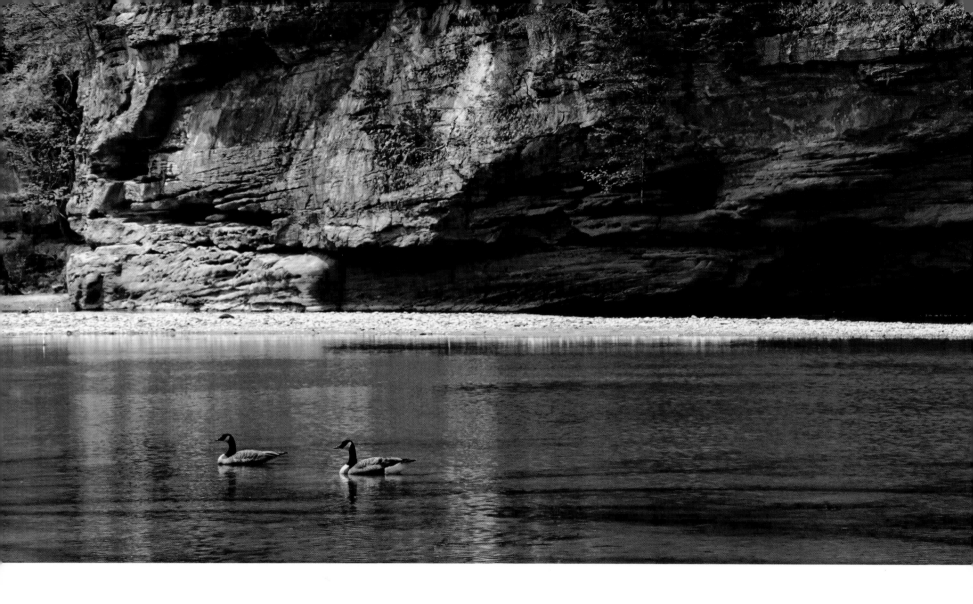

Ecologically, Sugar Creek serves as a pathway for seasonally migrating waterfowl and shorebirds. The river provides water, food, and cover that birds require during their migration to and from their winter and spring breeding grounds. This pair of Canada geese takes refuge in the creek during their spring migration. Cliff swallows return in the summer, building bulb-shaped mud nests under rock ledges along the bluffs above Sugar Creek. They nest in colonies and are strong, elegant fliers that feed on flying insects they snatch from the air above Sugar Creek.

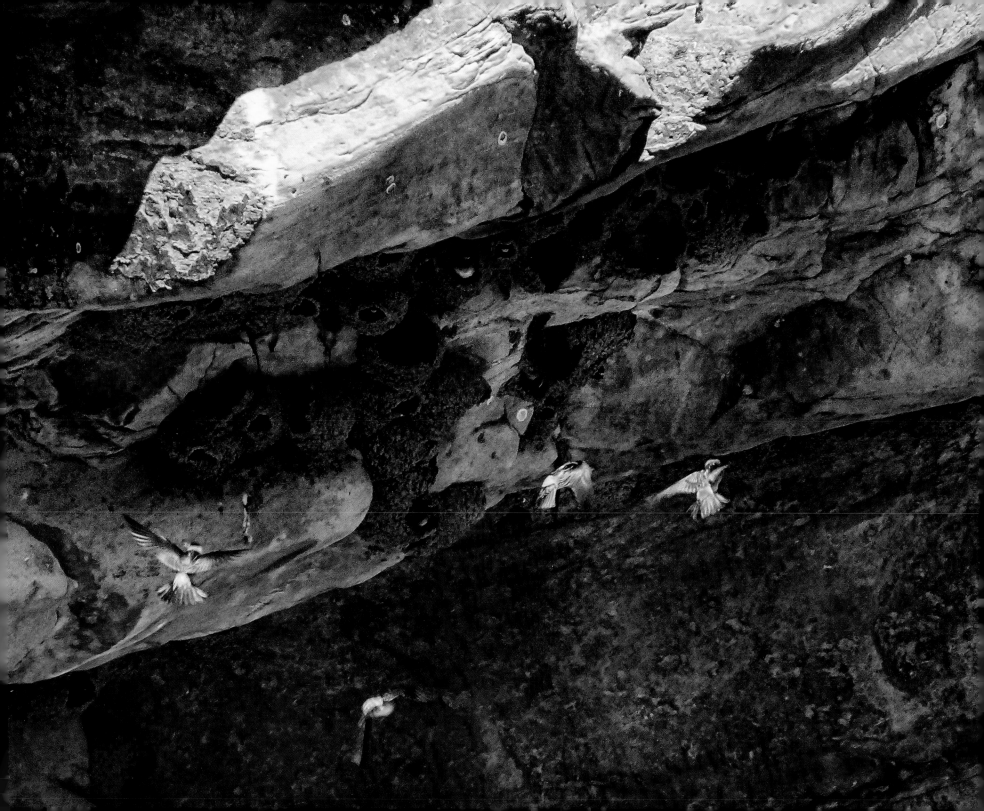

Bald eagles may be seen roosting on the sycamore trees above Sugar Creek in the winter, looking to catch fish in the open water. The bald eagle once nested throughout Indiana and the nation. The loss of wetland habitat and the use of pesticides (DDT, now banned) caused the bald eagle to disappear from Indiana. In 1985, the Indiana Department of Natural Resources (DNR) initiated a successful bald eagle reintroduction program that has resulted in over 200 nesting pairs today, returning the bald eagle to the state.

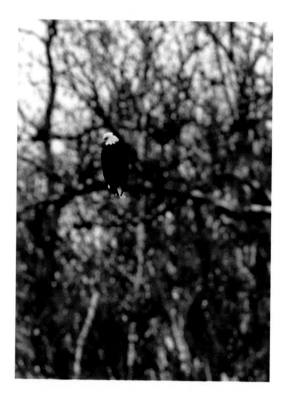

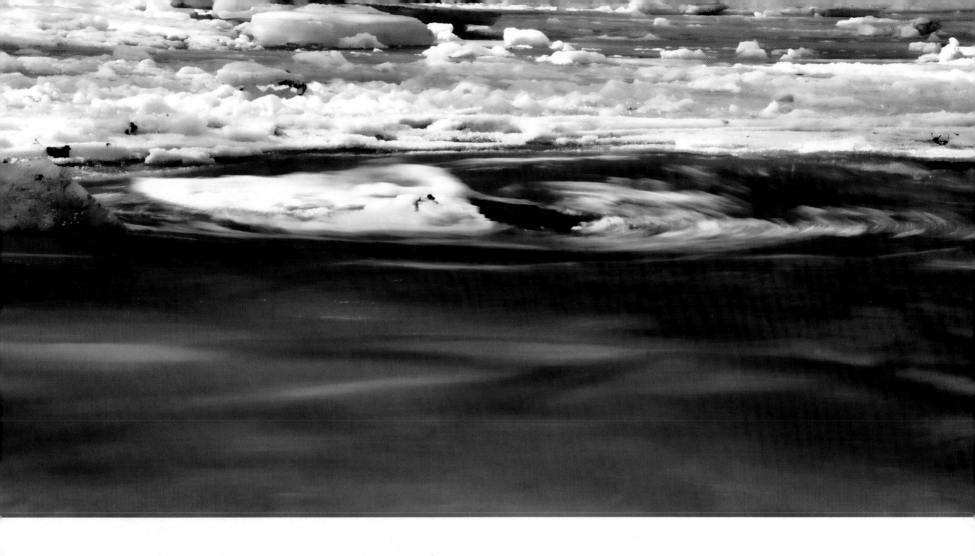

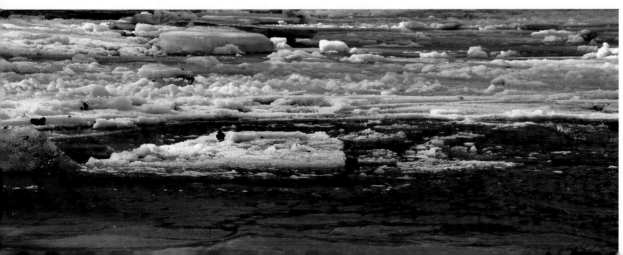

Ice flows on the surface of Sugar Creek. Here the ice is caught in an eddy, where it swirls endlessly in time and space. I used different shutter speeds to create different effects in each image.

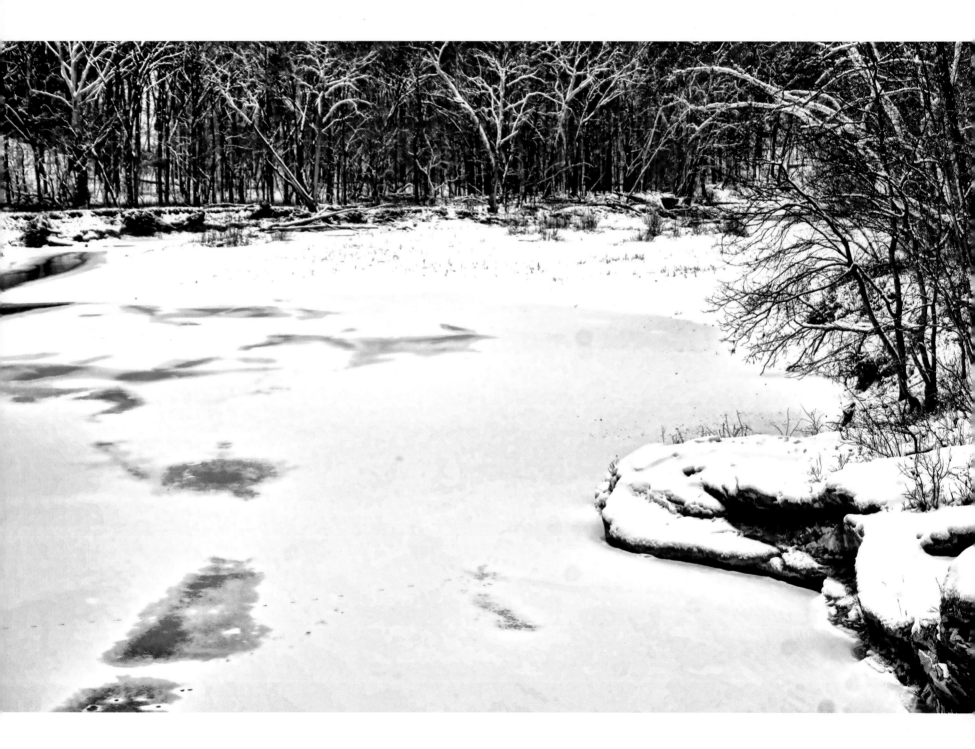

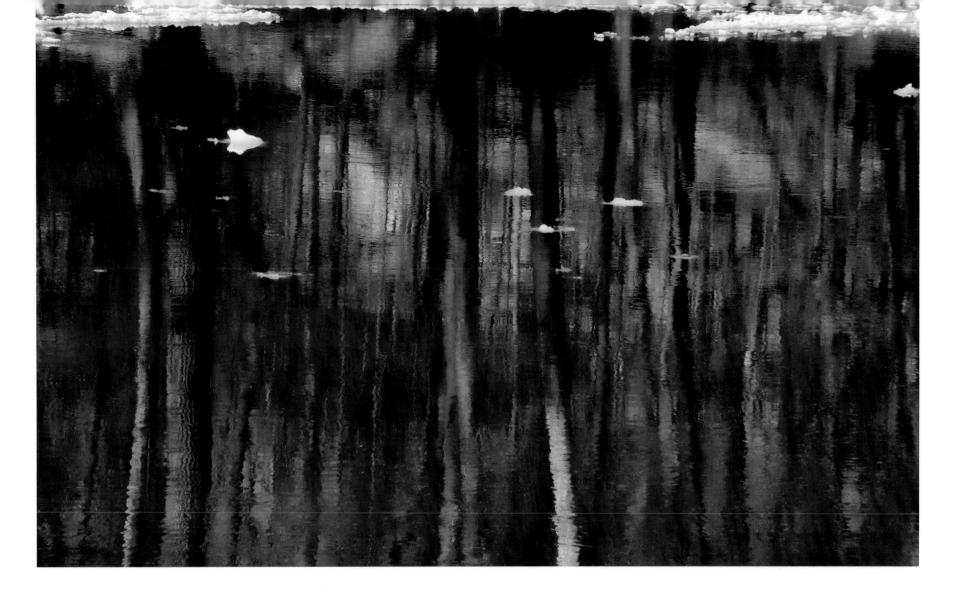

In winter, water still flows through Sugar Creek, but ice and snow transform the landscape into a gray, monochromatic scene. Where the water flows fast, the channel remains open.

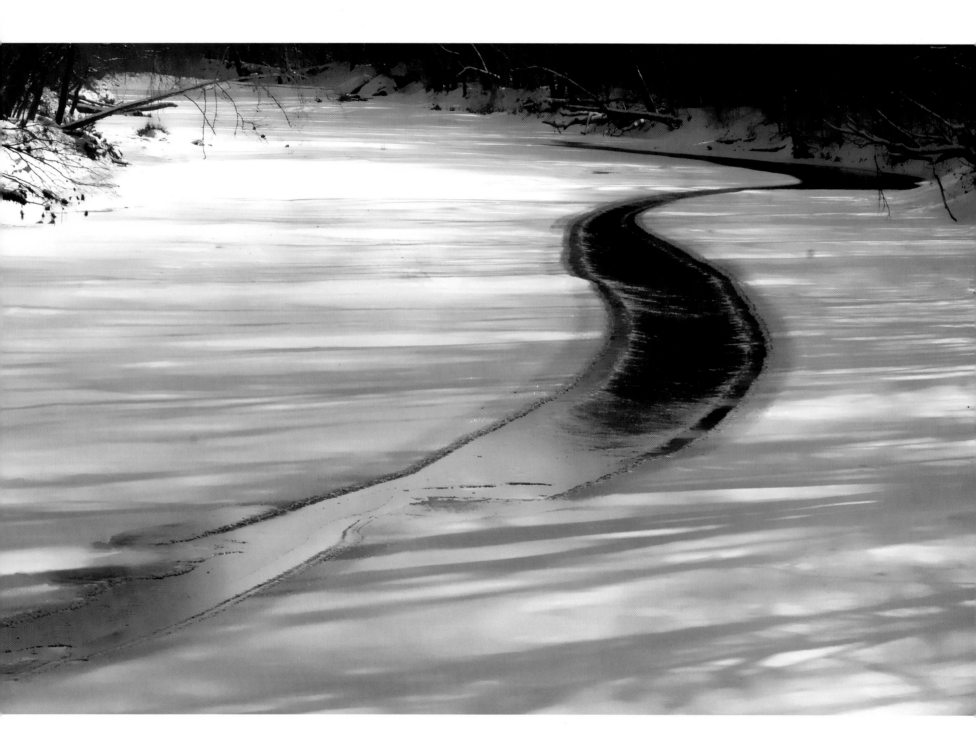

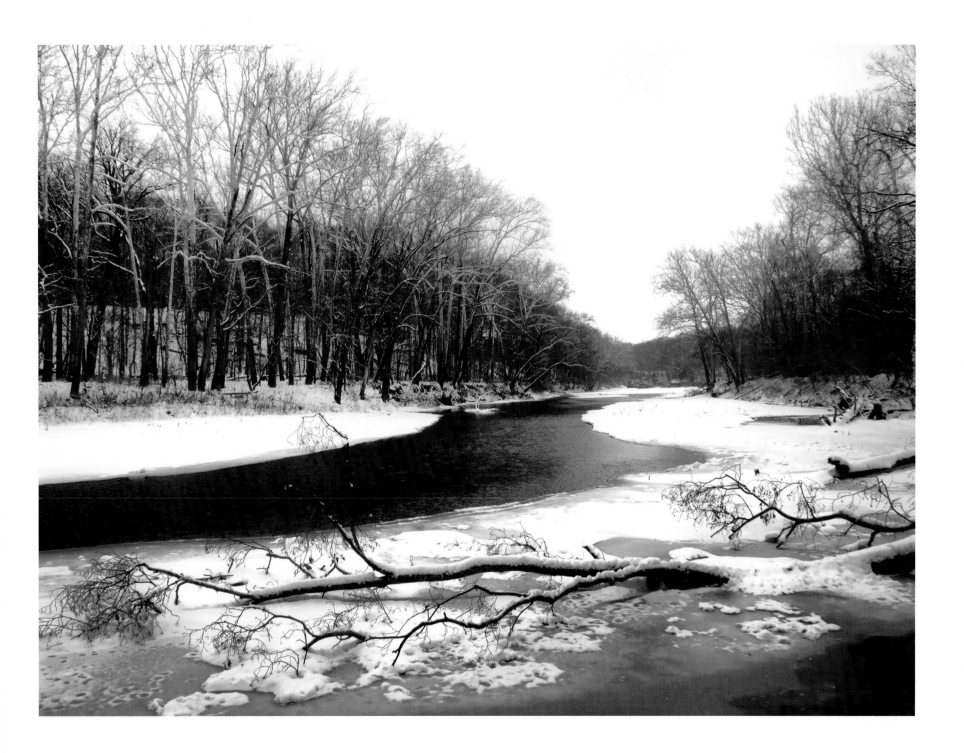

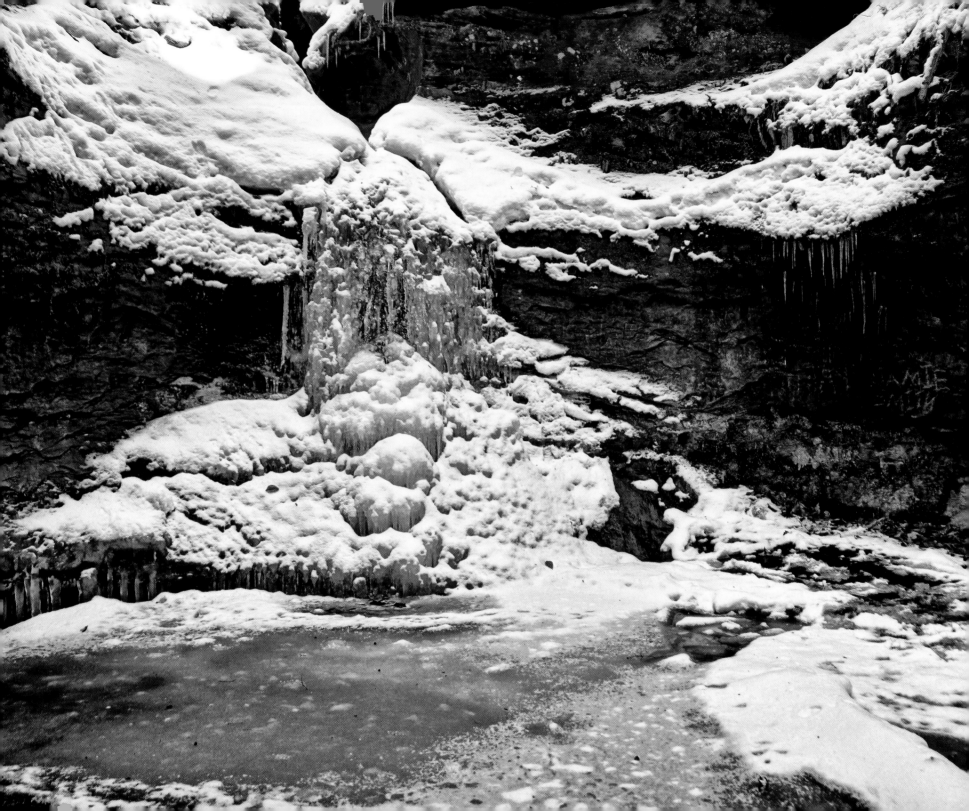

CHAPTER 4

<div align="right">

Snow and Ice

</div>

Have you ever hiked Turkey Run in the winter? Have you ever seen the park after a fresh-fallen snow? Have you ever thought about how snow and ice change the park's landscape? In this chapter we will explore the park covered in snow and ice.

I find the park dressed in snow and ice as impressive as it is in fall colors. Hiking the trails after a fresh-fallen snow gives one the sense of solitude and a greater connection to nature. The natural beauty of Turkey Run is revealed in a new way—it becomes a snowscape, a wonderland of snow and ice. This snow and ice transforms Turkey Run's landscape in two ways. First, the snow and ice blanket the land, creating a unique and visually appealing landscape. Second, the snow and ice slowly change the land by weathering and eroding the park's surface. Both of these processes give the park its exquisite landscape, one seasonally and the other over time.

Snow also affects the acoustics of the Turkey Run landscape. On your next snow hike, stop and listen to the park. You might be surprised by what you hear, or what you don't hear. Fresh-fallen snow absorbs sound, giving the landscape a gentle, quiet feel, softening the landscape both acoustically and visually. This sound-absorbing quality occurs as the air between the newly fallen snowflakes absorbs the sound. As the snow melts and refreezes, it hardens and thickens, and its sound-absorbing ability diminishes. The harder the snowpack becomes, the more sound will echo through the Turkey Run landscape. If you think about the sound as you walk in fresh-fallen snow, you will hear little sound in comparison to the loud, crunching sound when you walk on hard-packed snow. This is because when you walk on the hard-packed snow, you are breaking the ice crystals within the snow, thus producing the crunching sound.

Because snow and ice significantly transform the Turkey Run landscape, they warrant a separate chapter to showcase the beauty of the park in winter. For those who have never hiked the park in winter, I hope the images inspire you to do so in the future, to experience the tranquility and beauty of the snow and ice.

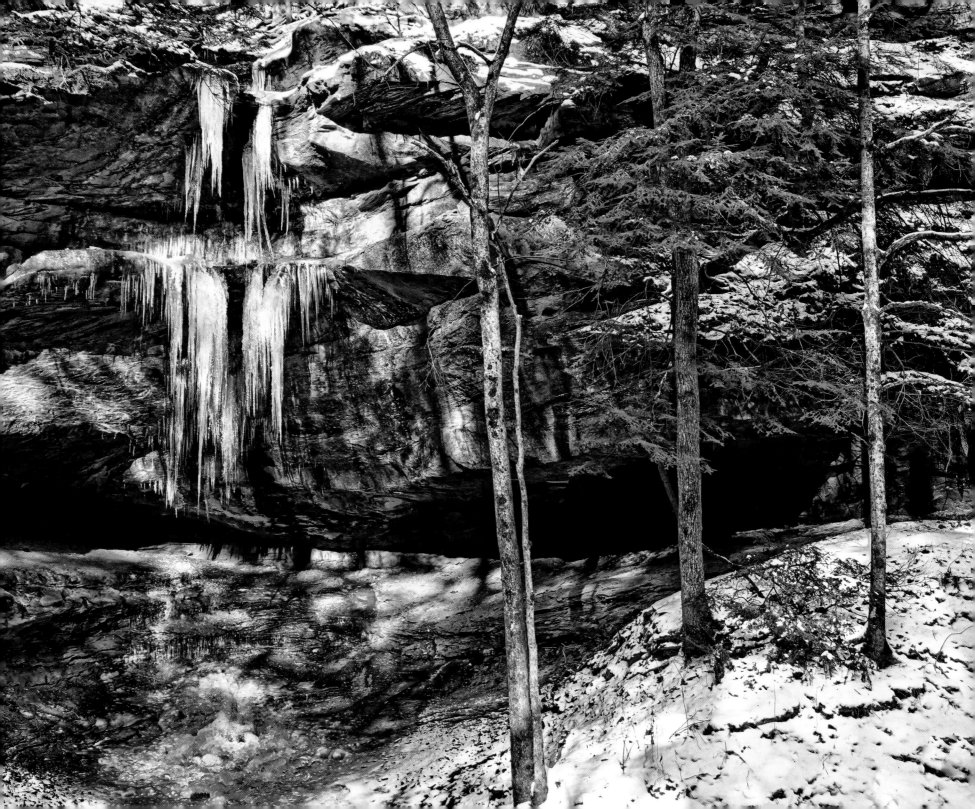

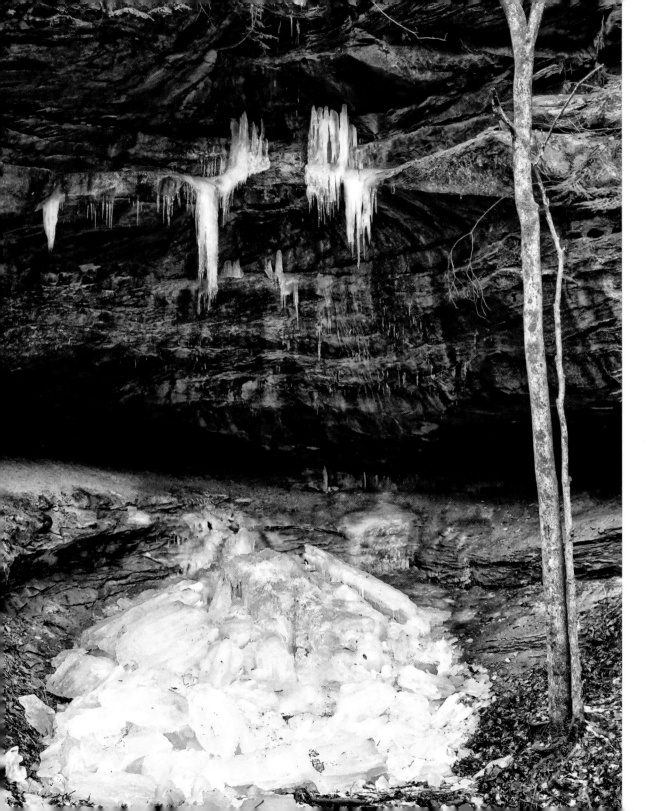

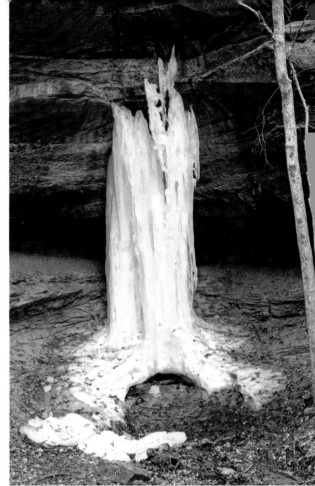

From an earth system science (ESS) perspective, the snow and ice of Turkey Run are part of the cryosphere, the frozen part of the earth system. Although we often think of the North Pole (Arctic) and South Pole (Antarctic) as the cryosphere, any location on earth that experiences a seasonal period of cold, snow, and ice is part of the cryosphere.

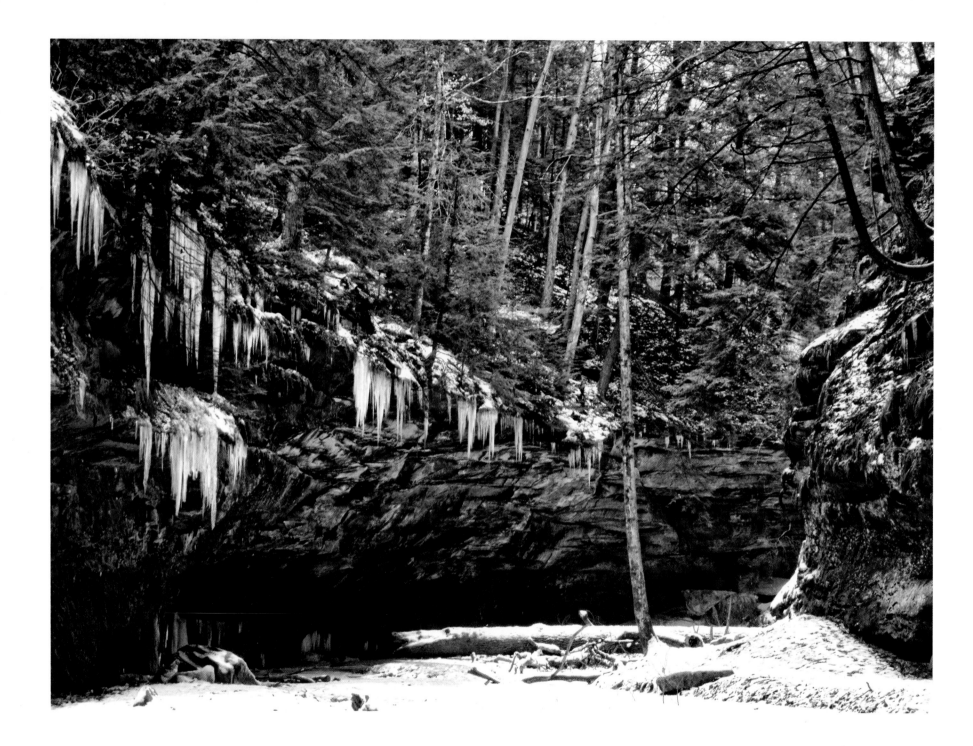

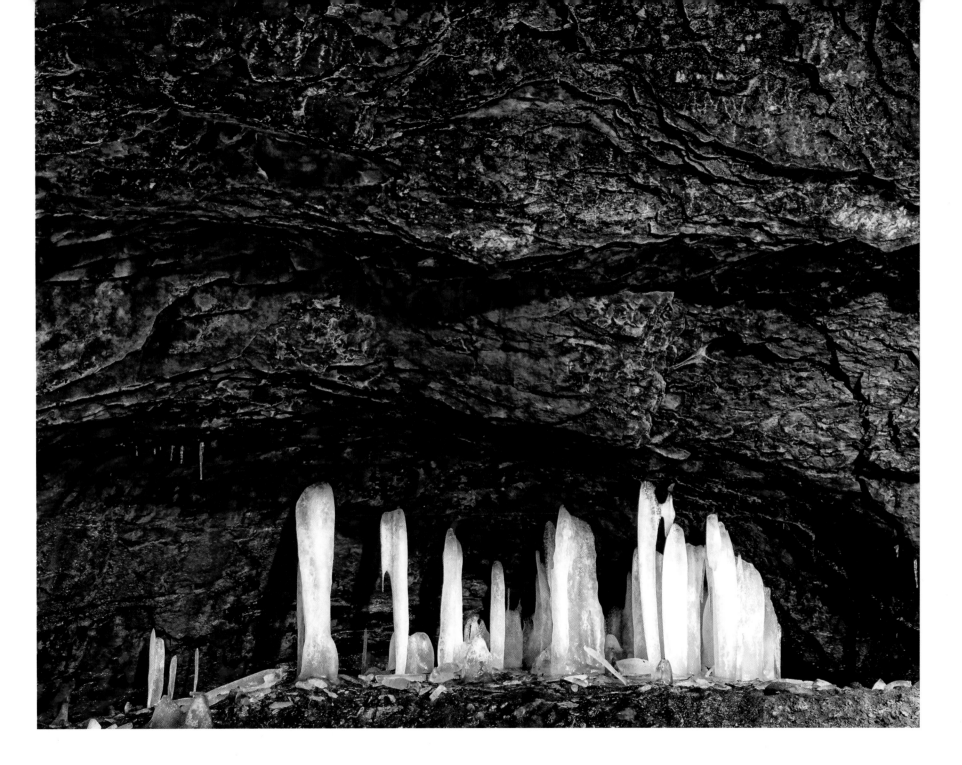

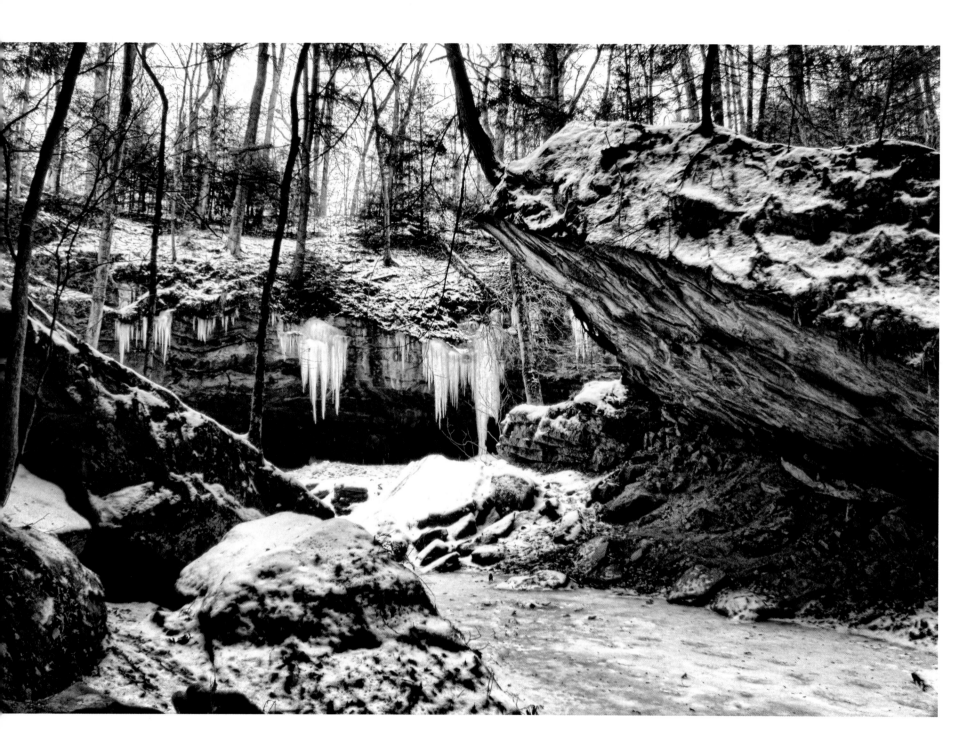

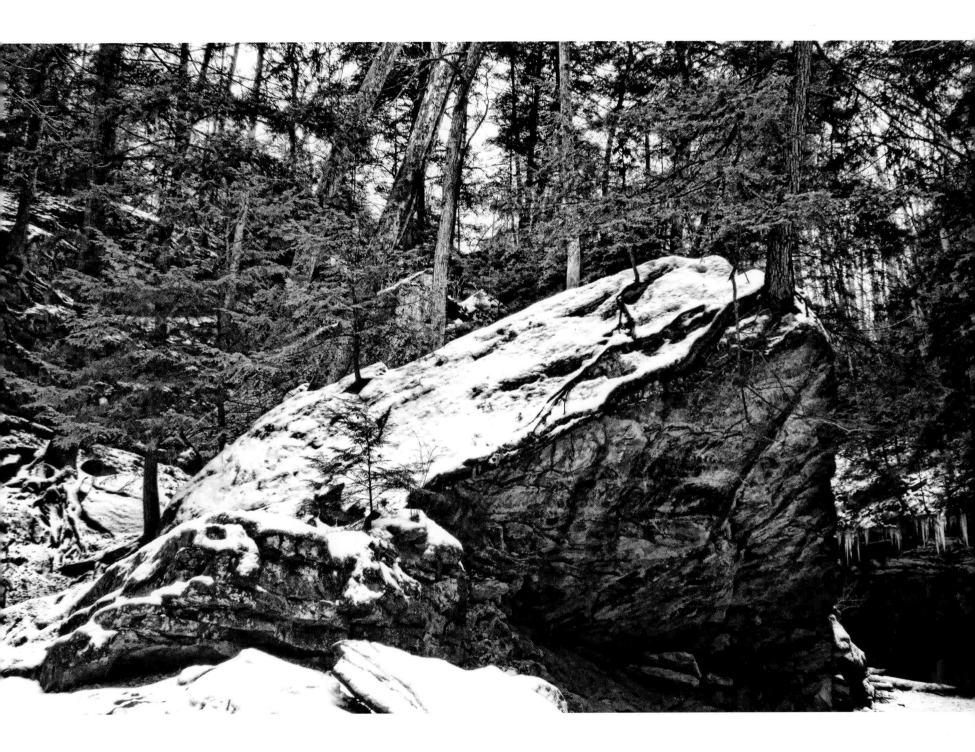

We often think of snow as a weather event, but because of its whiteness, snow reflects sunlight back toward space, influencing the earth's climate. Thus, snow cover, or lack thereof, influences the cooling and heating of the earth's land surface. Snow on the ground reflects the sun's energy, cooling the earth's surface. Without snow, the ground absorbs the sun's energy, warming the earth's surface. Thus, in Turkey Run, the snow cover keeps the temperature cooler because it reflects most of the sun's energy, and the absorbed sunlight melts the snow.

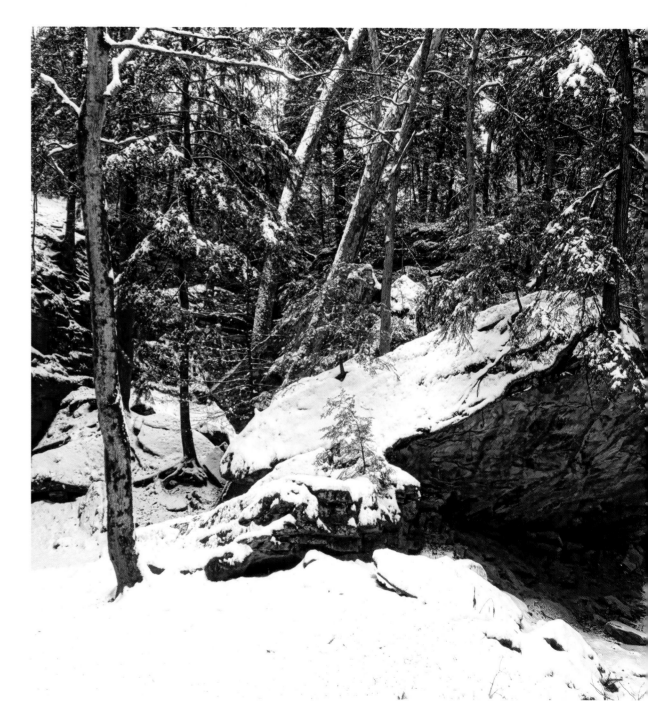

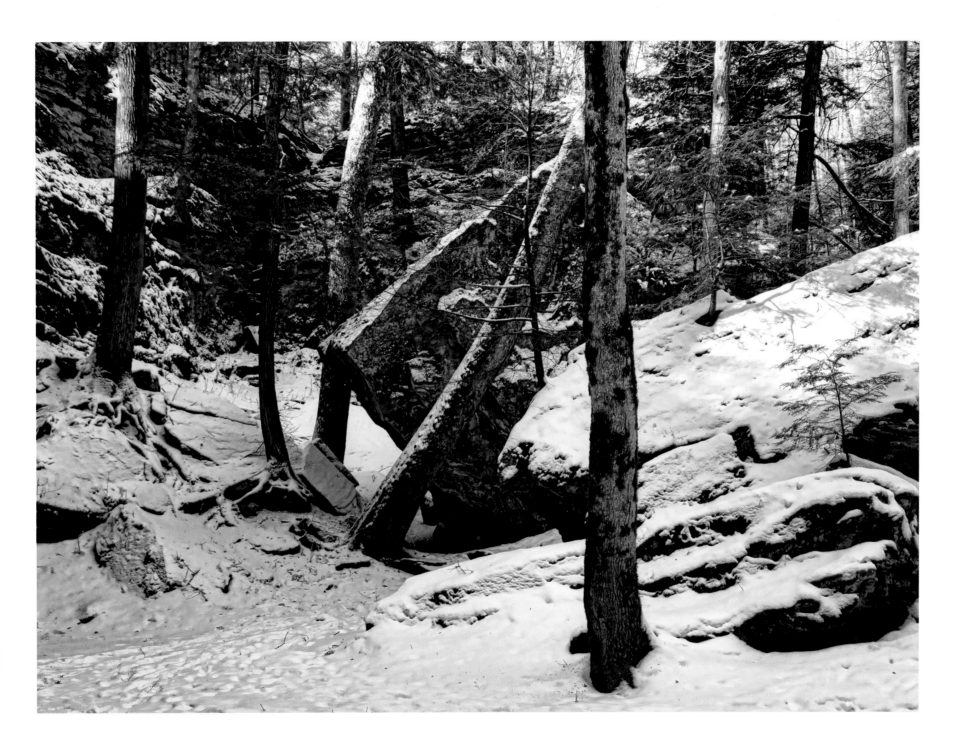

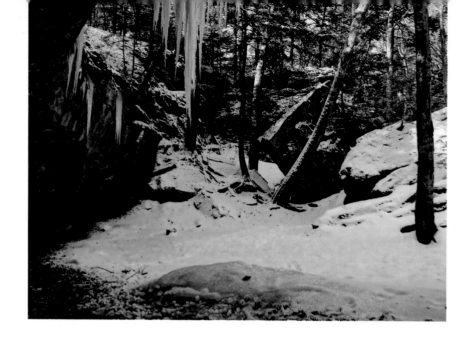

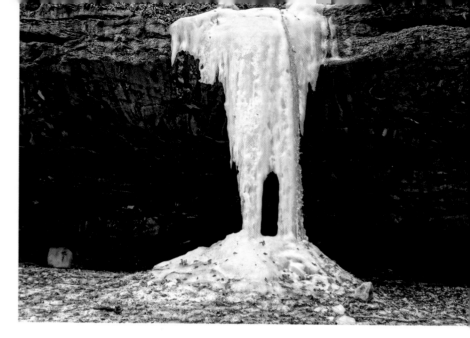

As snowmelt percolates through the sandstone bluffs and cliffs of Turkey Run, freezing and thawing, icicles form that weather the rock and give the bluffs and canyons a unique look and feel, decorating them in crystalline structures of beauty. In spring, the ice will melt and the water will flow, dissolving the rock and transporting it to the canyon floor in a gush and a splatter.

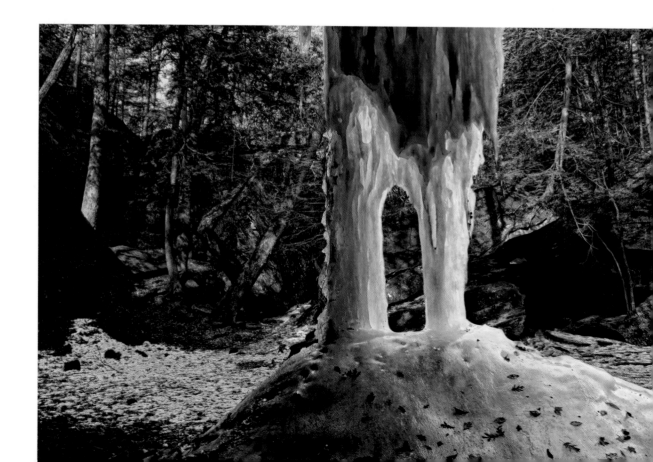

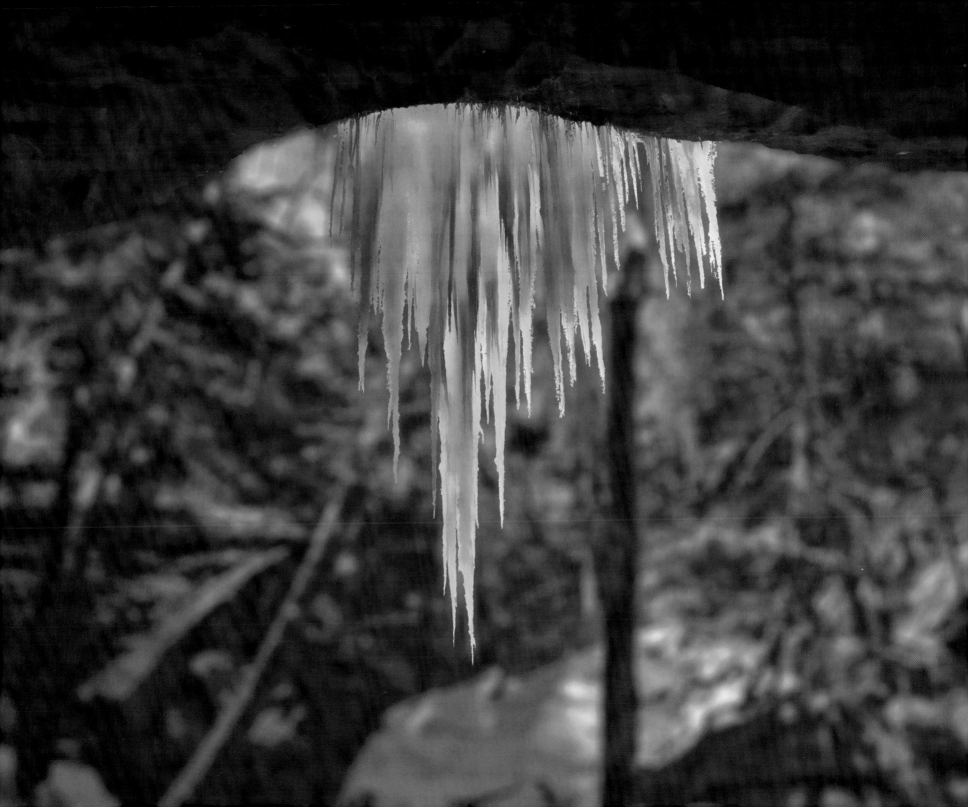

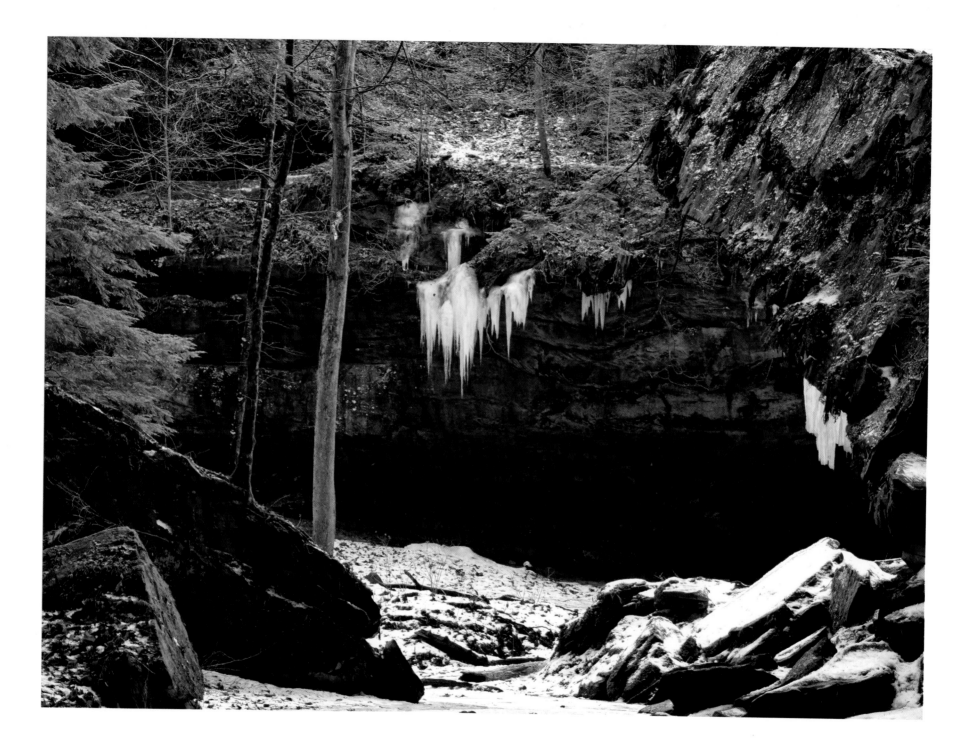

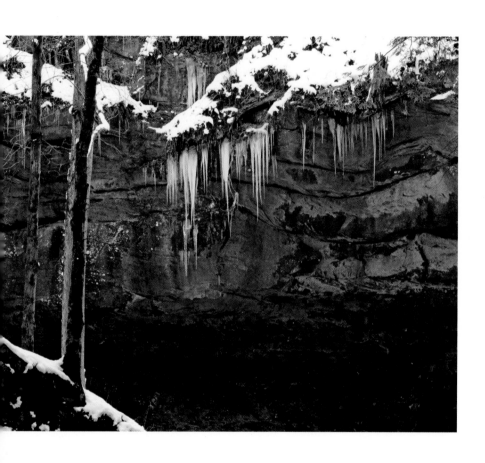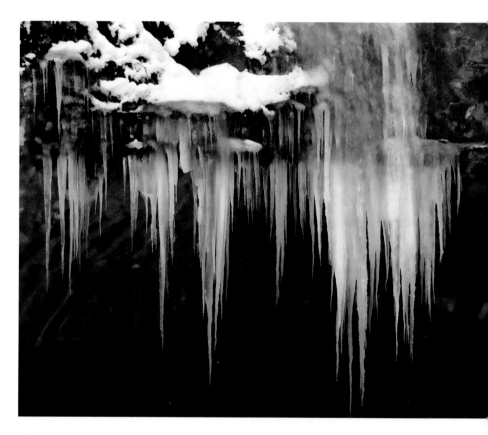

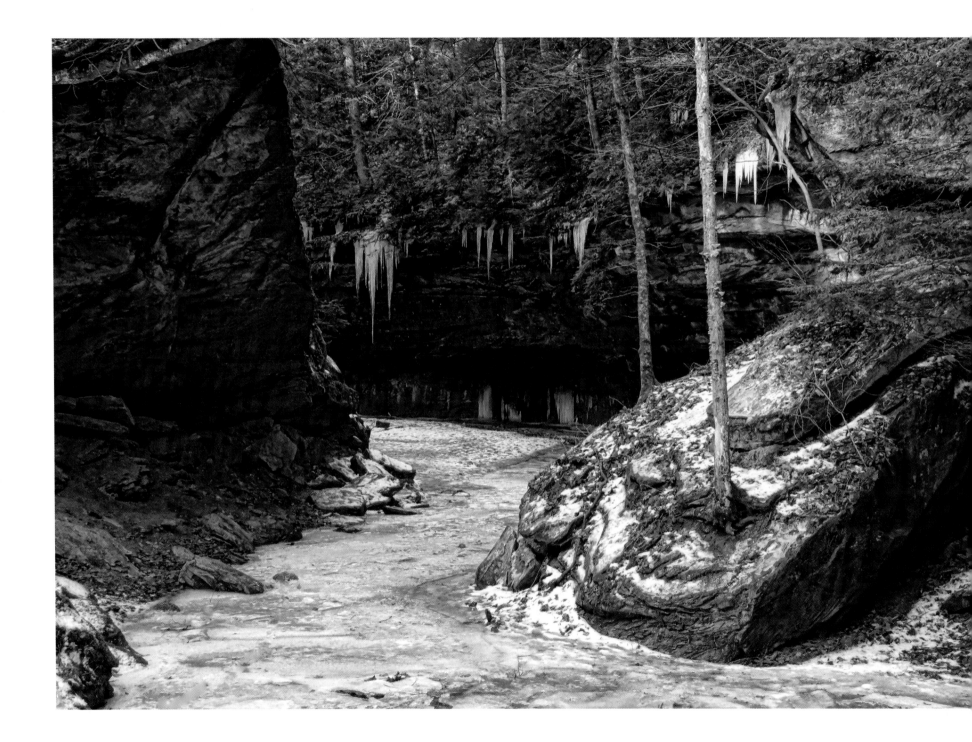

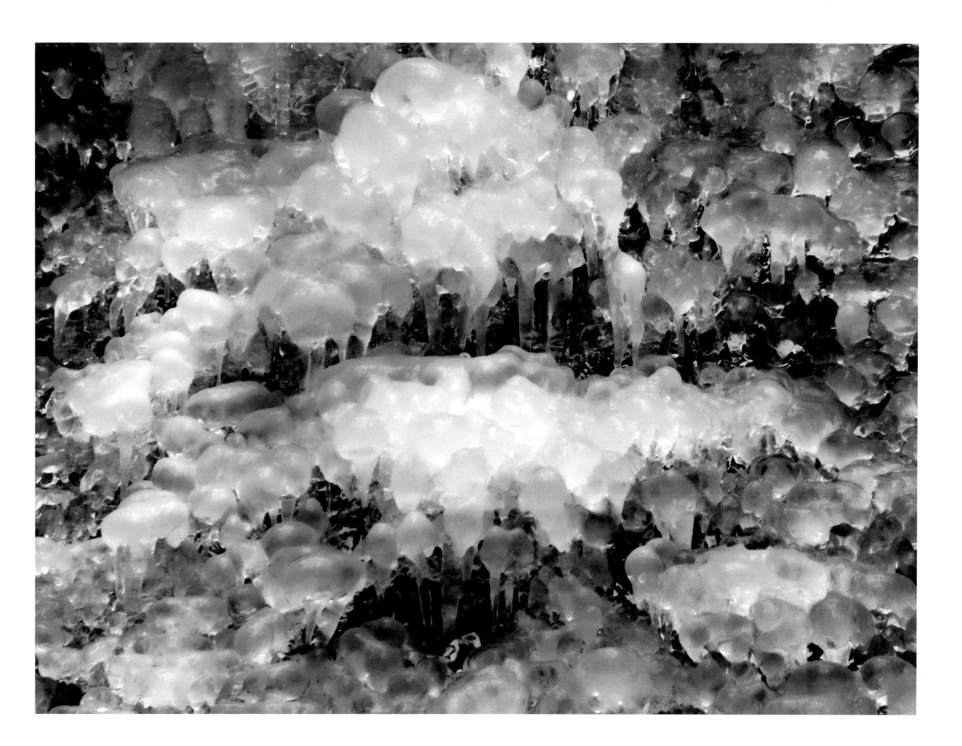

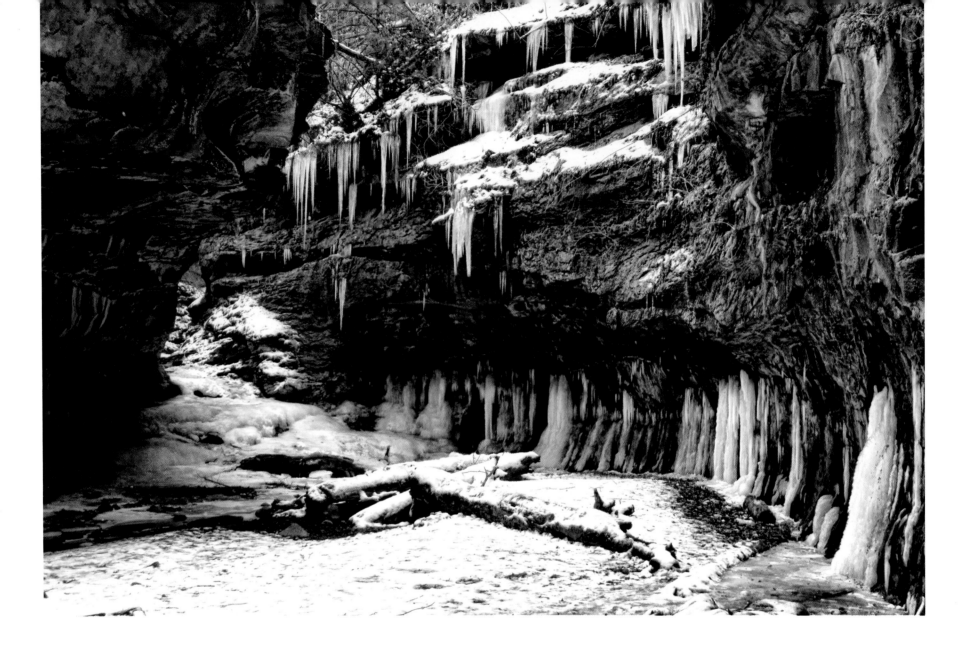

Is snow a mineral? You might be surprised to learn that geologists consider it one. Because snow is a naturally occurring solid, composed of ice (frozen water) and formed inorganically (by freezing), and it has a chemical composition with an atomic arrangement (H_2O) that gives it a crystalline structure, it is classified as a mineral. In this way, ice, too, is a mineral. Garnet, halite, quartz, and calcite are examples of some common minerals. Quartz, of course, is the main mineral found in the sandstone of Turkey Run.

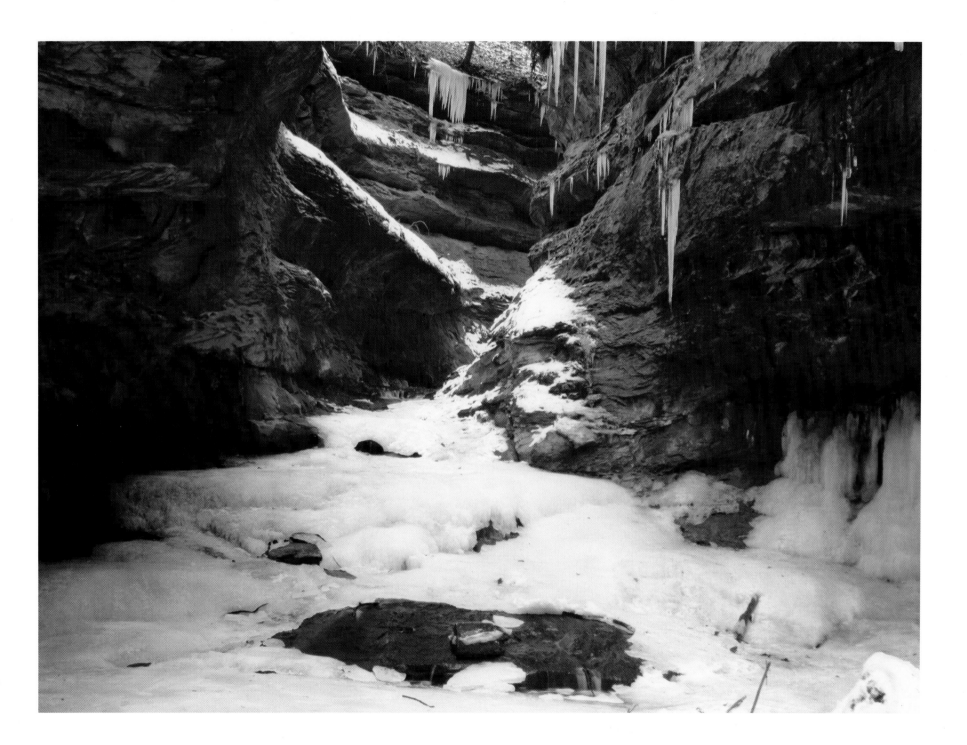

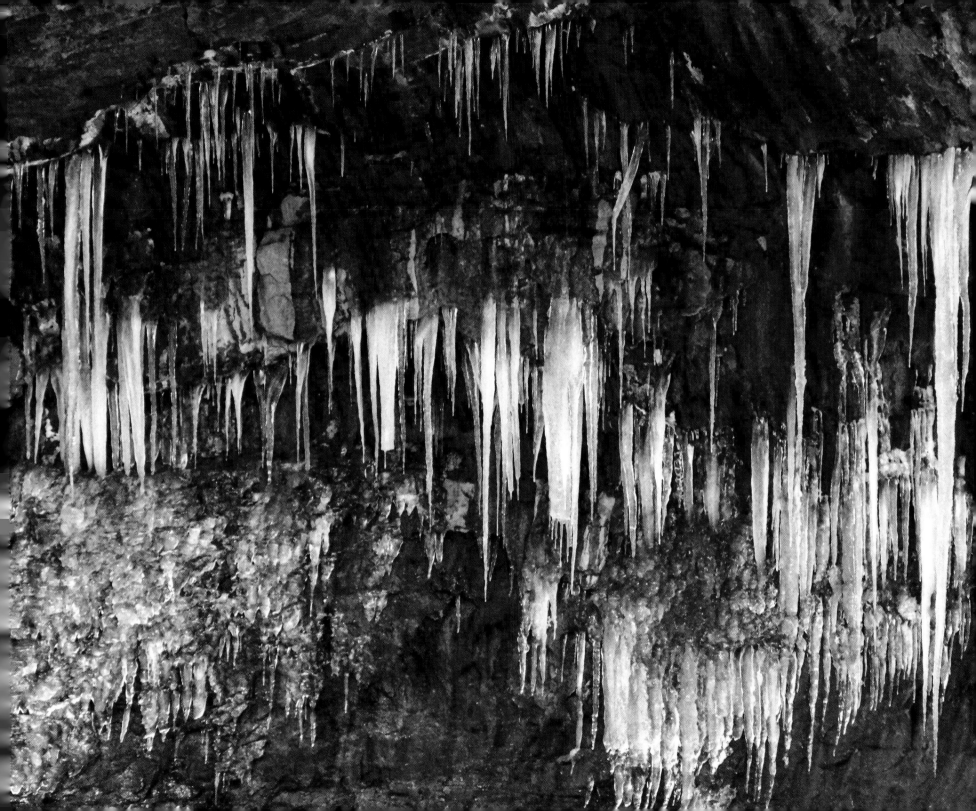

When water freezes it crystallizes. This process starts when colder temperatures cause the movement of water molecules to slow and gather together, forming crystals. As the crystals continue to cluster and grow, the ice expands and becomes thicker. Eventually, a layer of ice forms on the surface of the water. The ice floats on the surface because as water freezes it increases in volume. Thus, frozen water (a solid) is less dense than liquid water. If you look closely at the image, you can see crystals growing from the edge of the ice.

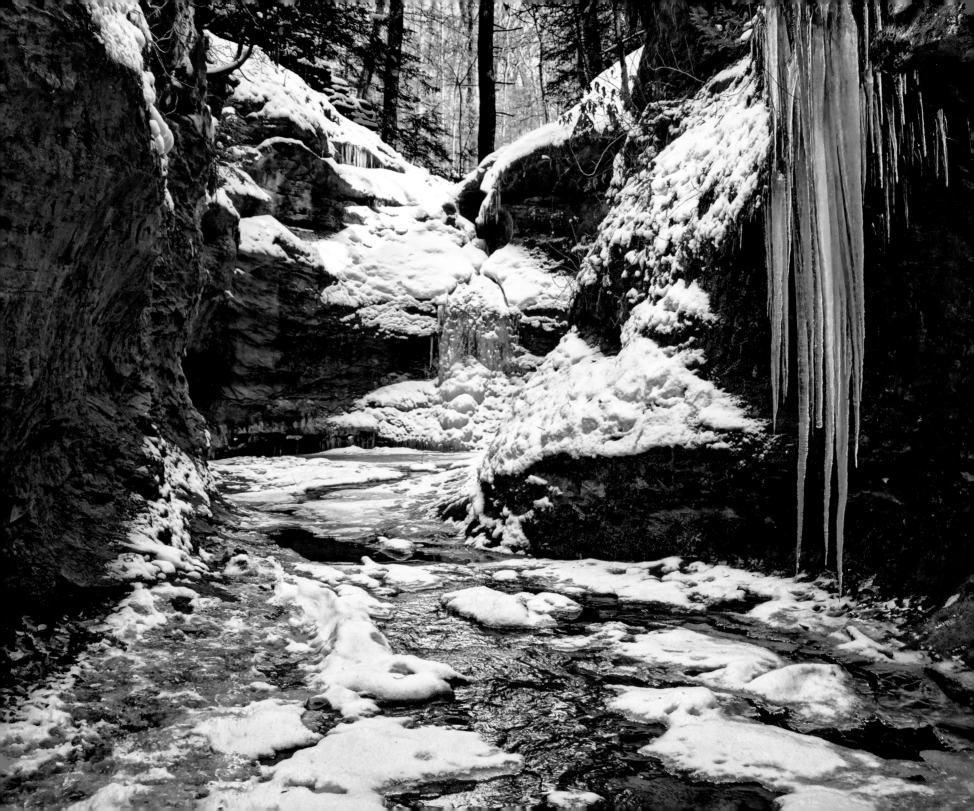

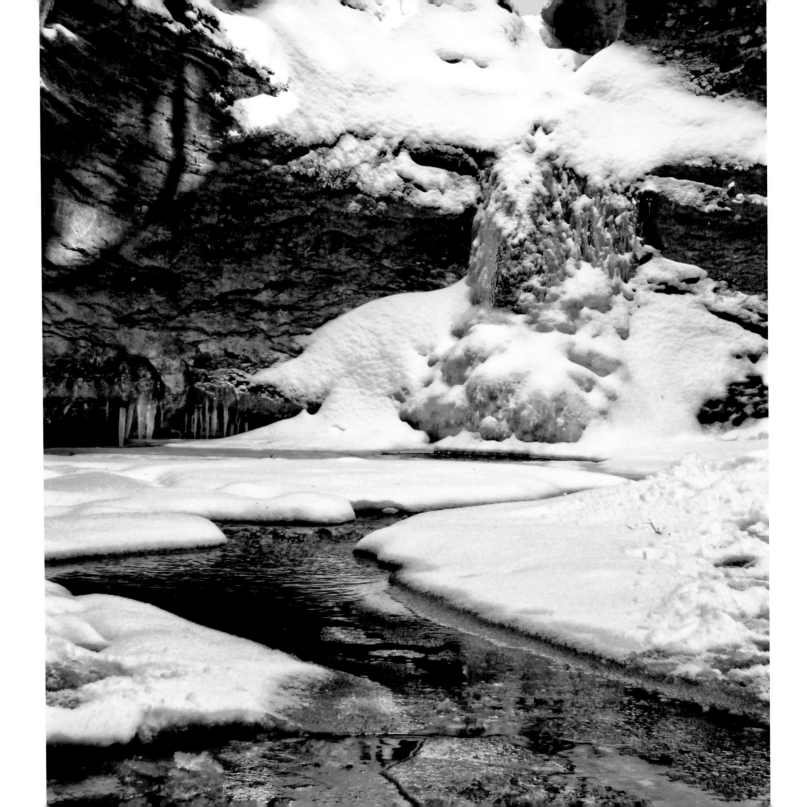

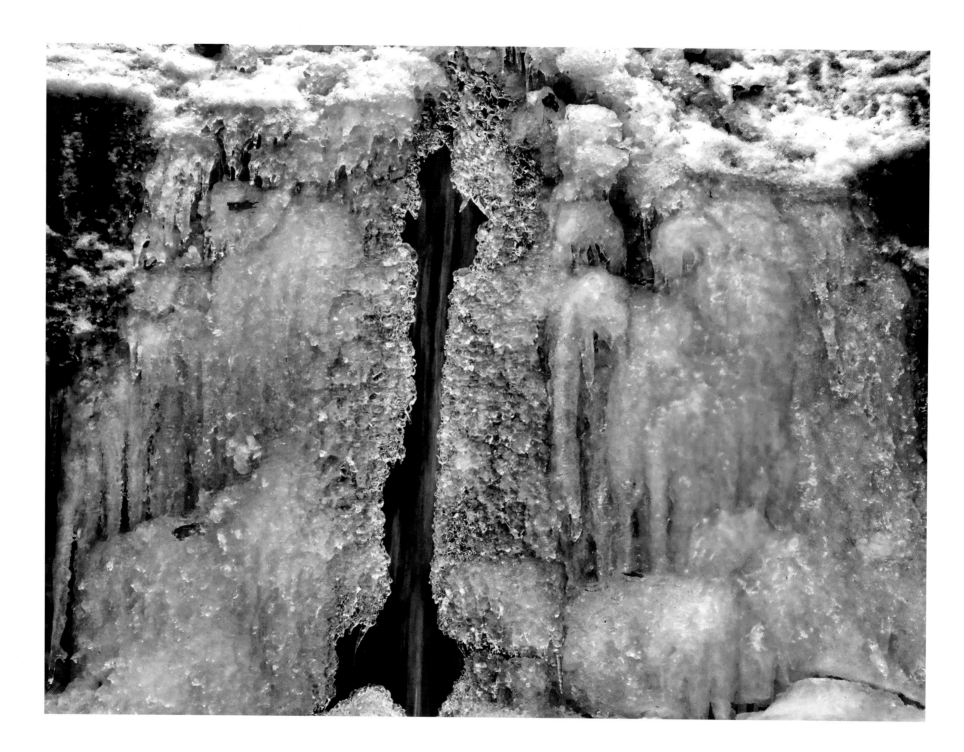

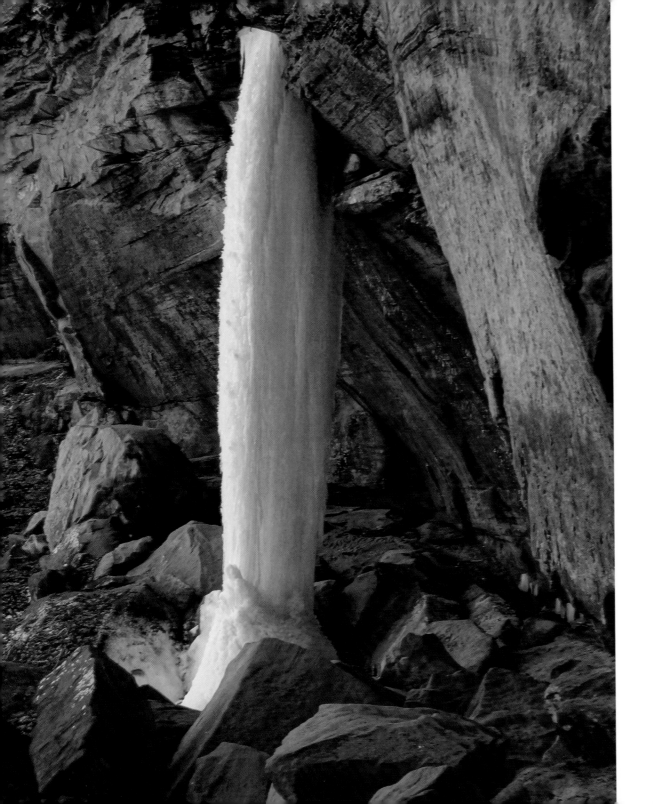

Ice's appearance is influenced by the presence or absence of impurities, such as soil particles, minerals, or air bubbles. Thus, ice may appear transparent (clear), opaque (cloudy or milky, caused by air bubbles), or white with a tinge of blue color. The color we see is due to the light-absorbing property of ice. Ice tends to absorb light at the red end of the spectrum; thus, it appears to have a blue-green tint. The color intensifies with the thickness of the ice. Impurities in the ice also absorb light and influence its appearance, giving the ice a brown, gray, or green color.

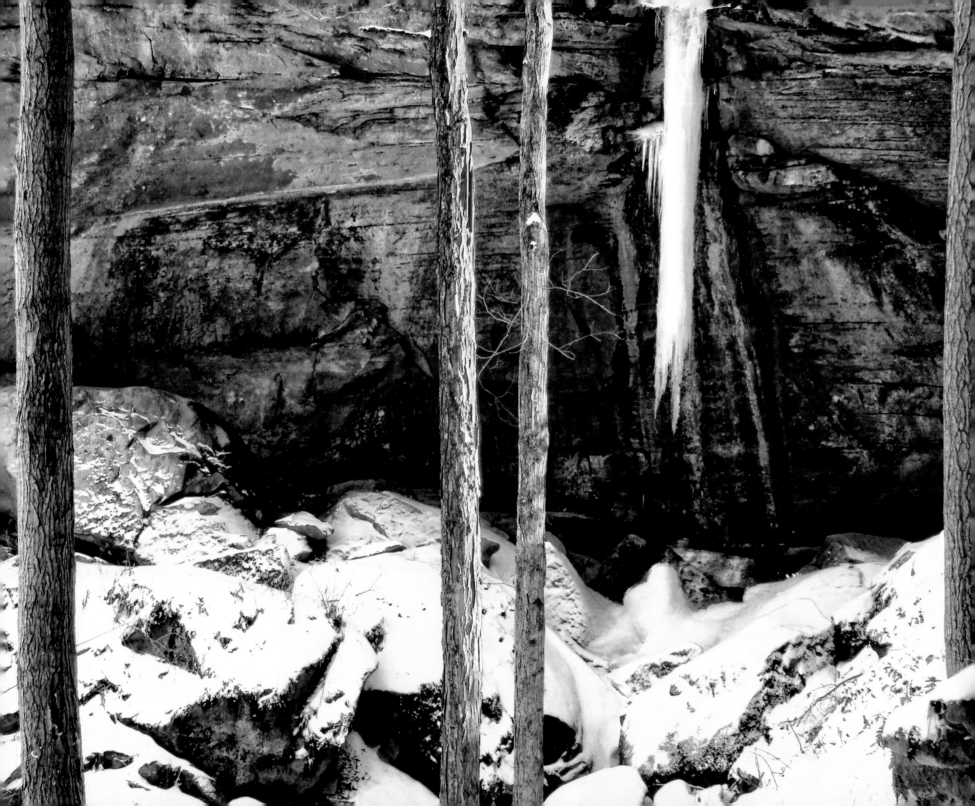

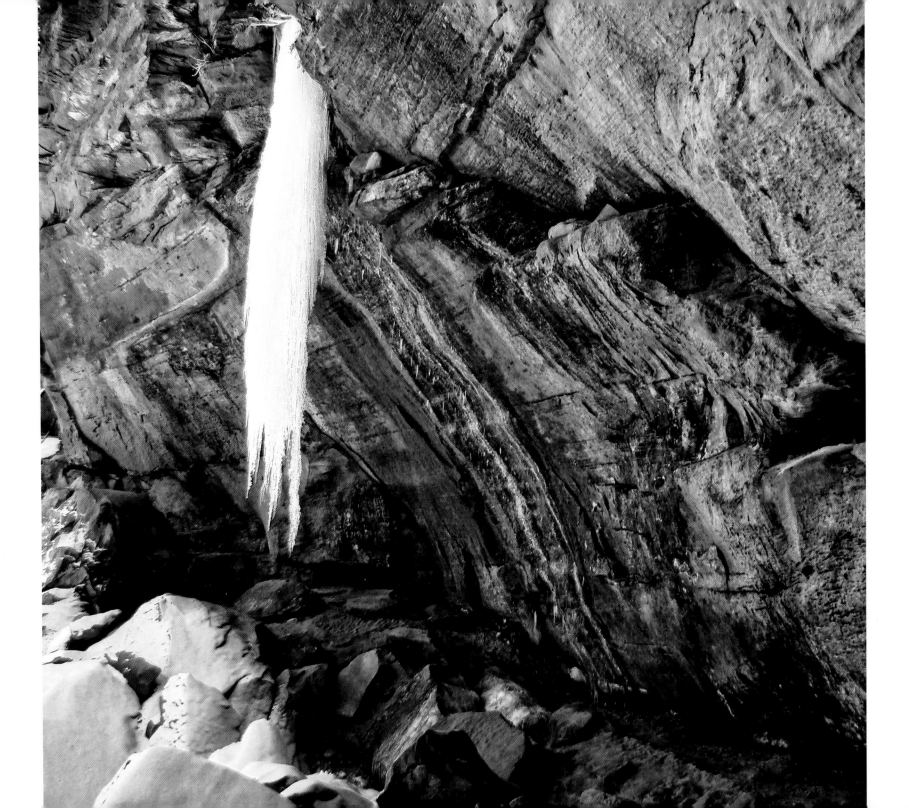

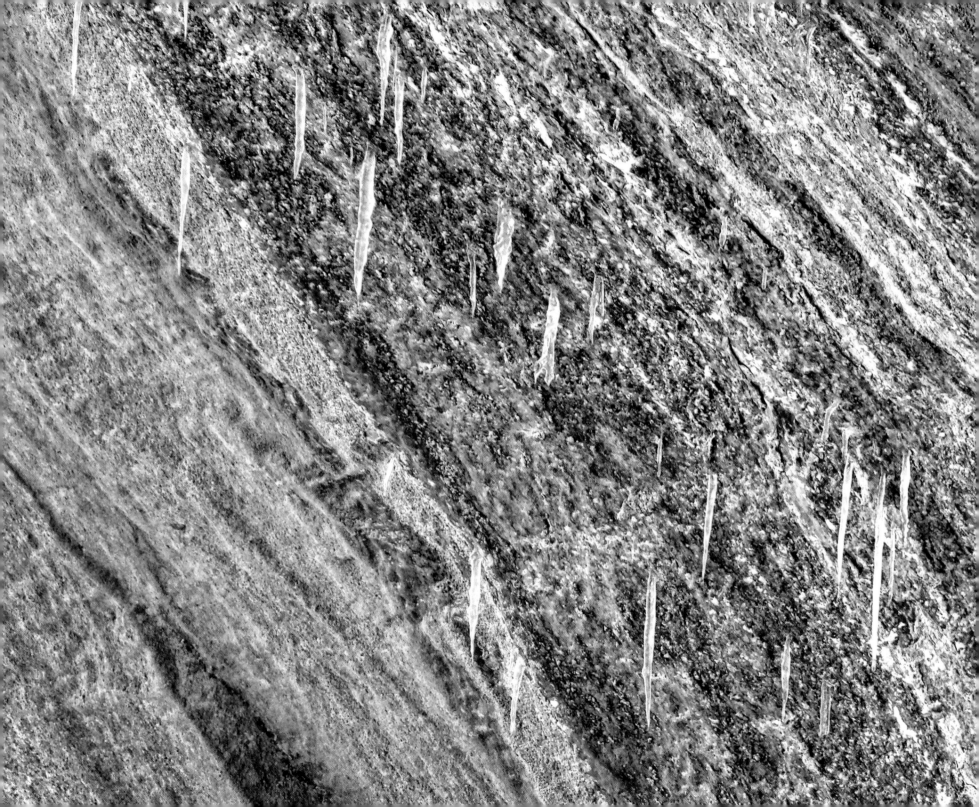

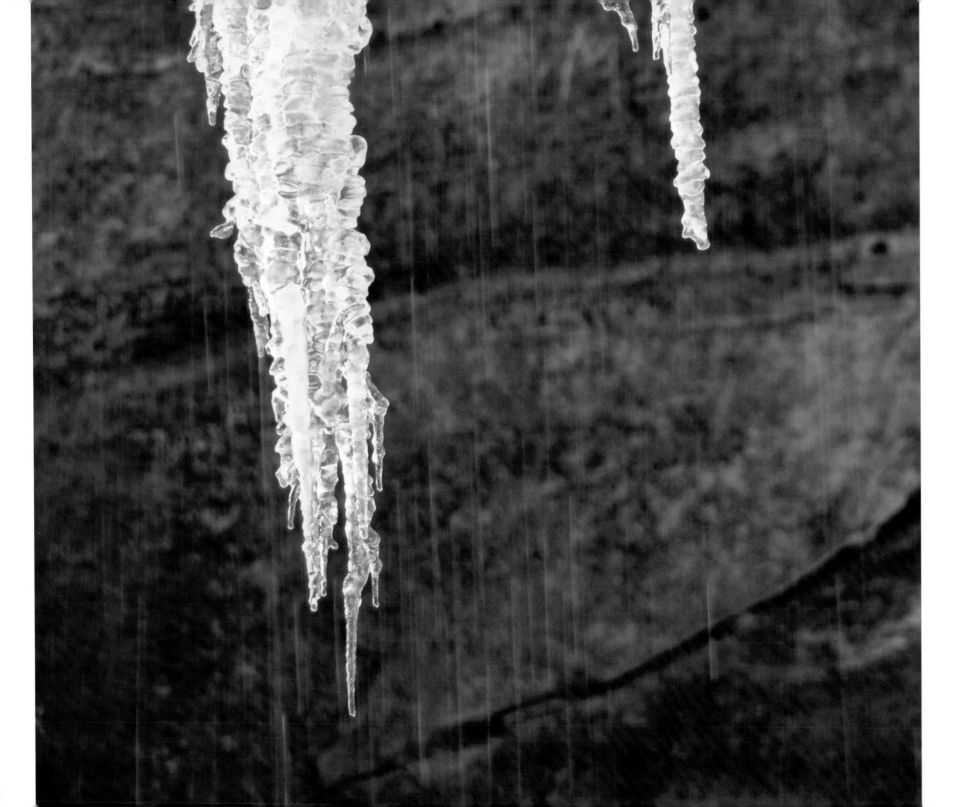

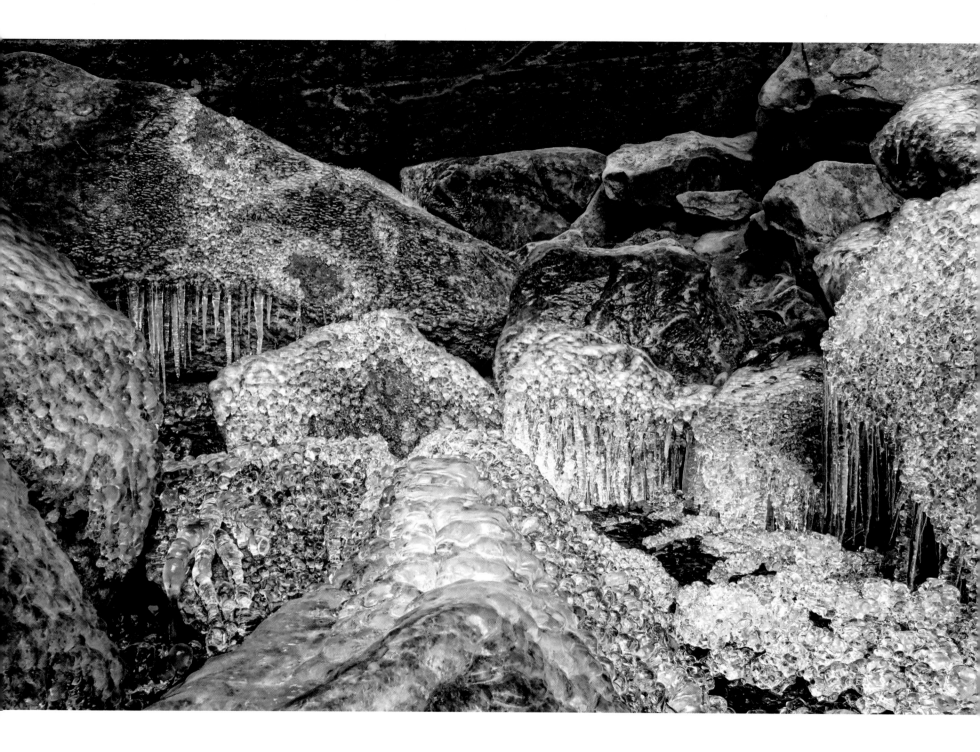

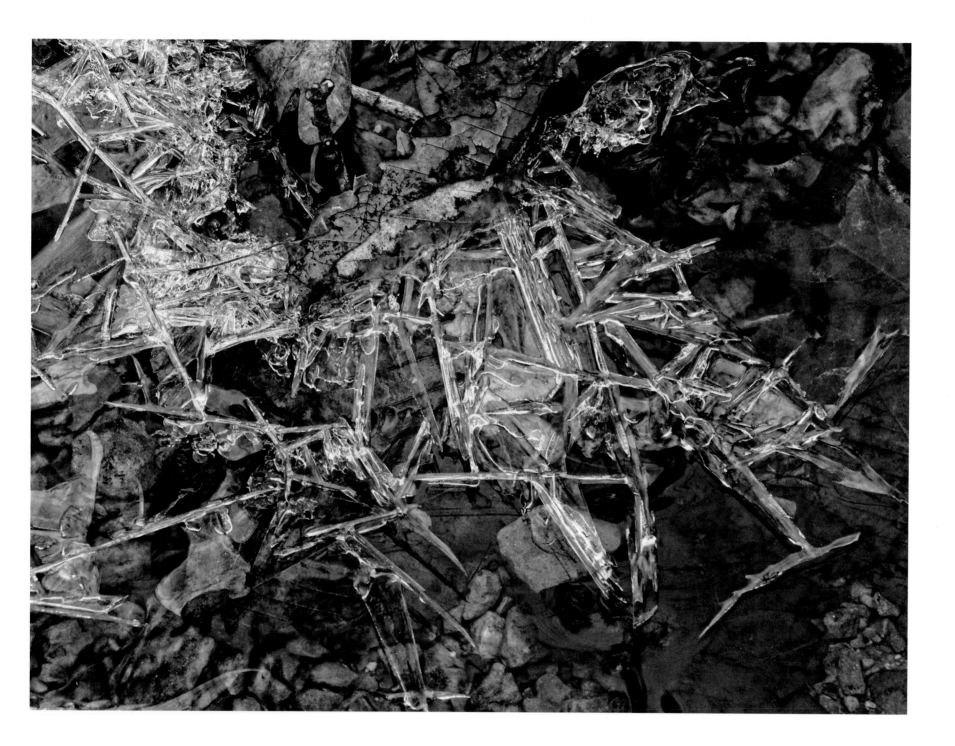

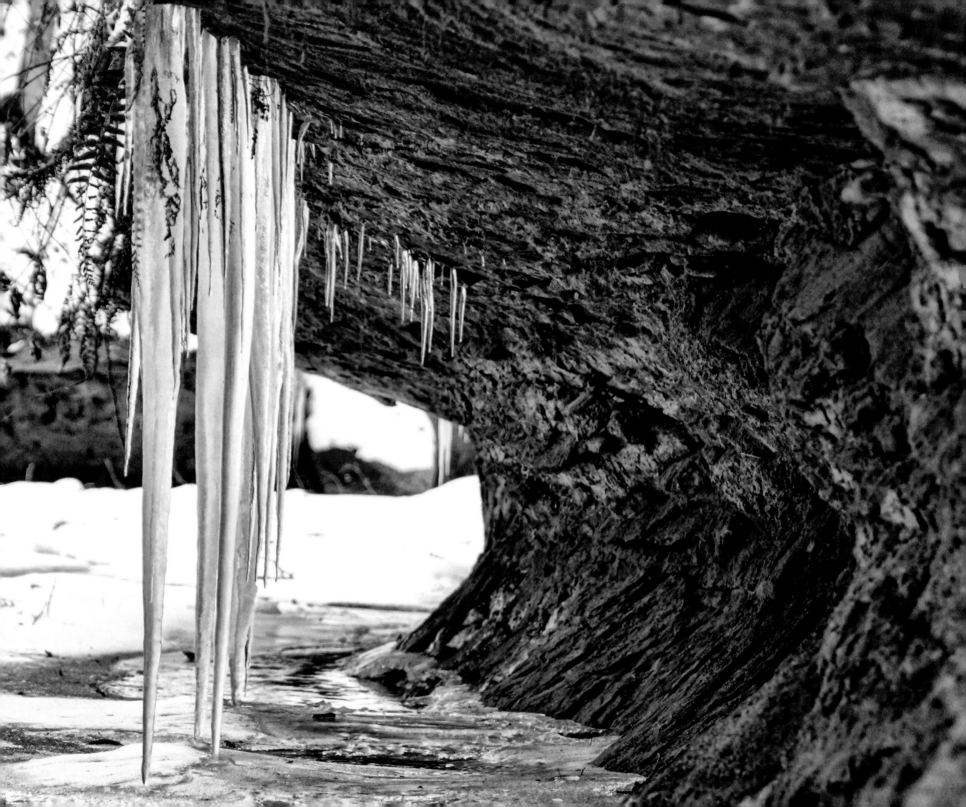

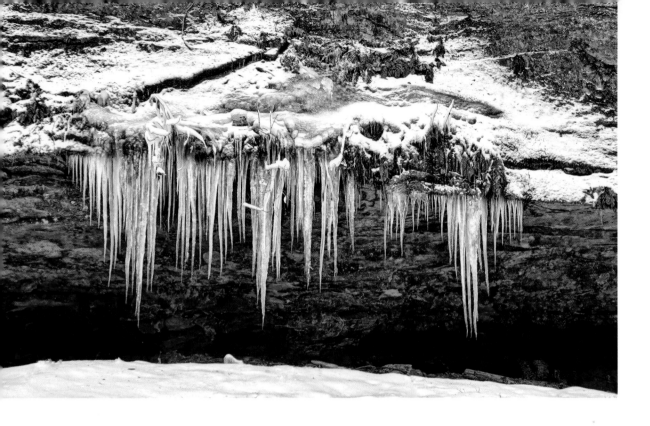

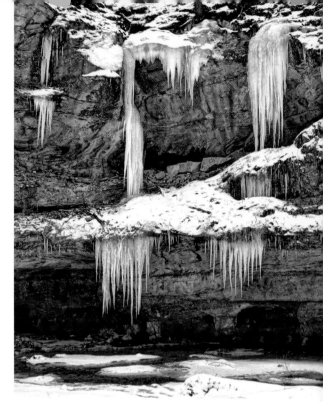

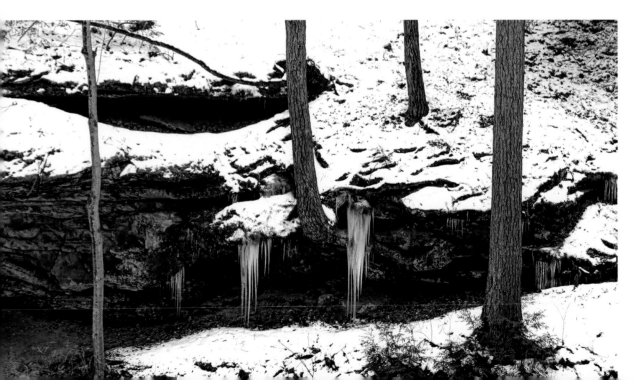

Snow and ice are an important part of the water cycle. During winter months, water is deposited and stored on the land as snow and ice. Come spring, the snow and ice melt, and the water runs off the land or percolates into the ground, recharging the water supply and providing an important source of fresh water.

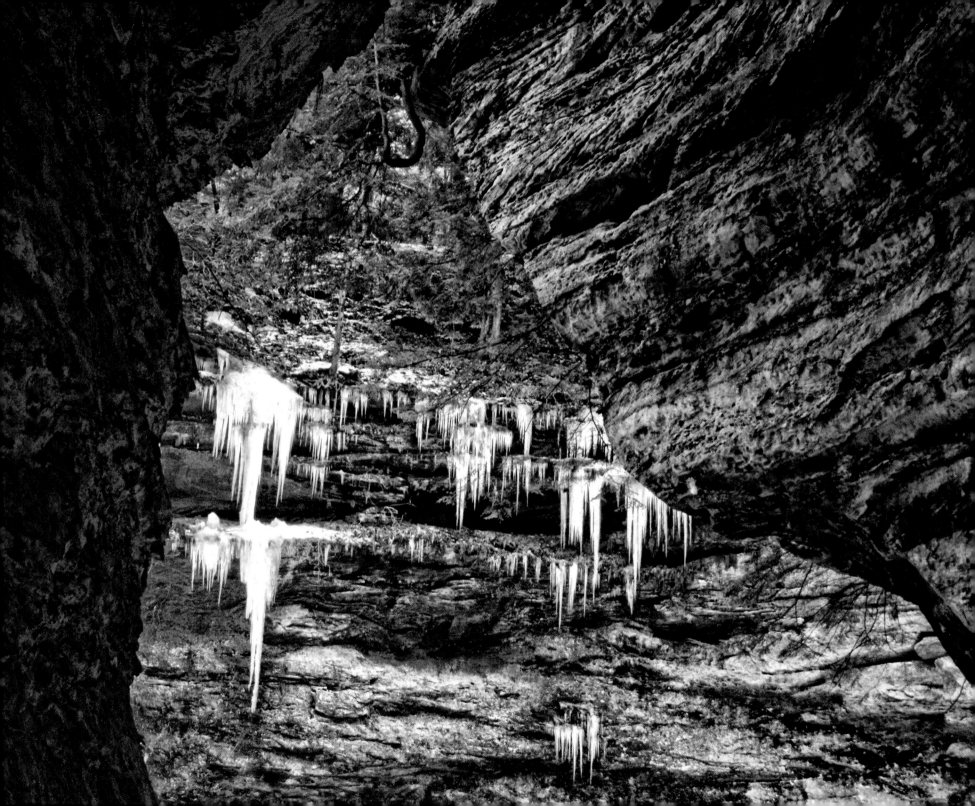

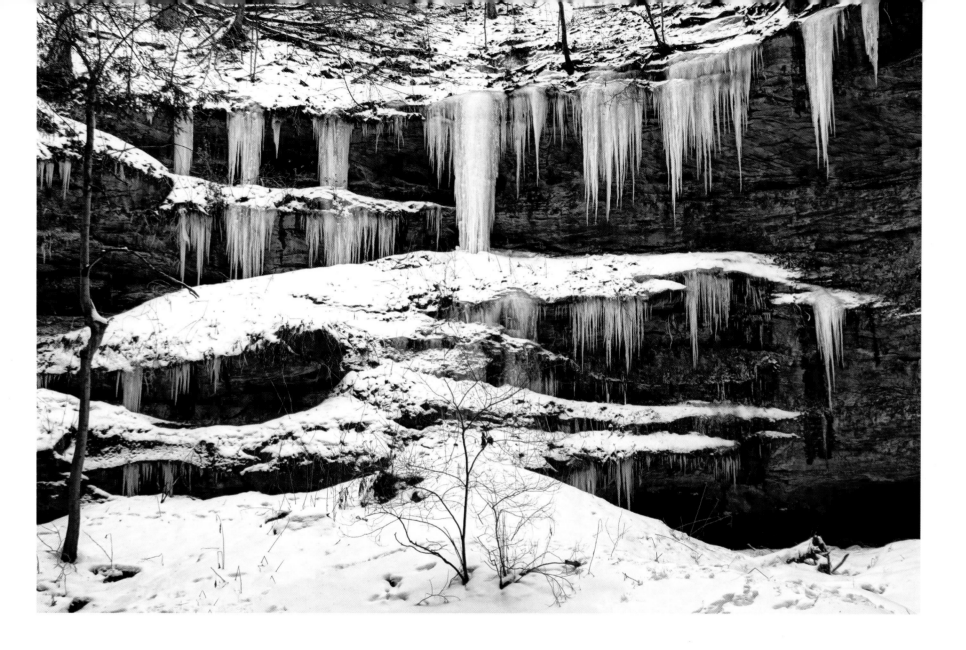

For some reason, we all connect with icicles, symbols of winter. We appreciate their beauty and admire their rippled surfaces and carrot-like shapes hanging from the sandstone. Icicles are nature's artistry—water flowing downward by the pull of gravity, freezing layer upon layer, ever reaching toward the ground.

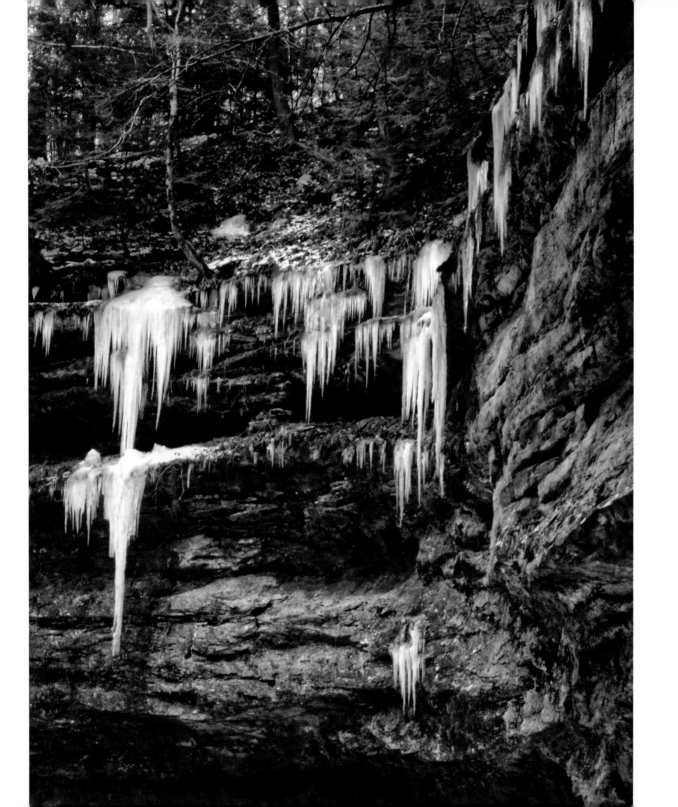

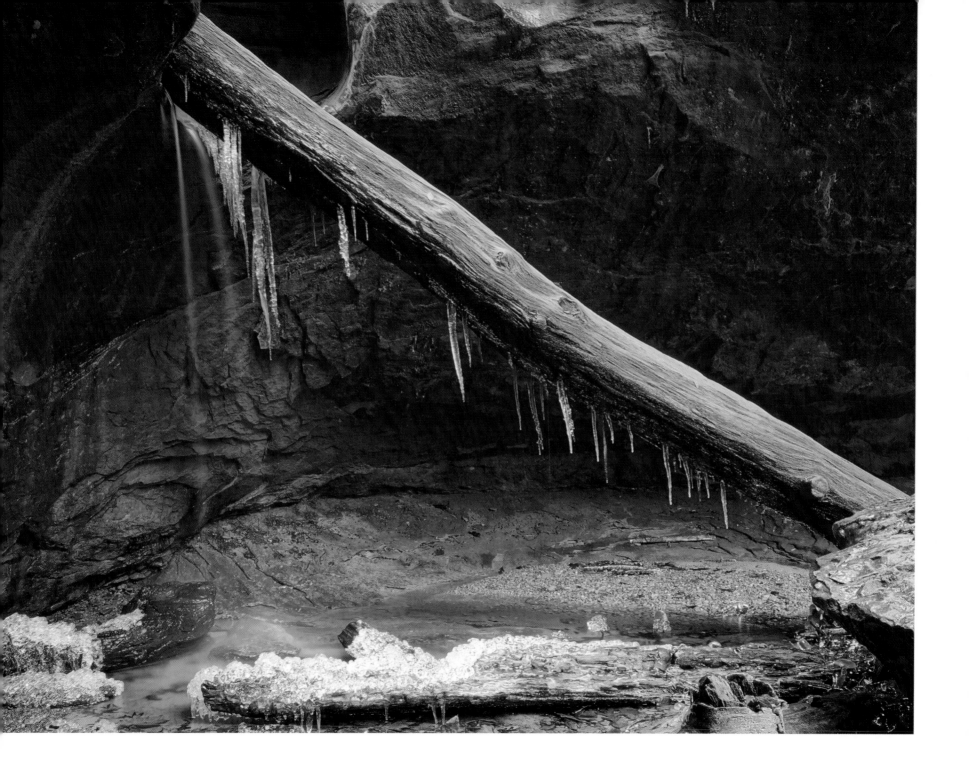

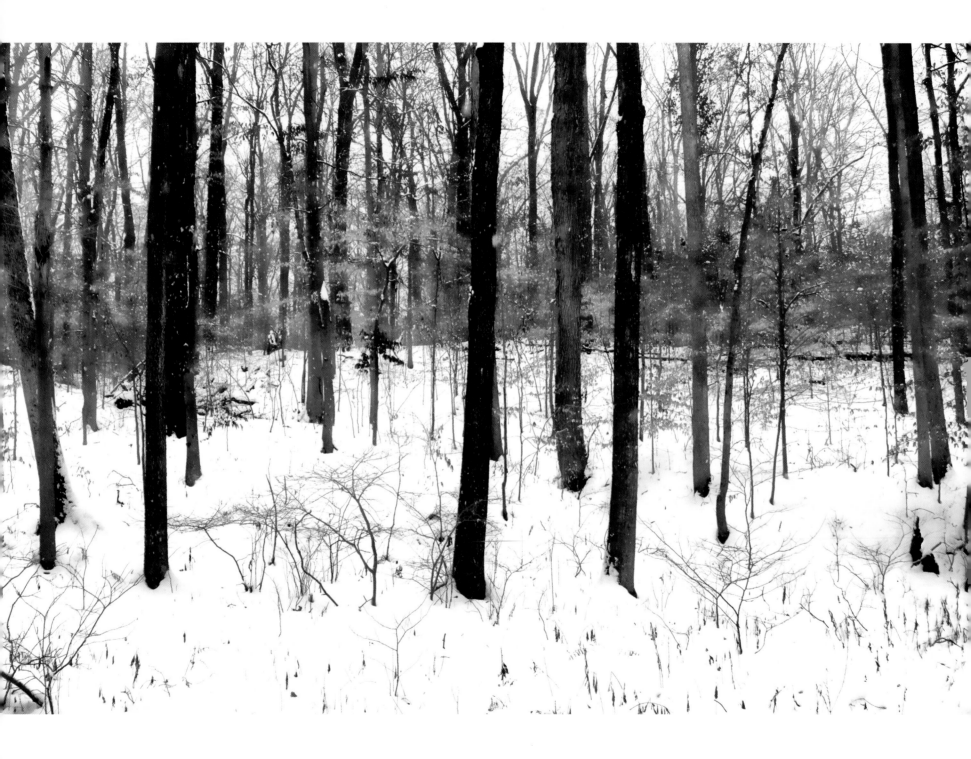

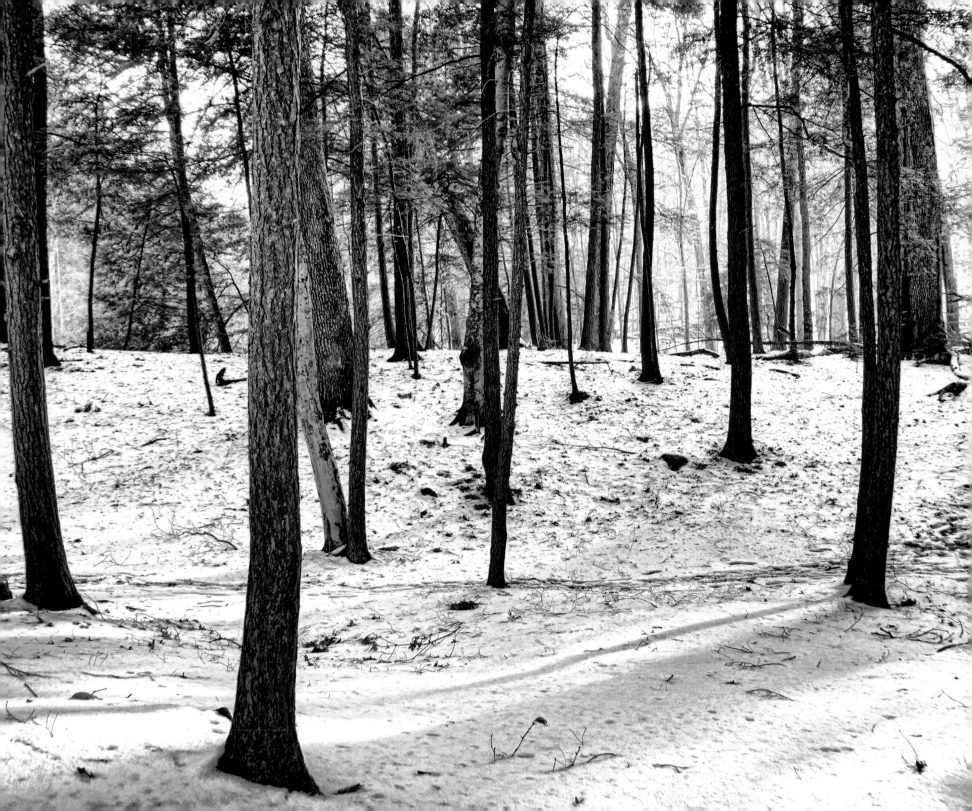

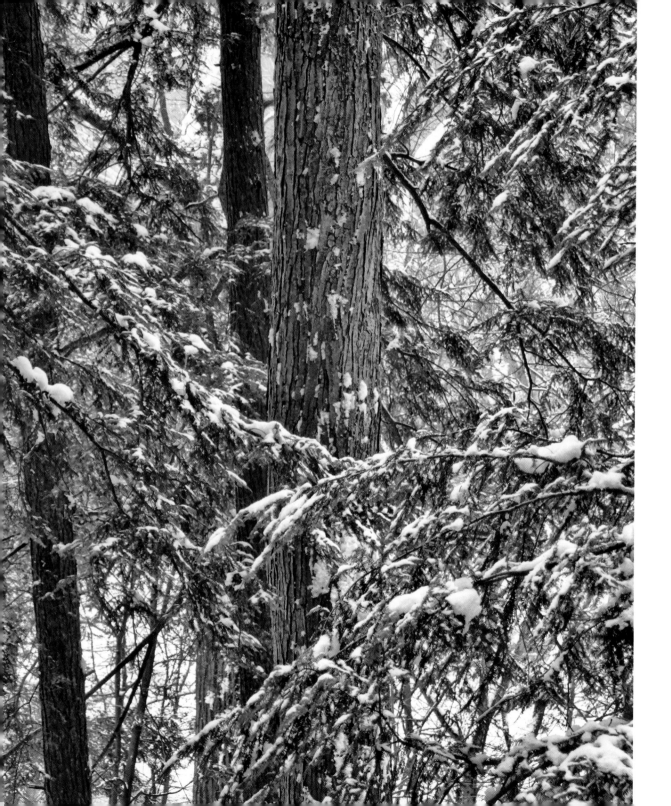
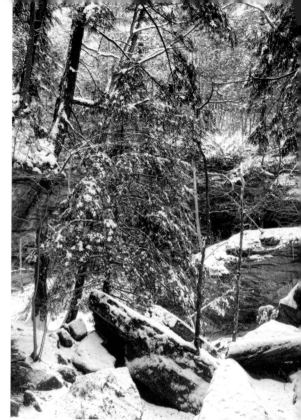
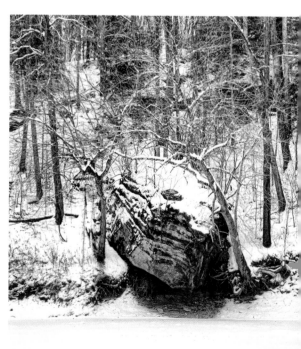

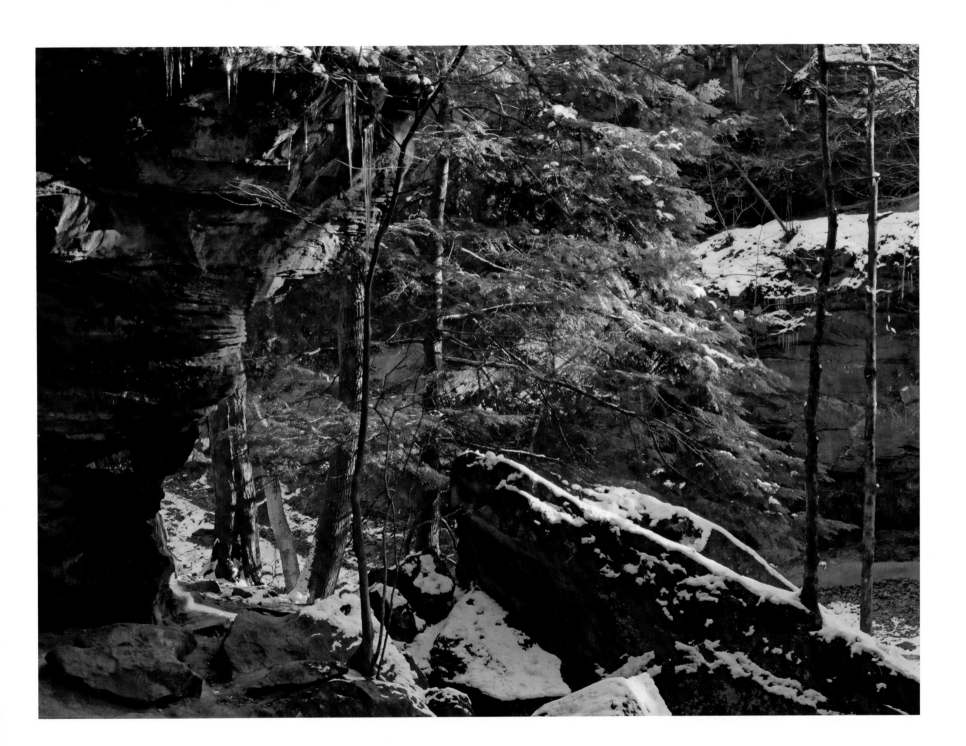

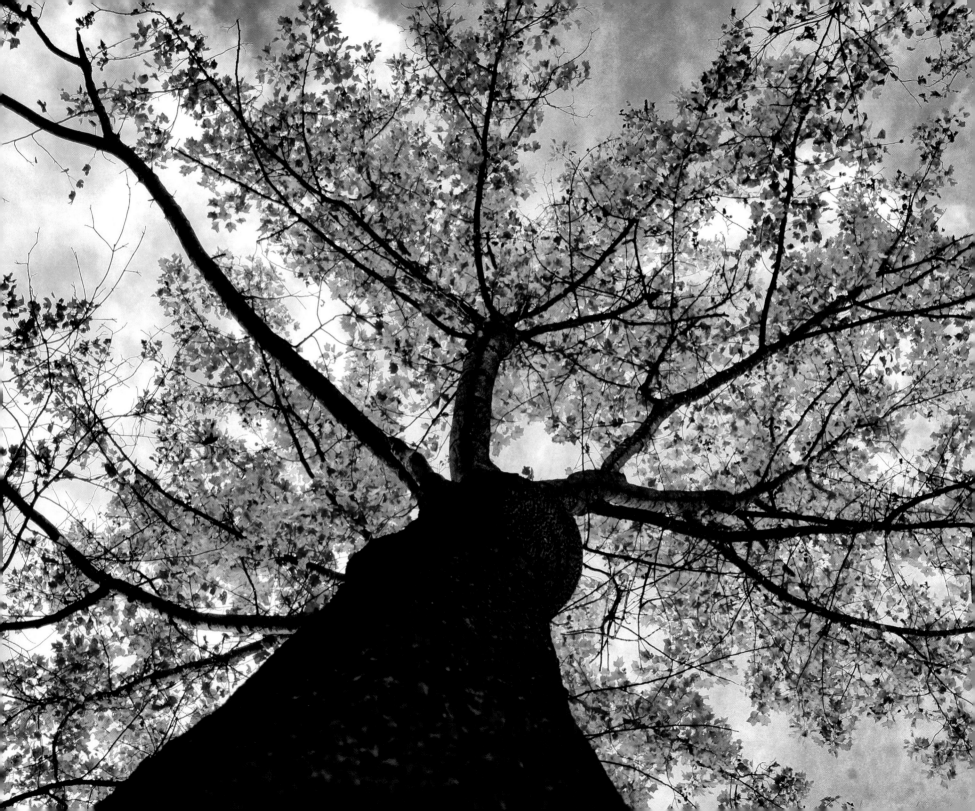

Have you ever noticed how unique and diverse the trees are that grow in Turkey Run? Have you ever wondered why different trees grow in different locations? Have you ever thought about how important the tall trees of Turkey Run are to life in the forest? In this chapter we will walk among the tall trees of Turkey Run, experiencing their beauty, their individuality, and their importance to life in the forest. In fact, it is the tall trees and other plants of the forest that shape the ecological community of Turkey Run. Although their presence in the park is determined by the type of soil and climate, they determine the existence of life in the park.

A single oak or maple tree in Turkey Run has individual beauty, but oaks and maples are quite impressive when massed to form a forest. Although Turkey Run's forest is dominated by deciduous trees like oaks, hickories, maples, and beeches, it also contains other deciduous trees such as ashes, cherries, and locusts. Coniferous trees like cedars and eastern hemlock—relics from glaciers past and cooler climates—are also found in special places throughout the park. They survive in unique areas that are cool and moist, such as the park's canyons and ravines. Although most of the trees in the park are second growth, old-growth walnut and sycamore trees grow in bottom lands and floodplains, where the soils are wetter. This

means that the tall trees of Turkey Run are exceptional, offering the hiker a striking display of life.

The tall trees are the oldest living element of the Turkey Run landscape. Because trees are long-lived, we often think of forests as serene, timeless, and enduring. Yet, Turkey Run's forest undergoes a constant and cyclical change from season to season and year to year. Leaves emerge, turn color, die, and fall to the forest floor. Older trees die and fall to the ground, giving way to young saplings, while new trees emerge from seeds and grow toward the sun. There is a quiet competition between trees in the forest for space, light, and water—the elements needed to survive and reproduce. This struggle to survive can be observed throughout the park.

Turkey Run's trees provide us the opportunity to connect with nature; the trees soothe the soul and inspire the mind. The park provides us the opportunity not only to read the forest, but also to think about how our lives are intricately connected to the natural world. The images and text in this chapter will take us on a journey through the tall trees of Turkey Run. We will see how the forest changes from season to season and how the tall trees shape the forest and support life.

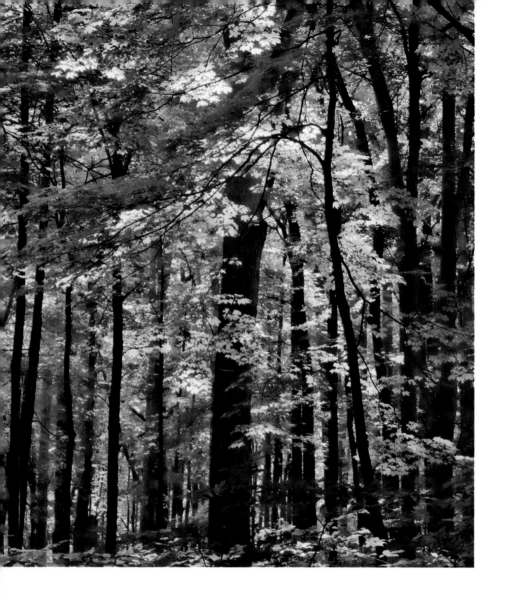

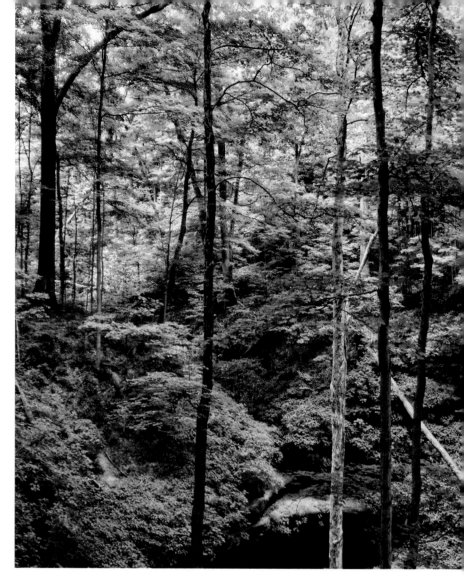

The different layers of the forest are determined, in part, by the amount of available light. The canopy consists of the branches and leaves of mature trees that absorb most of the sun's light during summer. The shade-tolerant understory consists of juvenile or immature trees, awaiting an opening in the canopy for light, enabling them to grow into tall trees. The next layer consists of tree seedlings, saplings, and shrubs capable of surviving in a low-light environment, as seen on the facing page. The lowest and most diverse area in the forest is the forest floor, consisting of herbs, ferns, and fungi (see chapter 6, "Flowers, Ferns, and Fungi," for more detail).

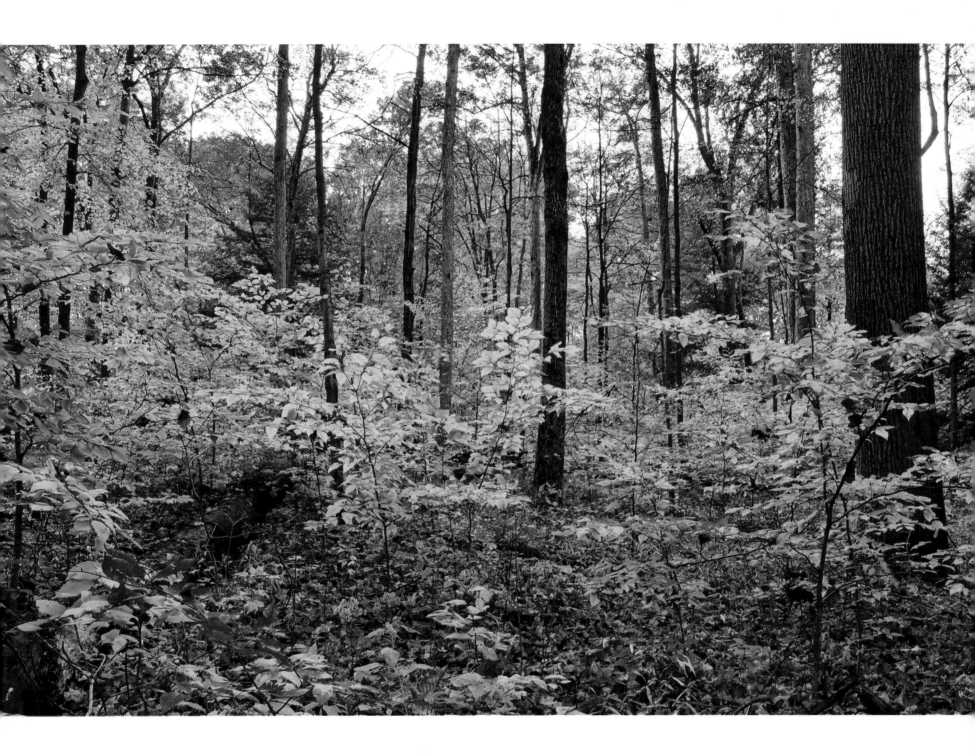

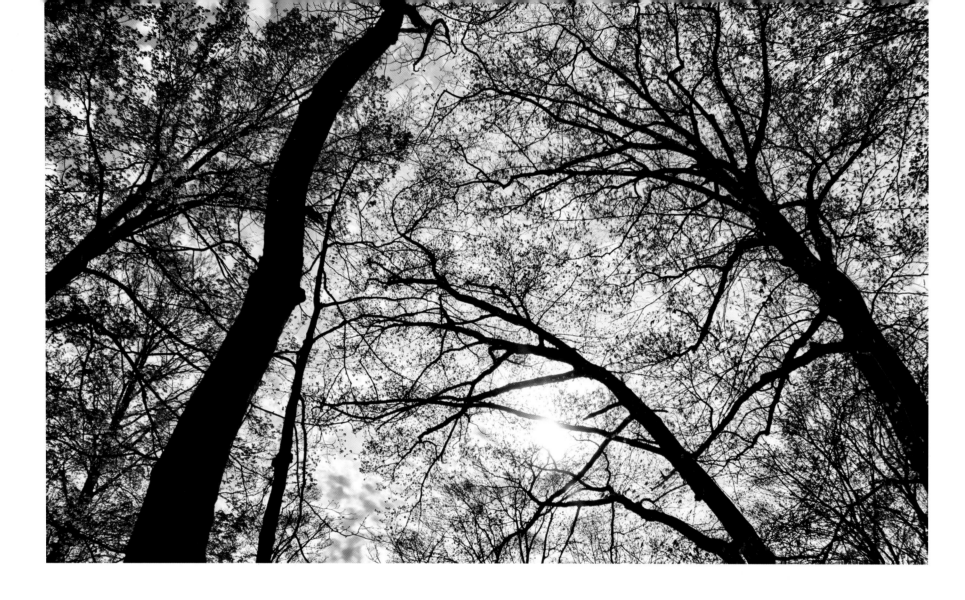

The trees in Turkey Run, and even the leaves on the trees, compete for sunlight to survive. Through photosynthesis, trees use the sun's energy to convert carbon dioxide and water into organic compounds or carbohydrates (sugars), releasing oxygen as a byproduct. Photosynthesis takes place in the leaf's chloroplasts—organelles that contain chlorophyll. This green pigment absorbs the sun's energy and gives the leaf its color. In temperate regions, like Indiana, broad leaves work as an advantage because the larger surface area absorbs more sunlight.

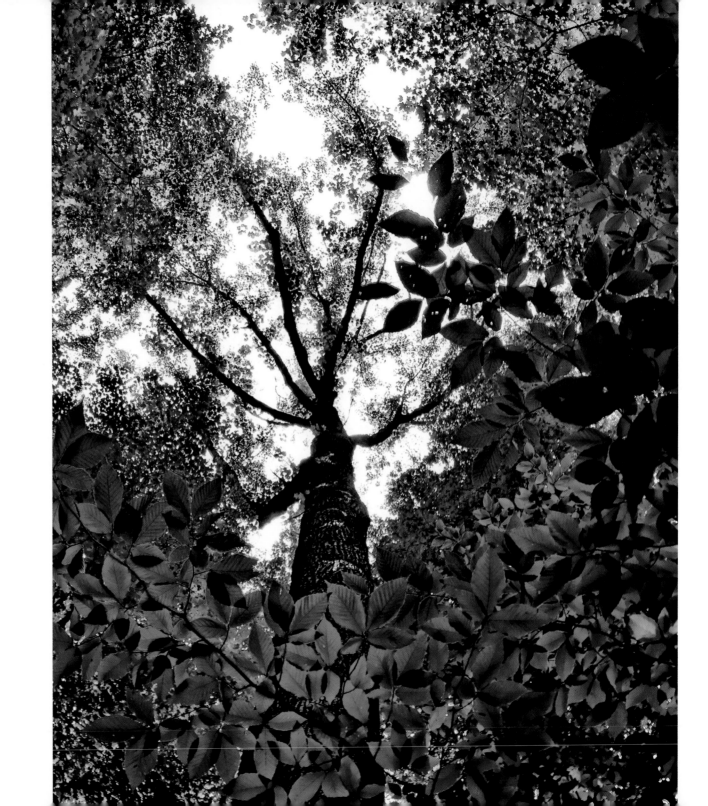

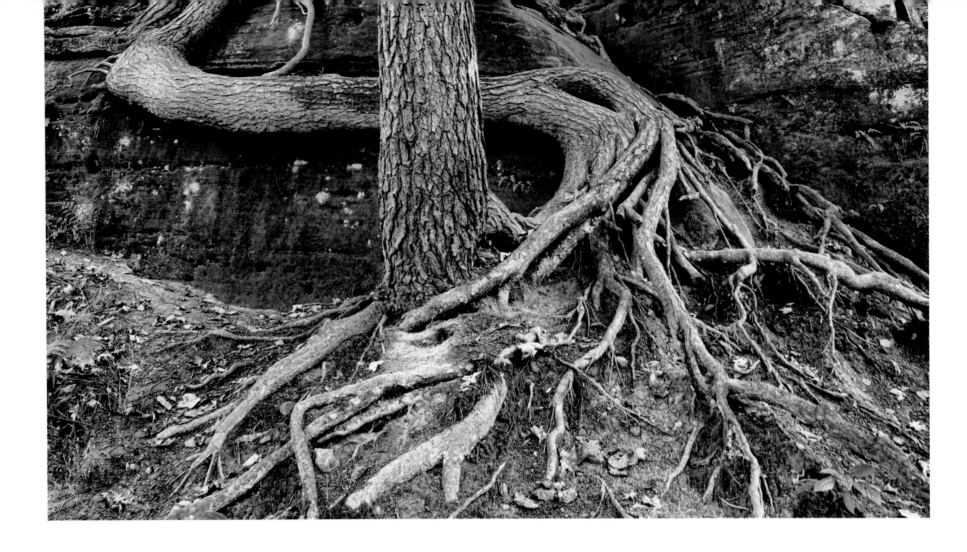

The trees of Turkey Run are incredible organisms adapted to live and grow in a variety of environments. If you think about it, the ordinary tree is anything but ordinary. The trees of Turkey Run can live for hundreds of years. They produce millions of seeds that give rise to saplings capable of colonizing favorable environments. And, for the most part, they live on nothing more than sunlight, carbon dioxide (from the air), and water. (They do need nutrients or minerals from the soil, too). Although the leaves of a tree produce the food (carbohydrates) the tree needs to live and grow, it is the roots that are the most remarkable. The roots are capable of penetrating soil and rock in search of water, thus anchoring the tree. They spread laterally to further locate and absorb water and nutrients, bracing the tree as it grows upward. The images that follow illustrate the resilience of the trees of Turkey Run as they live and grow along cliff faces, around rock outcrops, and between boulders.

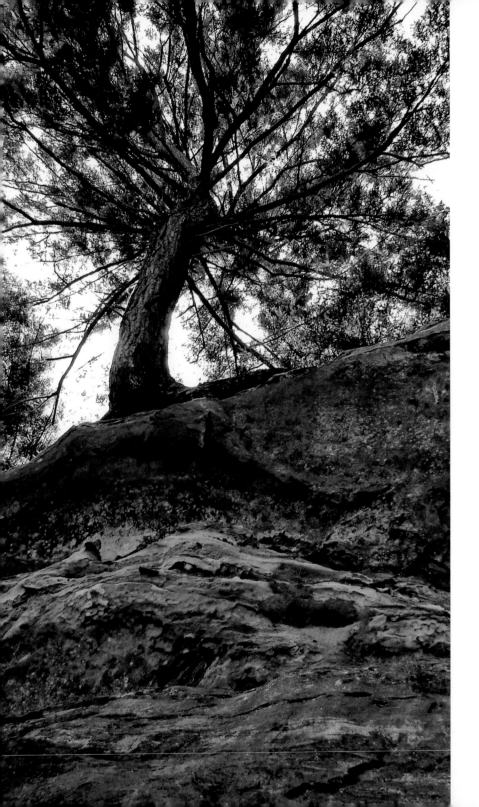

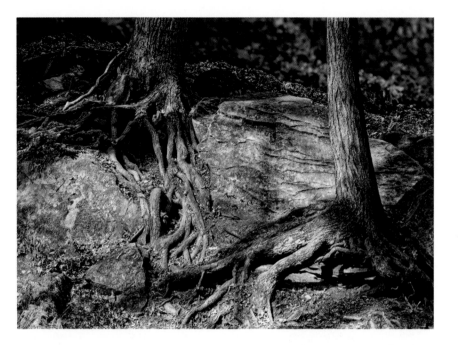

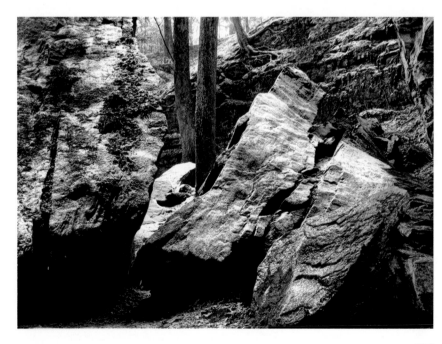

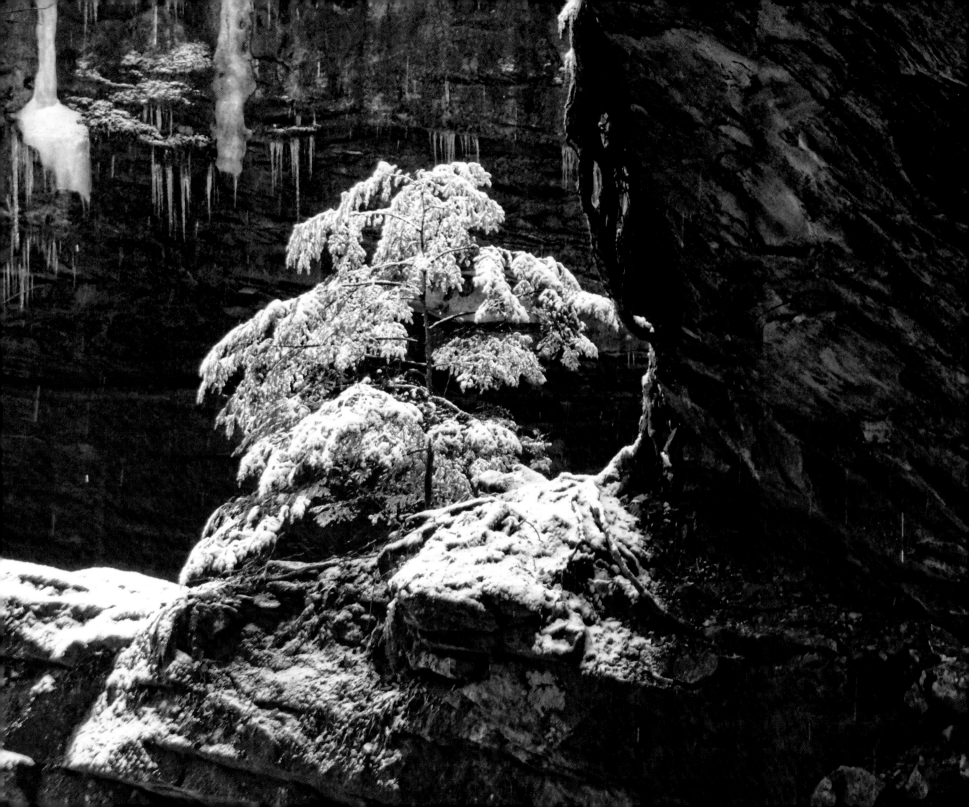

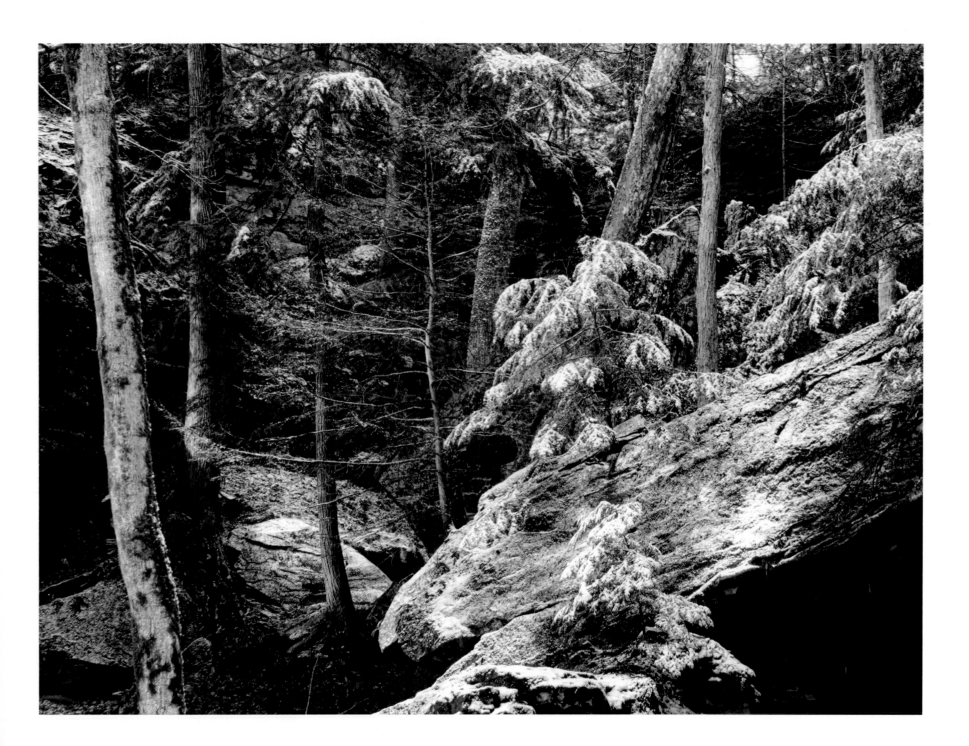

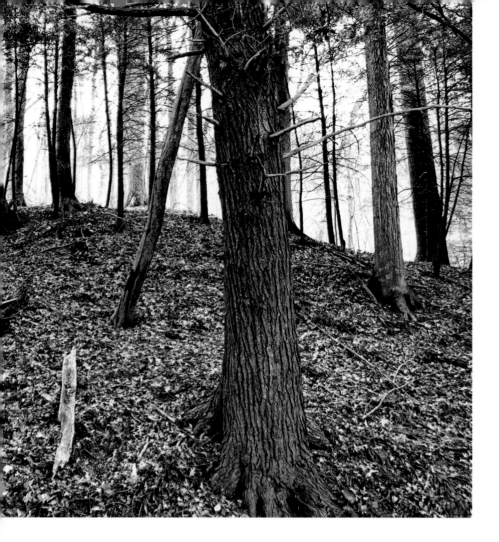
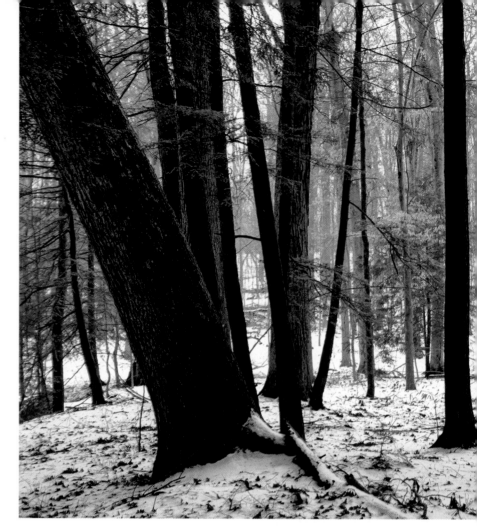

Although most of the trees in Turkey Run are deciduous, several conifers, needle- and cone-bearing trees, may also be found. Conifers reproduce by cones, and deciduous trees by flowers. Botanically, this is how one distinguishes the two groups of trees. The eastern hemlock (*Tsuga Canadensis*) is a conifer that sheds its needles throughout the year, unlike deciduous trees that drop all of their leaves in the fall. Notice that under the hemlock trees there is little to no plant growth. This is because the fallen needles make the soil more acidic, preventing the growth of shrubs, ferns, and herbs. Instead, the forest floor is a mat of brown needles. Hemlock saplings and juveniles are shown in the image on the facing page.

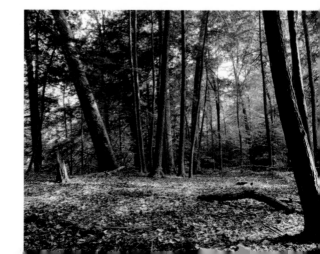

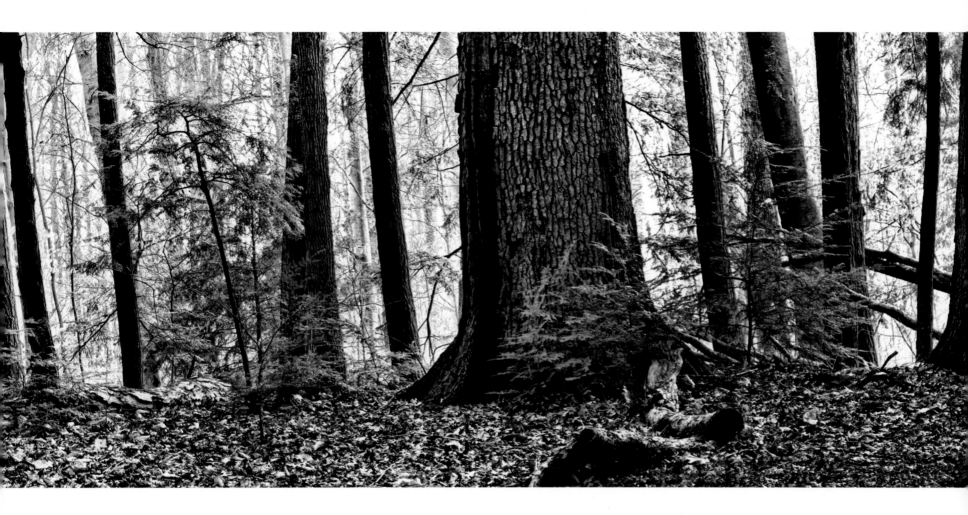

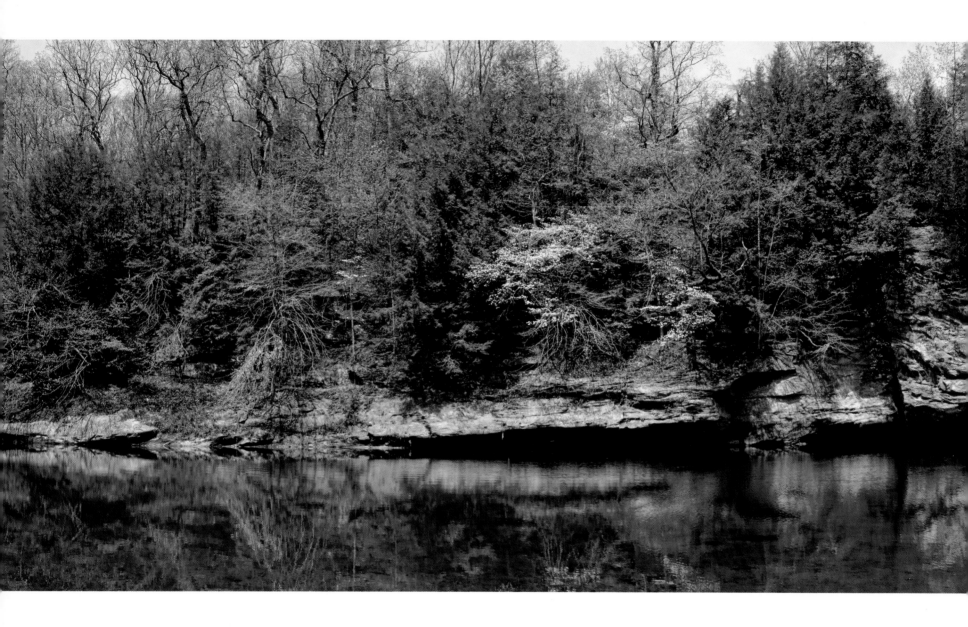

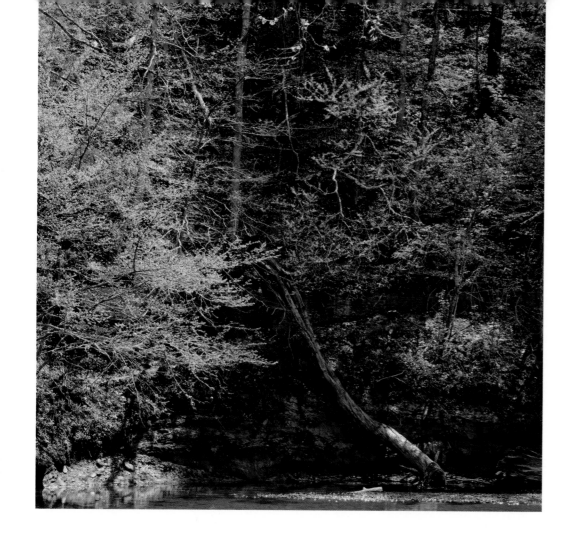

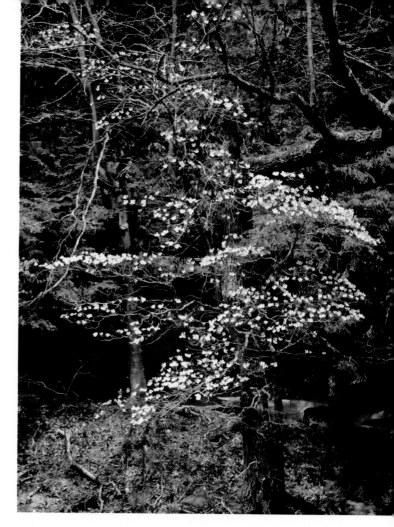

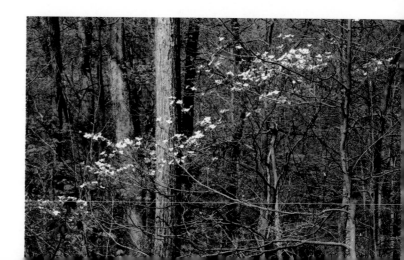

Have you seen a "flowering" tree in the park? This is somewhat of a trick question, for you are surrounded by flowering trees. Although the redbud and dogwood are quite obvious with their spring displays, the oak, maple, beech, and other deciduous trees in the park also flower. Their flowers are inconspicuous and often go unnoticed. The maple, for example, produces tassel-shaped, green-yellow flowers that blend in with its leaves. Other trees only produce flowers in the upper branches, where they are out of sight. Without flowers, many of the tall trees of Turkey Run would not be able to produce seeds that give rise to saplings, the next generation of tall trees.

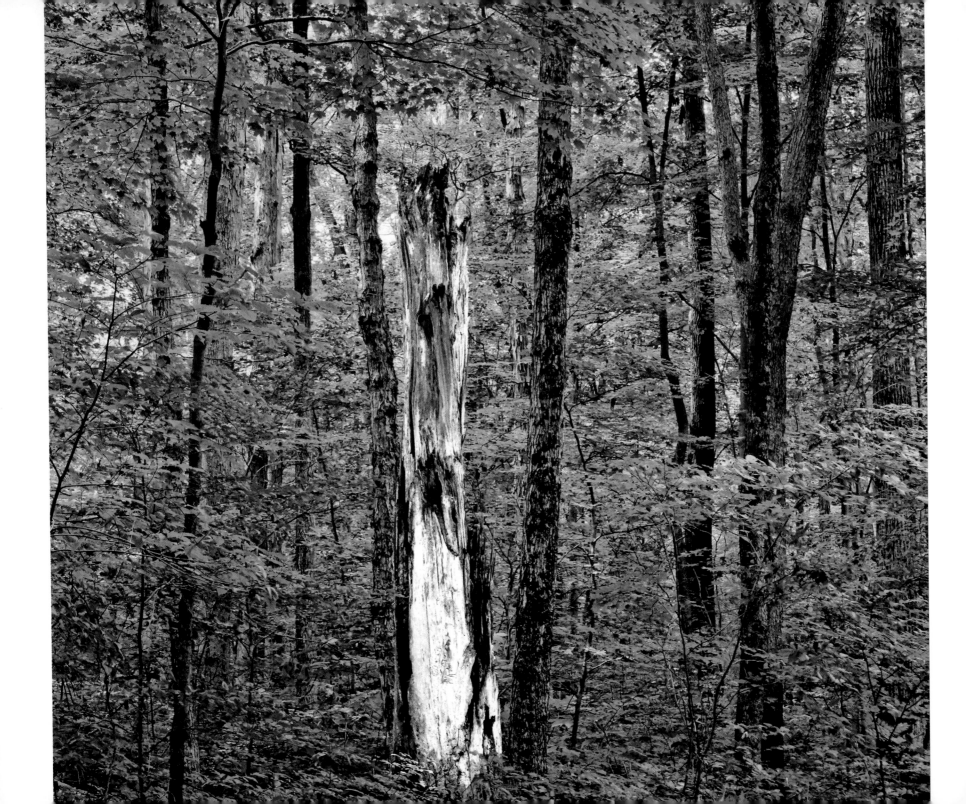

Snags are partly or completely dead standing trees, often without branches. Snags provide a critical habitat and source of food for many forest organisms; for example, woodpeckers must have snags for nesting and feeding. This red-bellied woodpecker is digging a nesting cavity in a snag at the edge of the forest. Red-bellied woodpeckers (*Melanerpes carolinus*) depend upon large trees and snags for nesting. The female lays four or five eggs in a clutch, frequently using the same nesting cavity year after year. Although red-bellied woodpeckers mainly pluck insects and other arthropods from tree trunks and snags, they also consume fruits, nuts, and seeds. Their name is misleading in that the belly is not red—the prominent red plumage is found on the head.

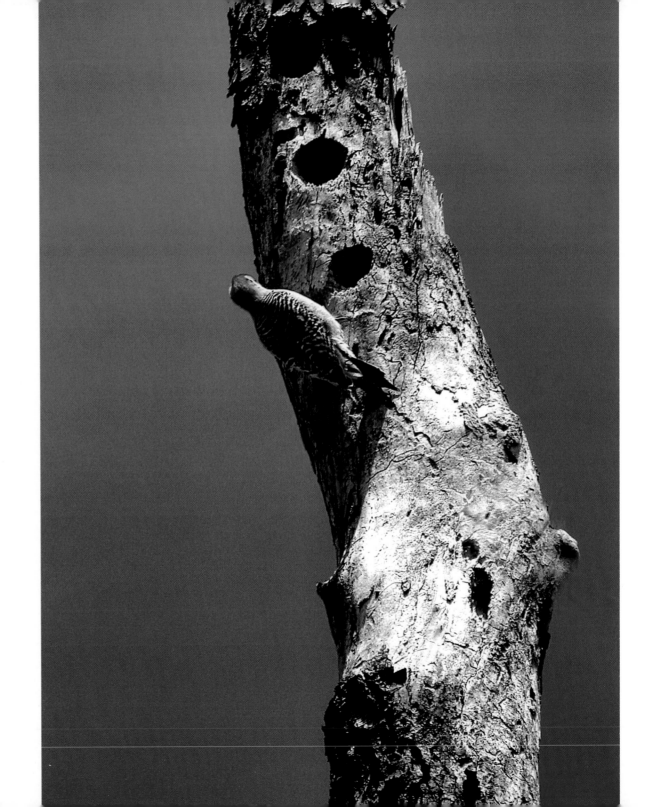

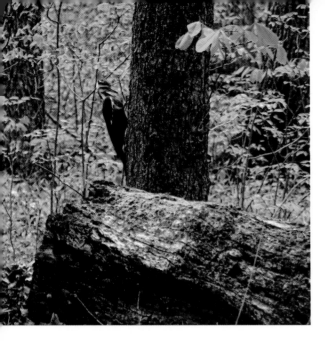

The pileated woodpecker (*Dryocopus pileatus*) flits from tree to tree and from log to log in search of carpenter ants and other insects. Its slow, loud, rhythmic hammering is distinctive and echoes among the tall trees. I often hear them hammering before I see them. With powerful whacks of the bill, they dig deep, rectangular-to-oval holes into the bark of a tree to locate insects. As these images show, the pileated woodpecker is a large bird with a unique red crest, a black and white head, and white wing linings that are quite conspicuous during flight. They may be seen year-round in Turkey Run.

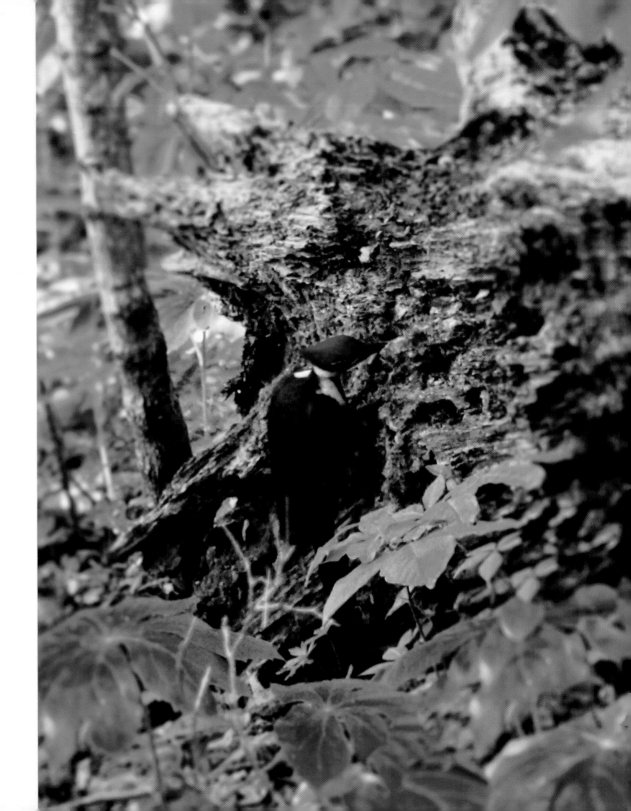

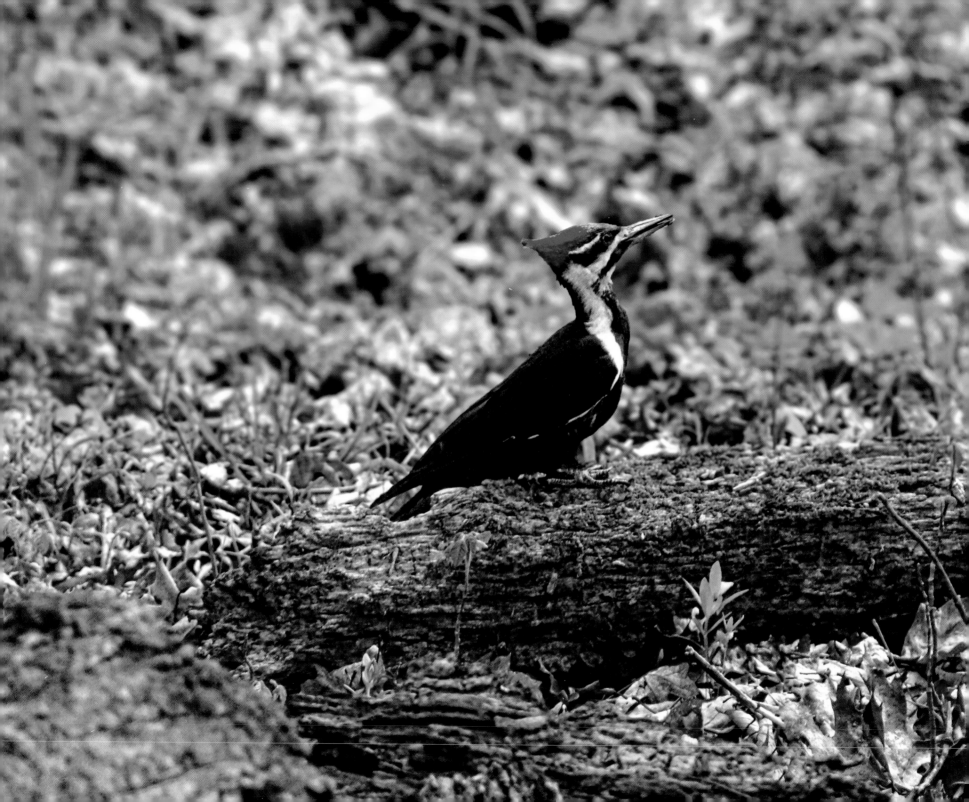

Nothing is wasted in the forest of Turkey Run. Throughout its lifespan, a tree uses the sun's energy to produce wood. As fallen logs decompose, nutrients are released to the soil for use by other trees and plants, recycling matter through the forest. Bark that once protected the tree becomes loose and spongy, creating an environment for decomposers such as fungi. Wood-boring beetles and termites are among the first insects to arrive. They create tunnels that serve as channels through which water and bacteria enter, further rotting the wood. As the wood becomes softer and spongier, more insects and fungi invade—even crickets eat at the rotting wood. Carpenter ants tunnel in, creating nesting chambers. Centipedes arrive to prey on the insects. Nuthatches and woodpeckers also feed on the insects. As the wood decays, the log slowly merges with the soil. This, in turn, adds humus to the soil, encouraging the growth of ferns and wildflowers.

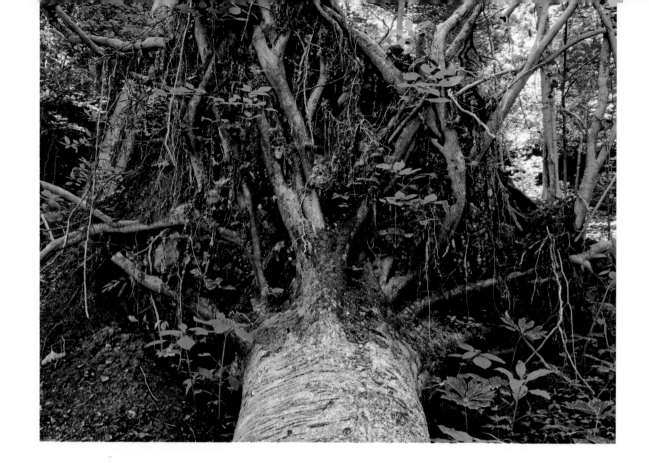

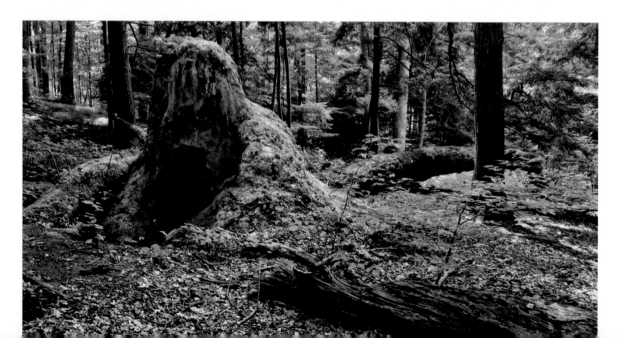

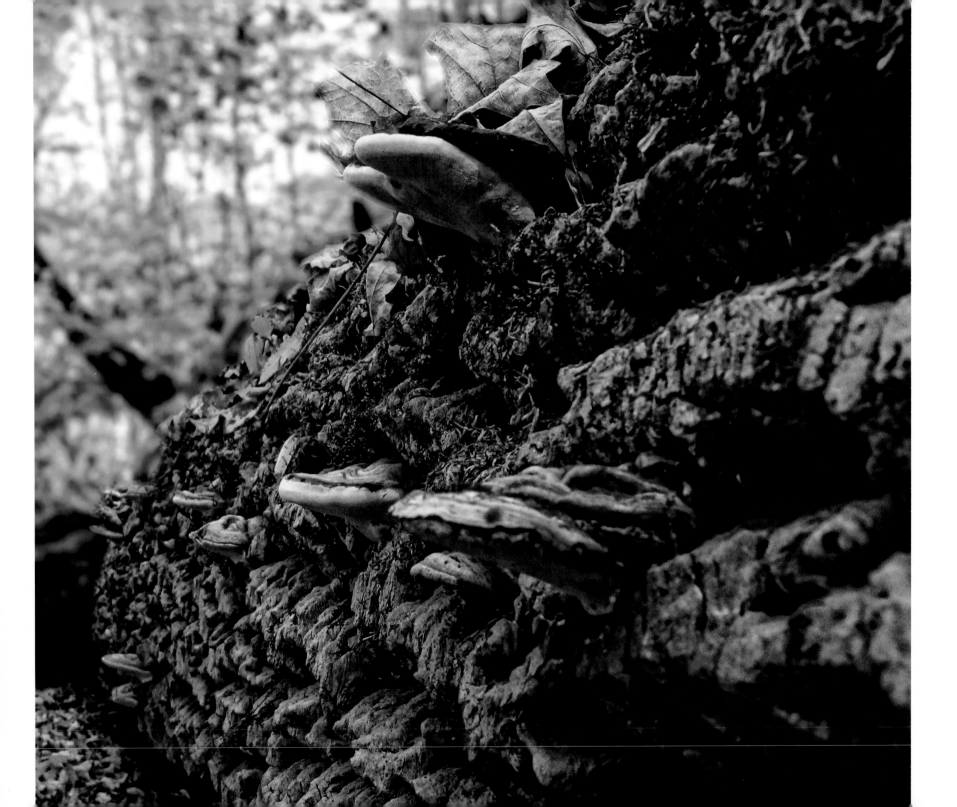

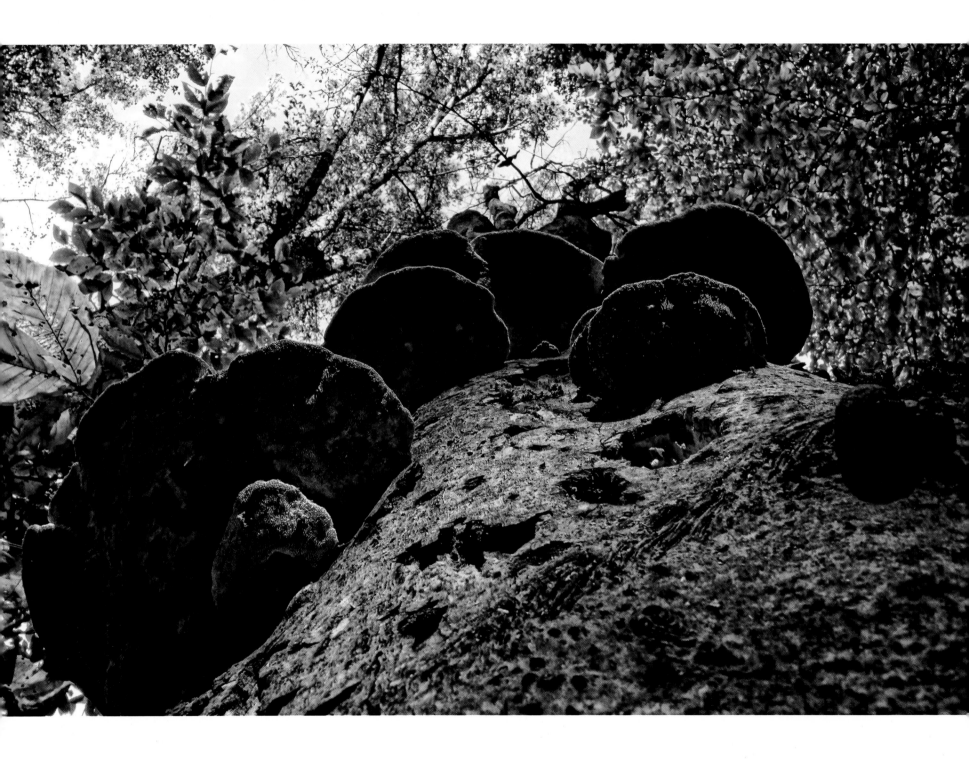

Have you ever wondered where the leaves go? Leaves, needles, twigs, seeds, cones, bark, and other dead plant material that fall to the forest floor is collectively called "litterfall." This fallen organic matter forms a layer of detritus on the forest floor. The detritus is decomposed by fungi and bacteria, returning the nutrients to the soil, or eaten by earthworms, millipedes, and insects. The tall trees and other plants then absorb the nutrients through their roots, cycling the nutrients through the forest environment. Many forest reptiles, amphibians, birds, and mammals use the litterfall for shelter, nesting material, and as a food source.

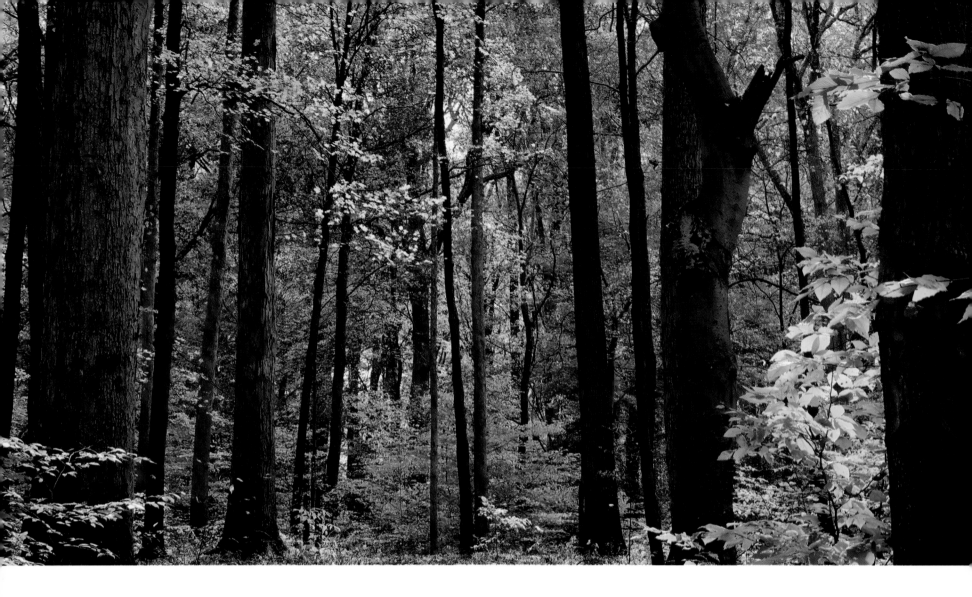

As autumn approaches, daylight decreases and temperatures cool, causing a drastic color change in the deciduous trees and shrubs of Turkey Run. The forest transforms from tints and tones of green to a range of reds and yellows. By autumn, the production of chlorophyll stops, and as a consequence, other leaf pigments emerge to give the leaves their color. Carotenoids result in an orange-yellow color. Anthocyanins provide a red-to-purple hue. The anthocyanins often combine with the carotenoids to produce deeper yellows and fiery reds.

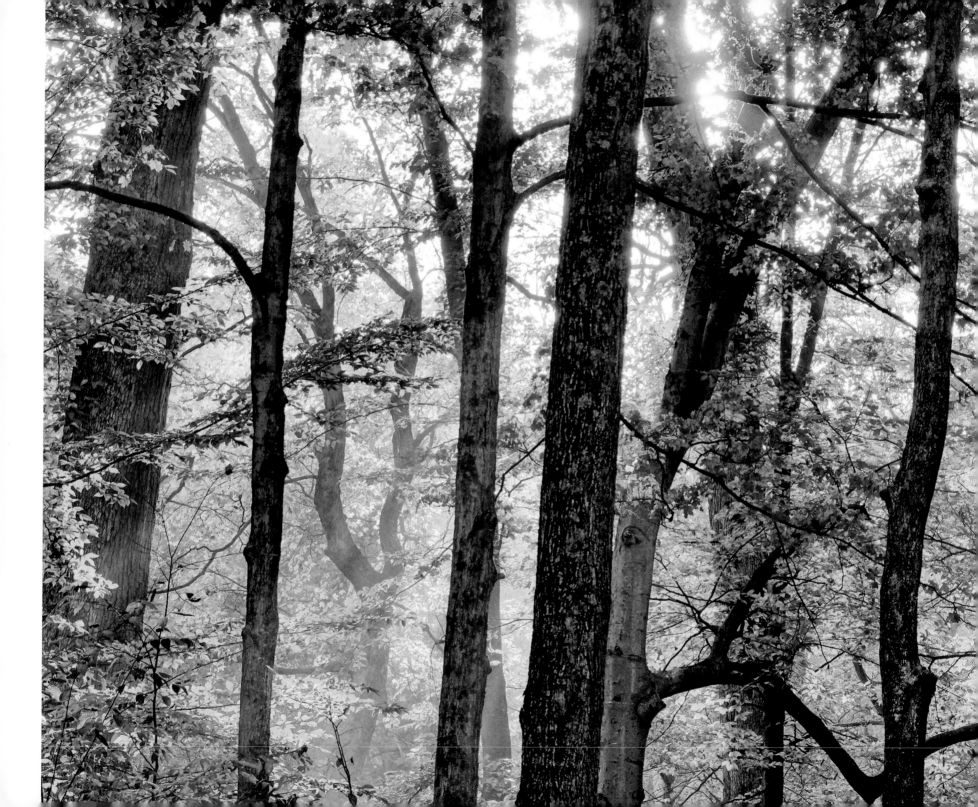

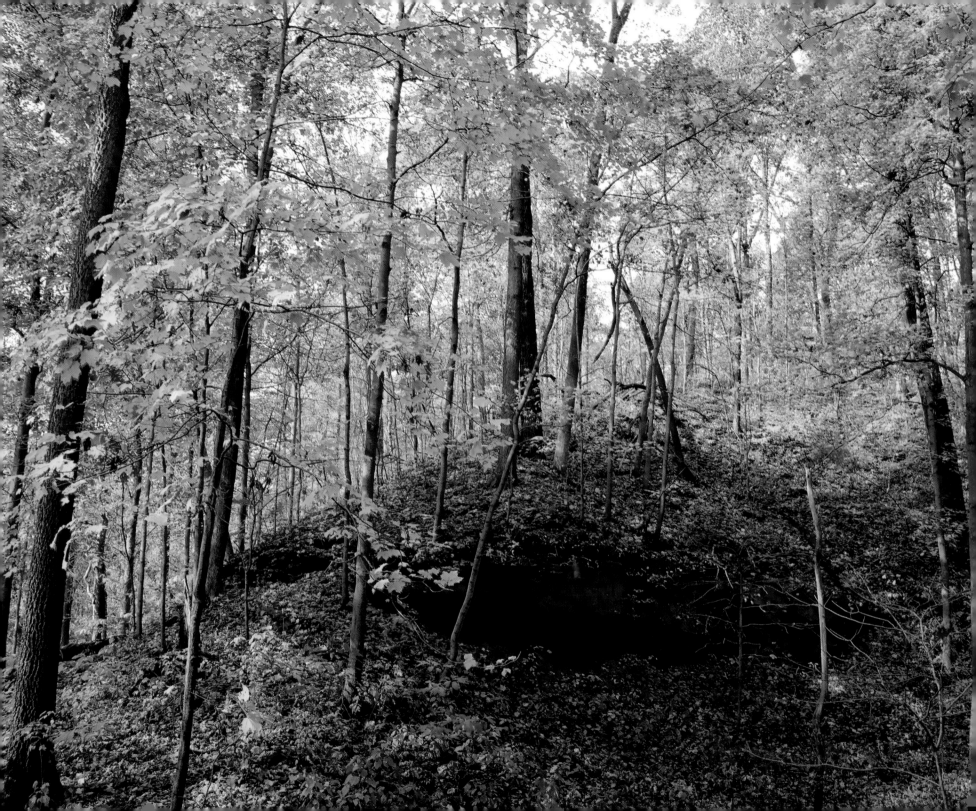

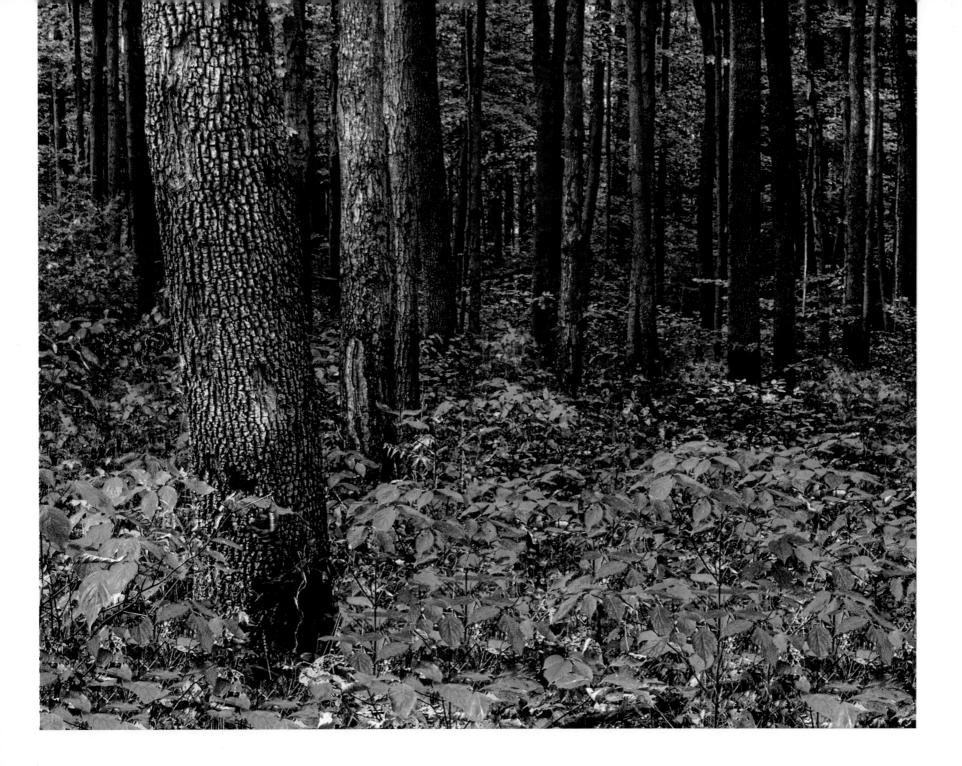

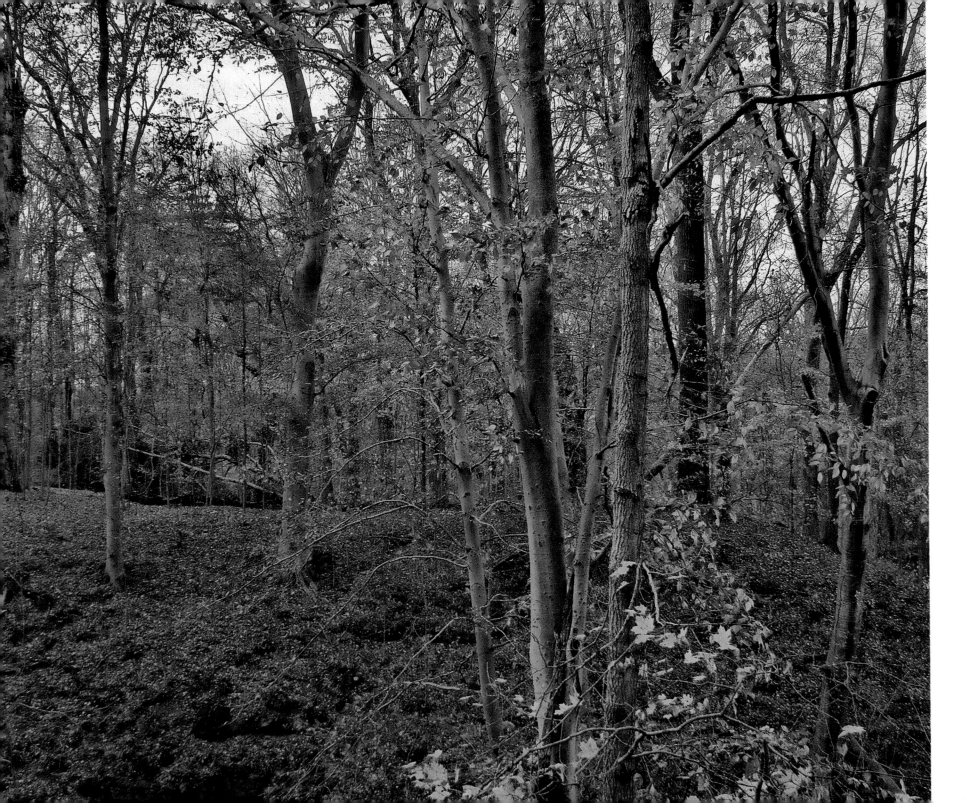

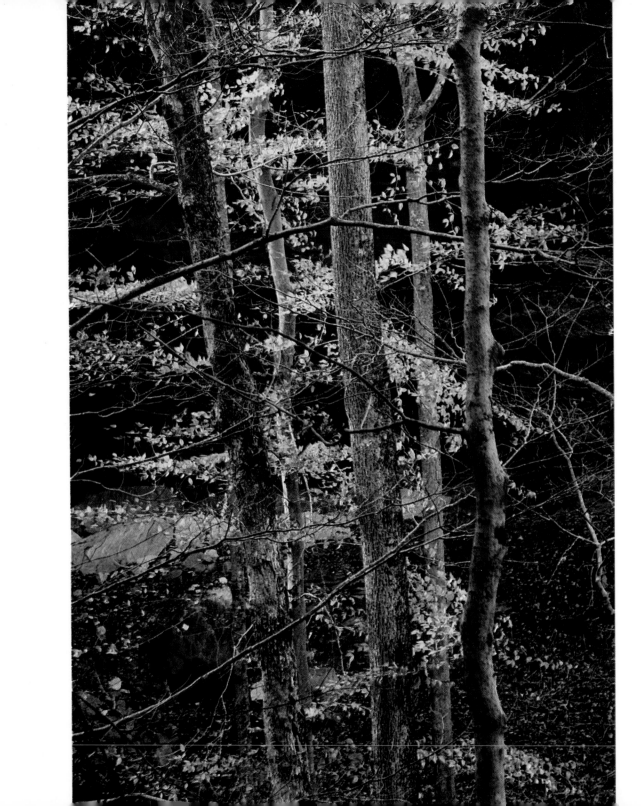

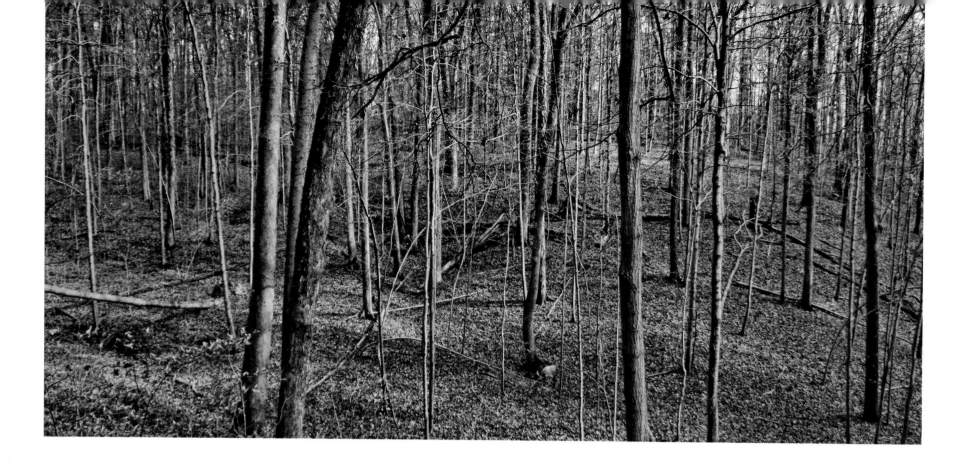

The tilt of the earth as it orbits the sun changes the intensity of the sun's energy that reaches the forest. The days become shorter and colder, and rain turns to snow. Turkey Run changes from a landscape of vibrant color to one of grays and whites. Dormant trees, void of leaves, stand tall and naked. At first glance, the forest seems lifeless, motionless, and barren, but a closer look reveals movement. Squirrels scurry about; birds flutter from tree to tree; and deer roam as they search for food, water, and shelter.

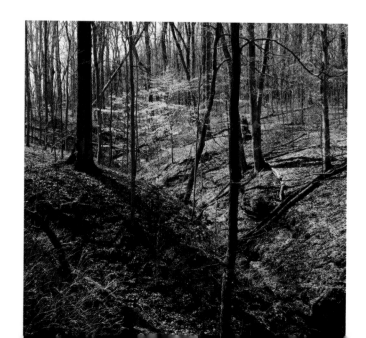

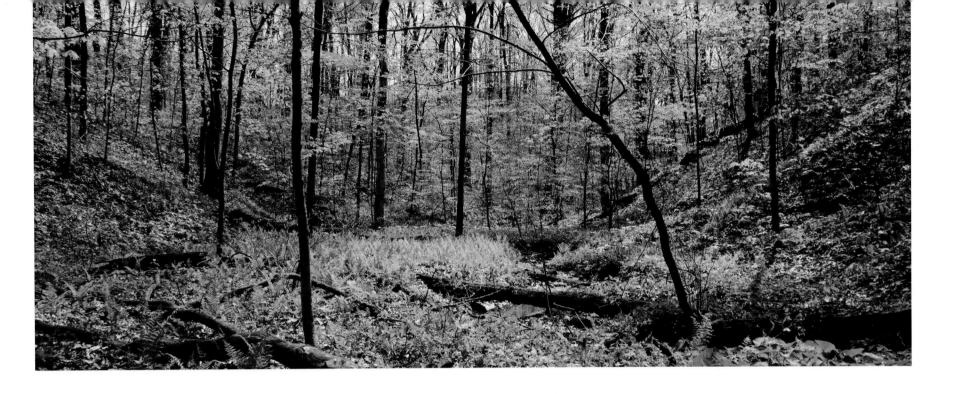

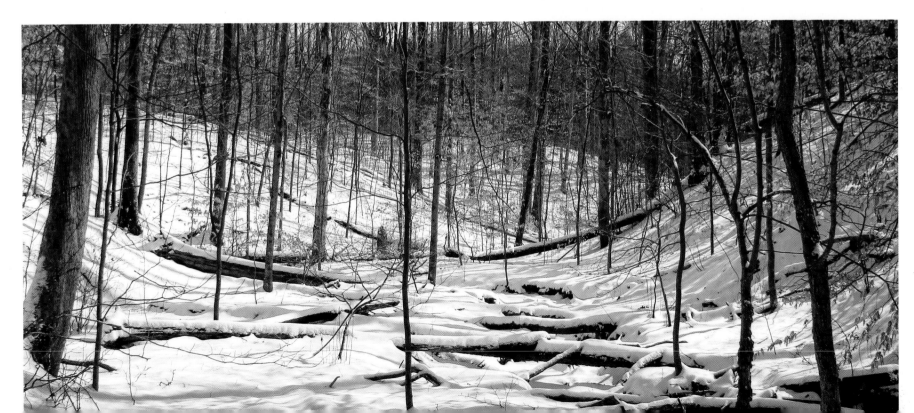

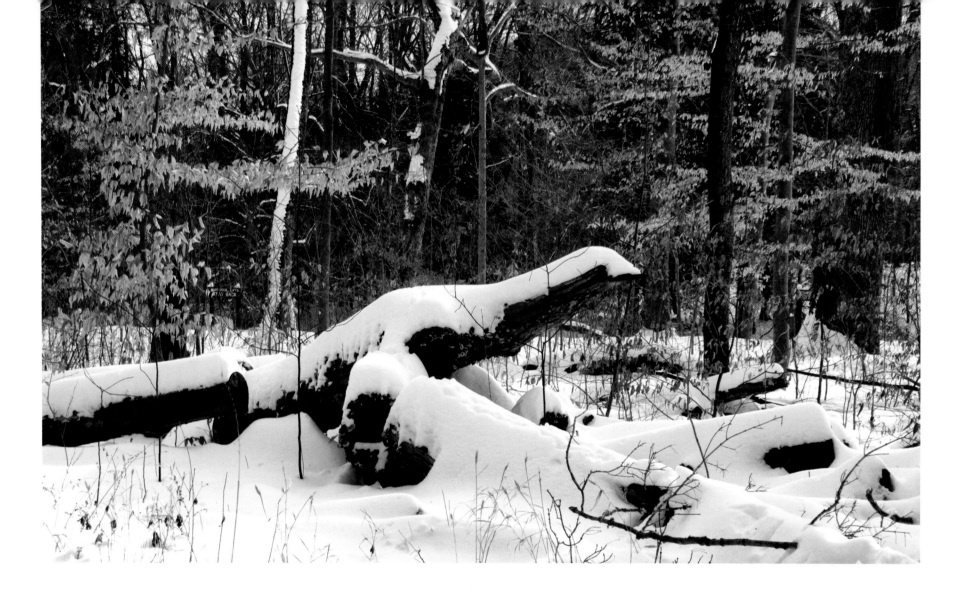

Because snow cover insulates the forest floor, the mice, voles, and other small mammals of Turkey Run remain active, feeding on plants and moving about under the blanket of snow. In winter, reptiles, amphibians, and insects take shelter in decaying logs and hollow trees, where they remain dormant until spring warms the air. Many insects reproduce and lay their eggs as fall approaches, and then die in winter. Other animals migrate to escape the bitter cold; for example, insect-eating birds, like warblers, move southward as the temperature drops. Seed-eating birds, like cedar waxwings and blue jays, remain, seeking out seeds while woodpeckers and nuthatches work trees, snags, and logs, feeding on insects.

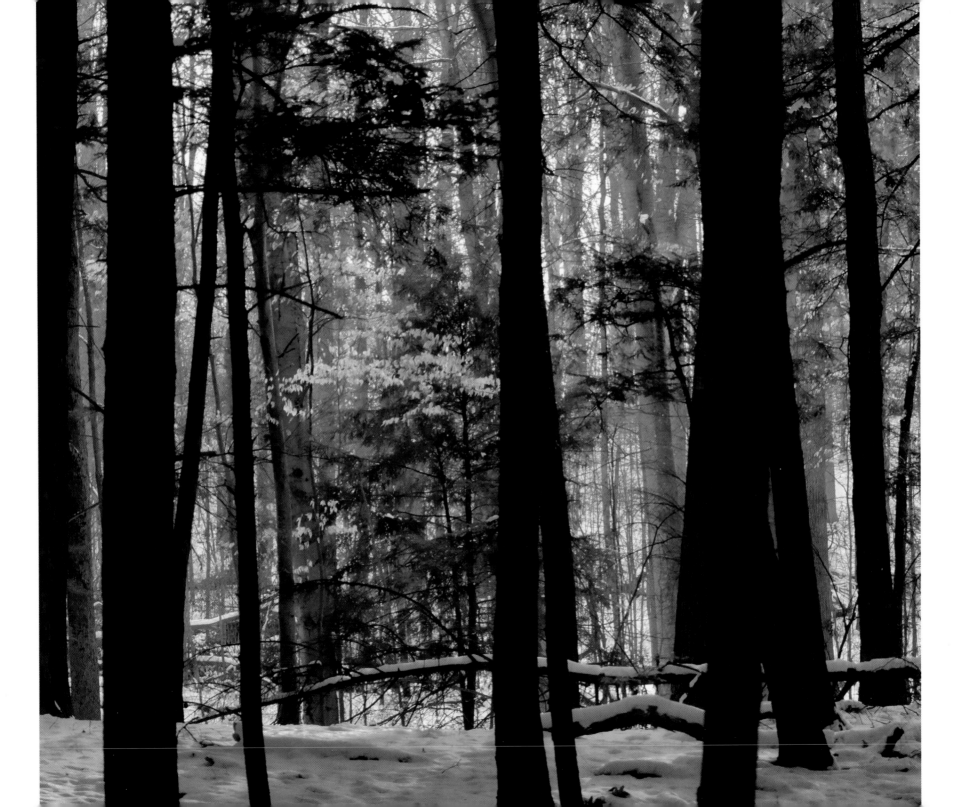

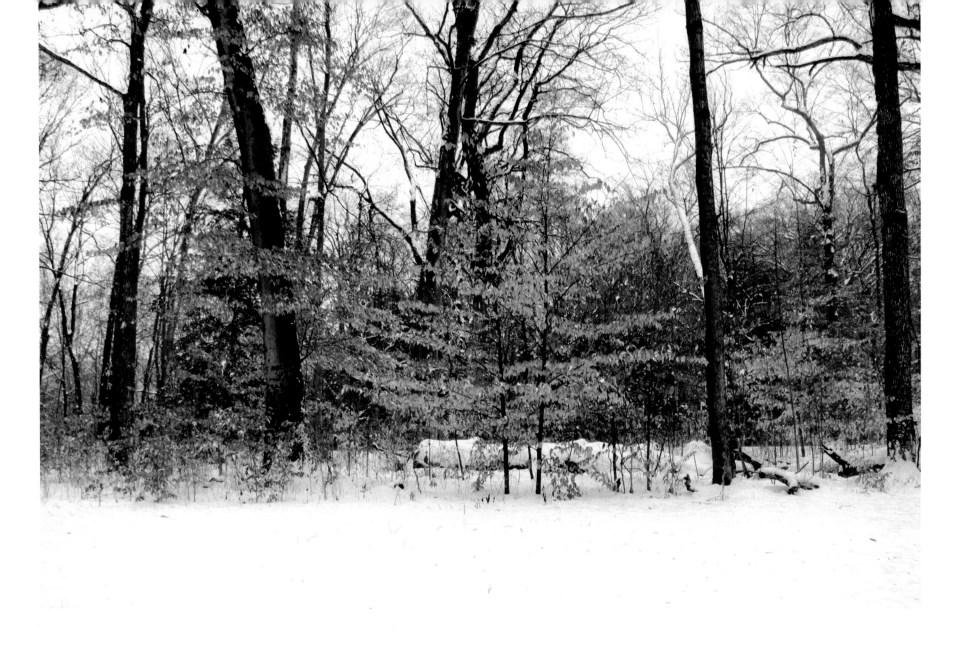

Turkey Run in winter is a place of solitude. You encounter few humans on the trails. The snow-draped forest creates a calm and quiet sense of place. The American beech trees (*Fagus grandifolia*) hold their copper-toned leaves that glow when the sun's rays strike them.

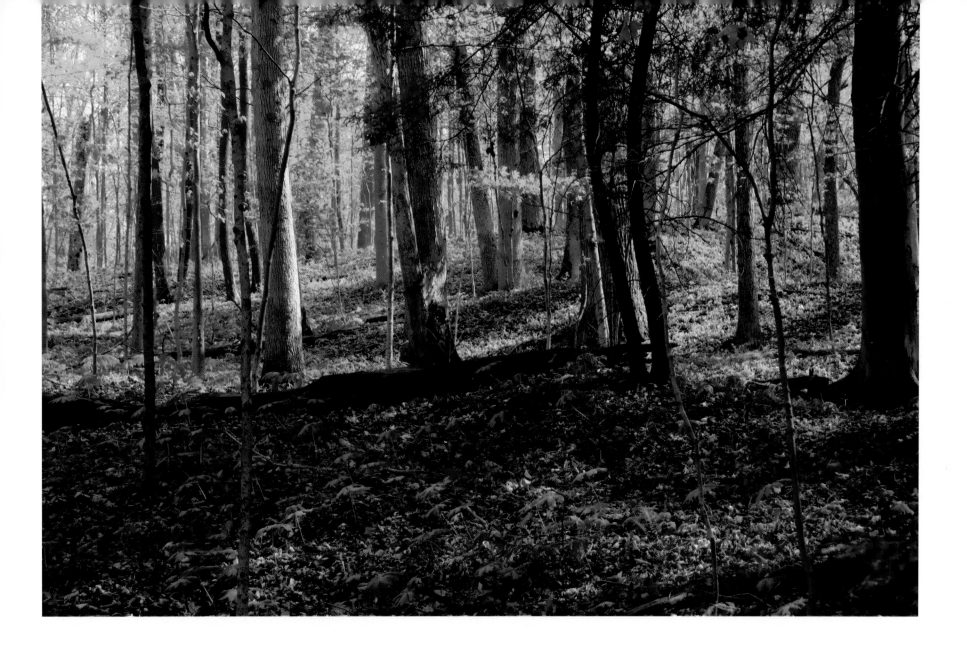

Slowly but surely, winter fades in Turkey Run, on cue as the earth completes its orbit. The days lengthen and warm, and the forest transitions to the blossoms of spring and warmer days ahead. Cycles of life and earth link as one. Here, mayapples emerge as the soil warms, and the forest glows yellow-green as light passes through the new, young leaves of the tall trees.

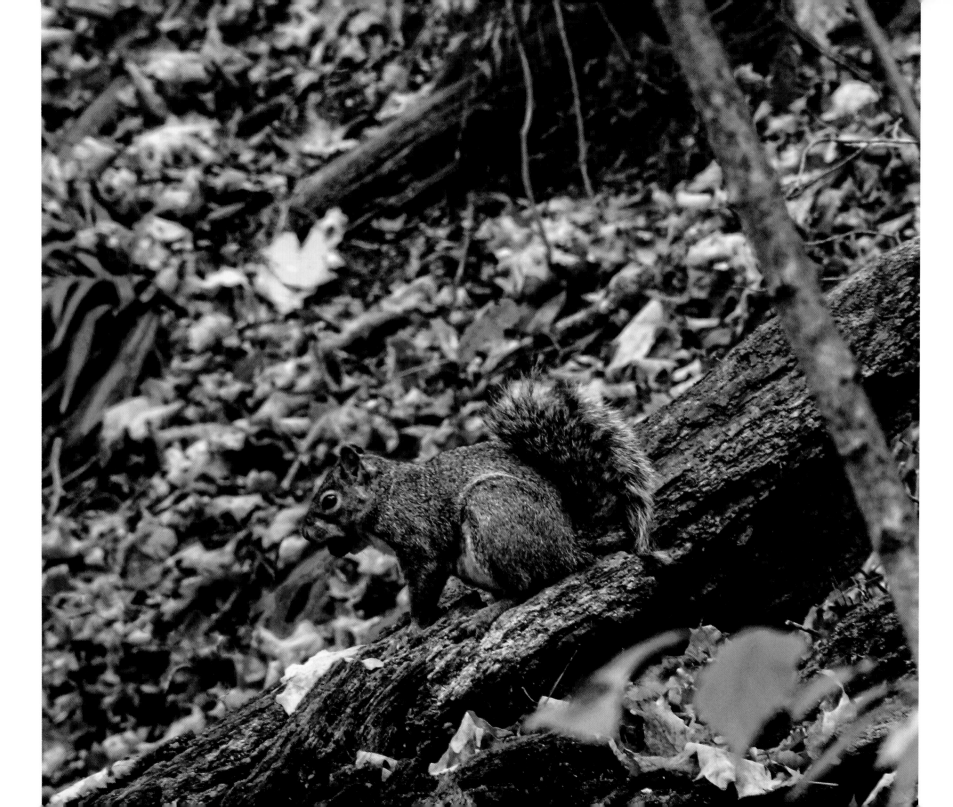

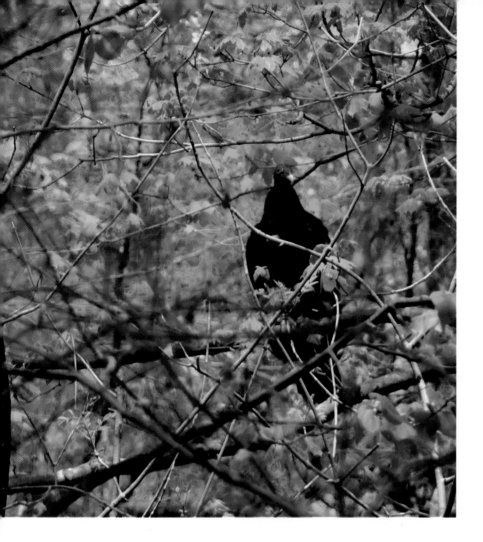

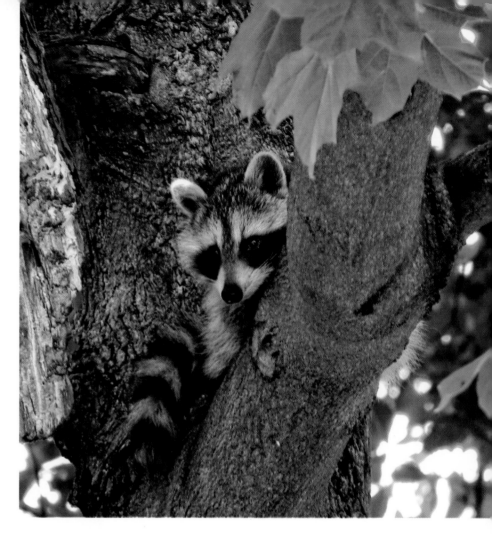

Without the tall trees of Turkey Run, many birds and mammals would not have a place to live. The trees provide fruits and seeds as well as shelter. Along with chipmunks, gray squirrels thrash about the forest floor in search of acorns that they store as a food source for the winter. A wily raccoon may prowl the banks of Sugar Creek, waddle along the forest floor, or pause in the branches of a tree. Raccoons eat almost anything: nuts, berries, bird eggs, insects, and even crayfish. They do not hibernate, but den-up for long periods of time during winter. You may have seen turkey vultures soaring overhead, but if you look closely, you might catch a glimpse of them roosting in the tall trees. They sail in the sky for hours, holding their wings outright in order to catch the thermal updrafts (pockets of hot air) as they scour the landscape for carrion. Because of this, the turkey vultures come and go with the seasons.

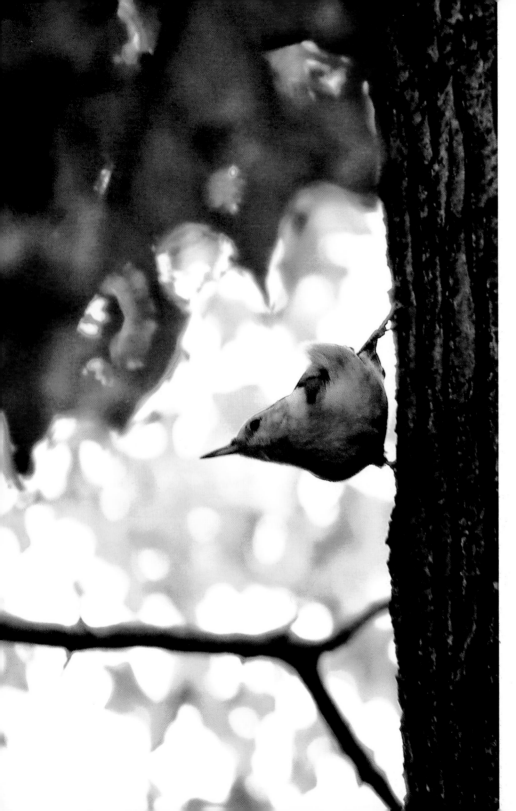

The white-breasted nuthatch (*Sitta carolinensis*) is unique in that it is the only bird that habitually climbs down tree trunks headfirst. As it moves down the trunk of the tree, it uses its slender beak to probe the crevices and bark, feeding on insects and insect eggs. The nuthatch also eats seeds and nuts. It wedges the seeds and nuts into the bark crevices and then chops them into pieces with its beak, feeding on the pieces.

The Cooper's hawk (*Accipiter cooperii*), while present year-round in the park, is more easily seen in the fall. It perches on tree branches in search of unwary birds and small mammals.

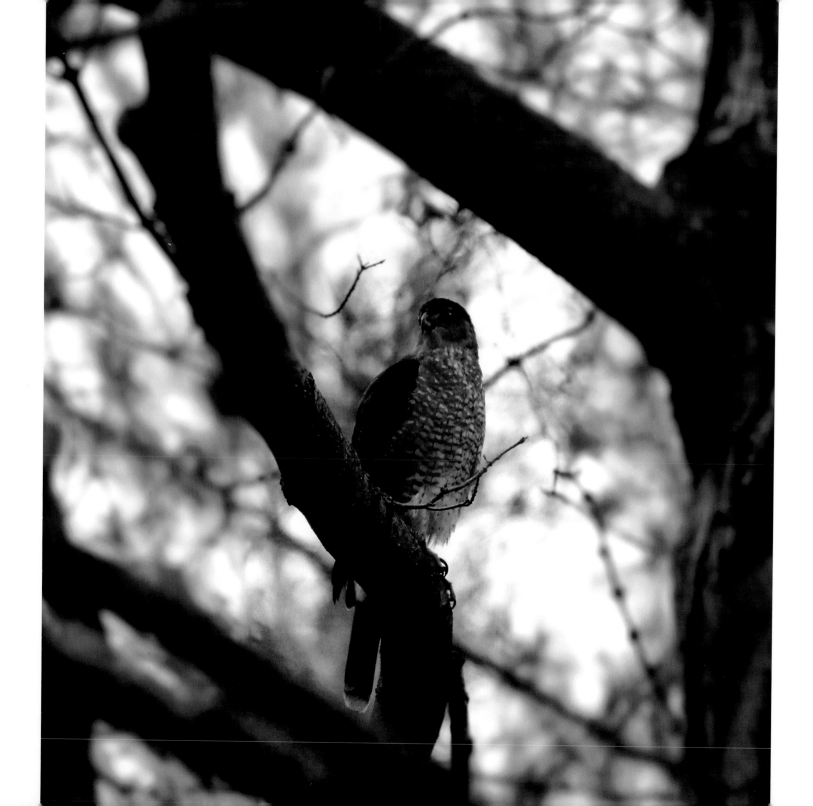

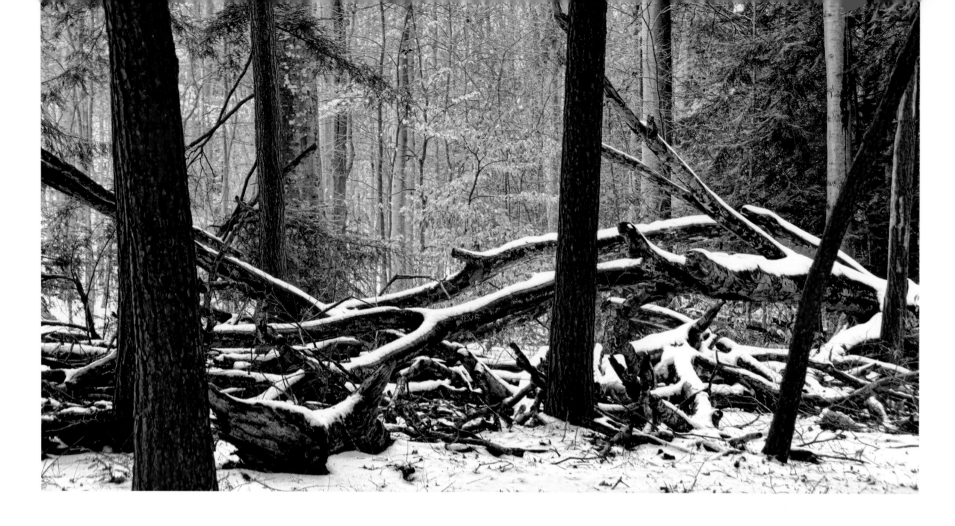

The trees in Turkey Run struggle to survive, defending themselves from drought, lightning, wind, insects, disease, and humans who carve their bark, all of which may damage and kill a tree. An American beech tree is toppled by the wind and dusted with snow, and an eastern hemlock is weakened by a lightning strike, eventually falling to the ground.

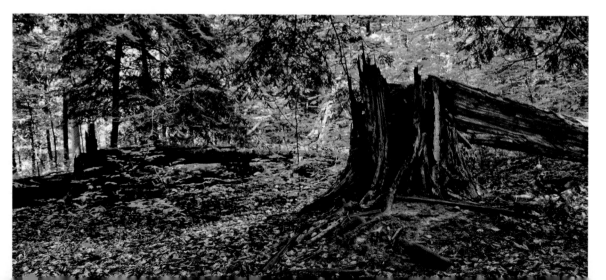

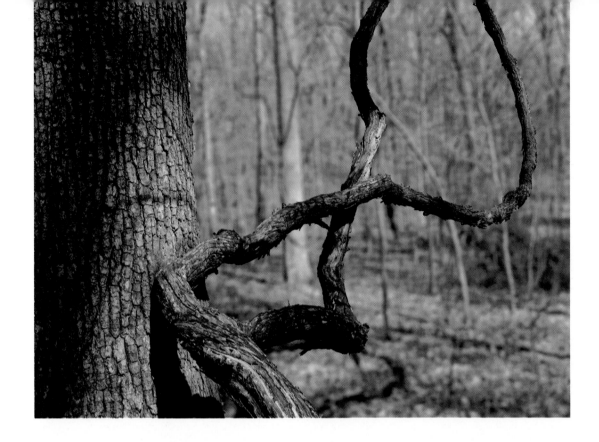

Forest grapevines (top left image) may live to be over a hundred years old, climbing high into the treetops. Tendrils from the stem hold the vine to the tree. Grapevines and poison ivy (top right image) may damage or even kill trees if they become weighed down by snow and ice. The vines may also prevent sunlight from reaching the tree's leaves. The berries, however, are an important food source for birds and small mammals that live in the forest. Insects and their larva feed on the leaves of trees. Some chew on the leaf edges and others mine tunnels in the leaf, damaging and even killing it (bottom image).

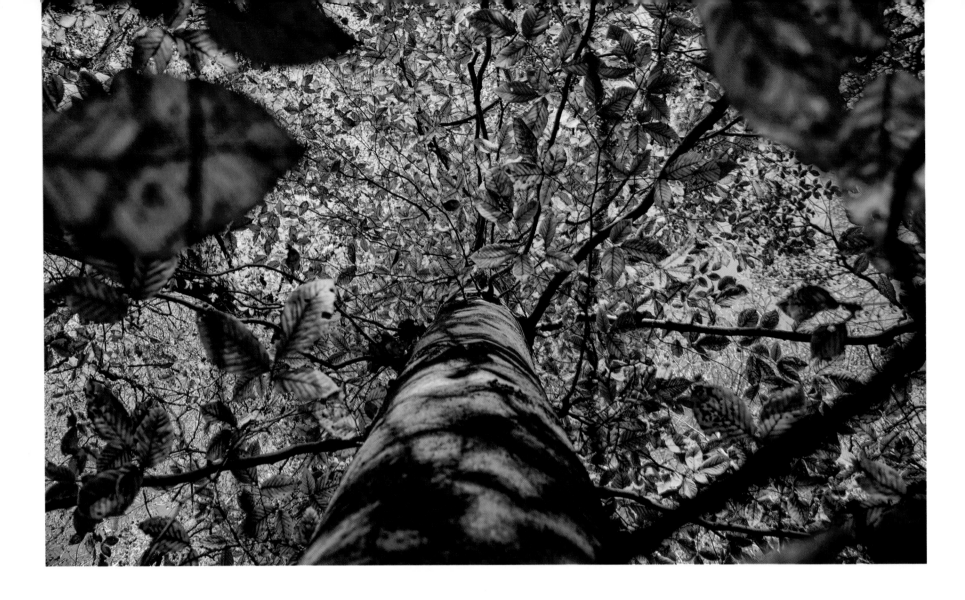

Stand at the base of a tall tree and look upward. The trunk twists and turns toward the sun. Trees, branches, and leaves compete for sunlight. In fall, the sun's light may give the leaves a glow. In early spring, as shown in the image on the facing page, the tall trees stand naked, barren of leaves, as if exposed to the elements. I often wonder what it would be like to stand at the top of the tall trees and look downward. Although difficult to see in the image on the facing page, a flock of sandhill cranes passes overhead on their annual migration northward.

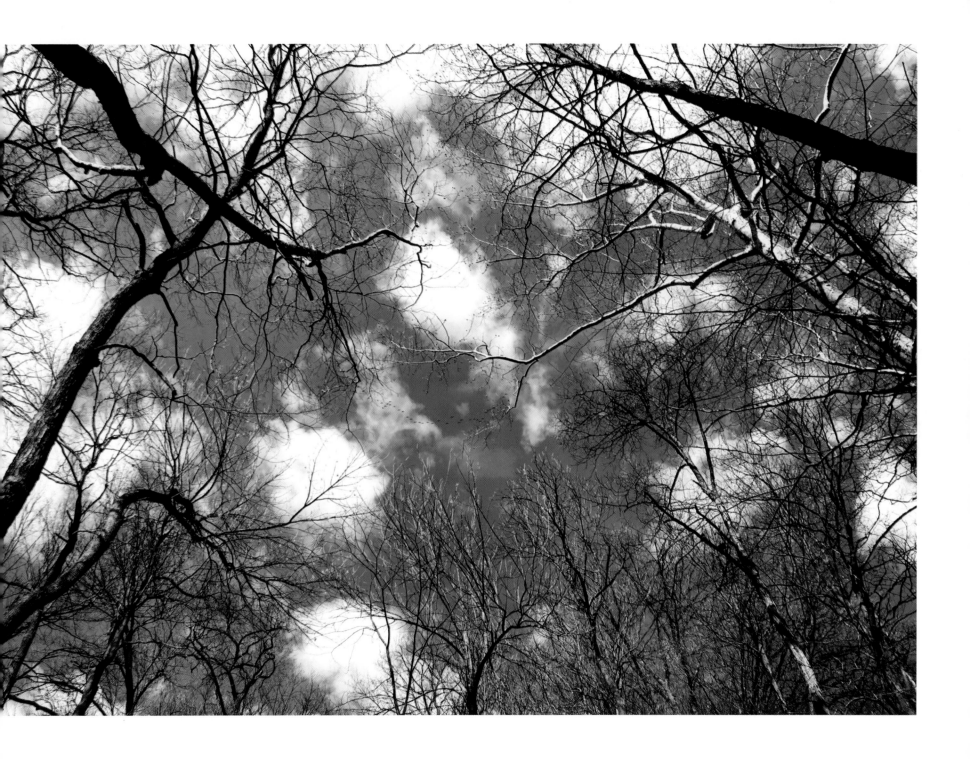

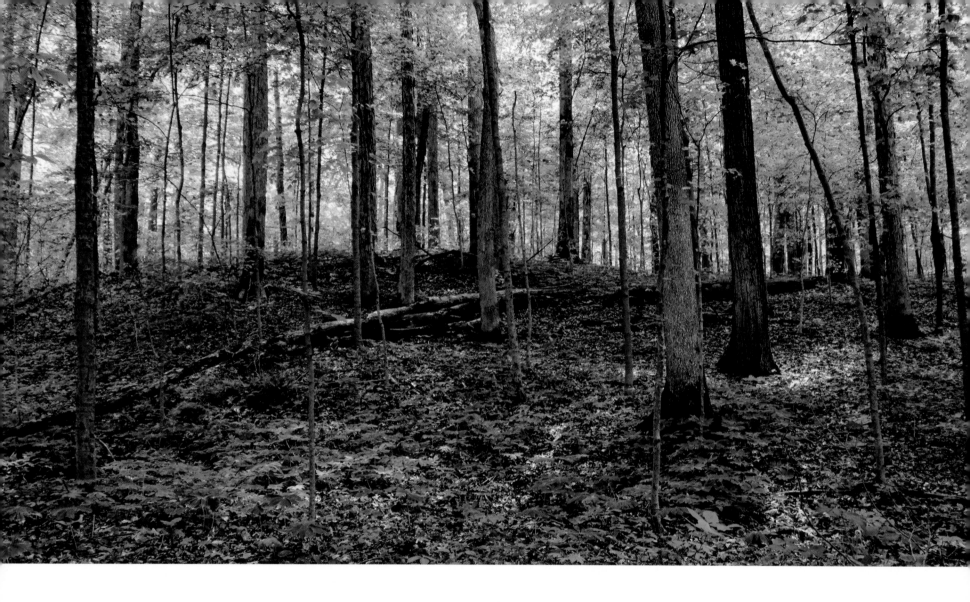

The images of the tall trees in this chapter reflect today's park as shaped by the past, but what does the future hold? The Wisconsinan glacier deposited the fertile glacial soils that support the park's forest. This glacial till is most evident in the rolling terrain seen in the northern part of the park (image above). Humans, too, have affected the forest of Turkey Run. Much of the forest today is second growth, or the regrowth of forest after the land had been cleared by early European settlers. In fact, European settlers cleared 95 percent of the original deciduous forest in the US. Humans have also introduced invasive species that outcompete the native trees and plants of the park. Invasive insects like the emerald ash borer will eventually kill the ash trees of Turkey Run.

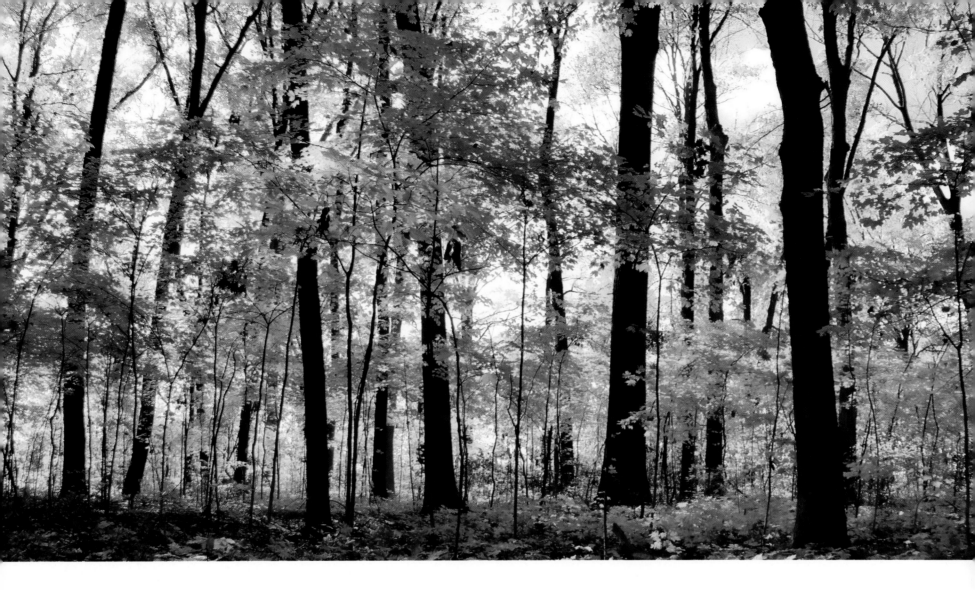

Humans are changing the earth's climate through the burning of fossil fuels. This emits carbon dioxide and other greenhouse gases into the atmosphere. The increase in the atmospheric concentration of greenhouse gases causes global warming and climate change. As a result, models predict that our forests will change in the future. For Turkey Run, this means the disappearance of the sugar maples (*Acer saccharum*) and American beech trees with their yellow fall glow.

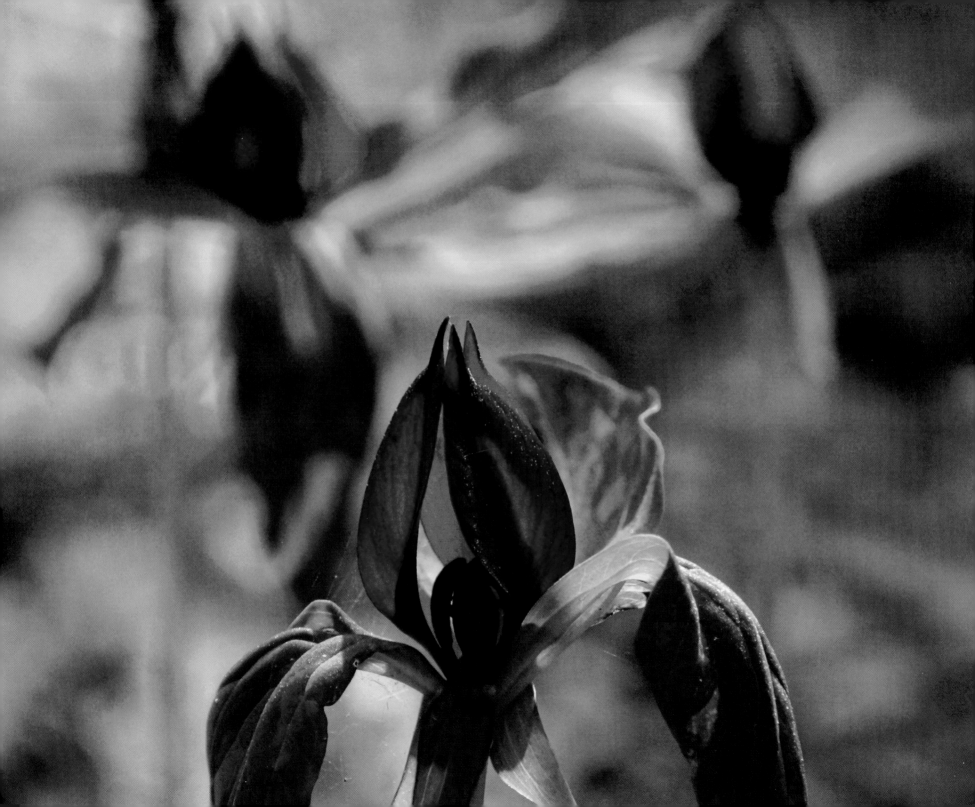

CHAPTER 6

Flowers, Ferns, and Fungi

The most biologically diverse area in Turkey Run is the forest floor, consisting of many different herbs (flowers), ferns, and fungi (mushrooms and toadstools). This diversity is perhaps most evident with the emergence of the woodland wildflowers in spring. This spring bloom is equal to the spring bloom of alpine flowers and the summer bloom of prairie forbs. It is triggered by the sun's energy as it reaches the forest floor to warm the soil and stimulate the growth of the spring beauties. This window of growth, however, is short-lived. As the leaves of the tall trees unfold, they block more and more of the sun's rays. This, in turn, prevents the sun's light from reaching the spring wildflowers; as a result, they slowly fade away, completing their life cycle in several weeks. By summer, the thickening forest canopy completely obscures the forest floor. Once covered in colorful displays of spring wildflowers, the forest floor now supports the growth of green shrubs and summer herbs that require less light and display less conspicuous flowers. Other nonflowering plants, ferns, and fungi also make their presence known.

Ferns are a diverse group of nonflowering plants capable of growing in a variety of areas within the park, but moist and shady locations are preferable. They can grow on rock ledges as well as on tree stumps and in the shade of tall trees. They often go unnoticed and fail to grab our attention, like the spring wildflowers. Yet, their graceful and delicate form and texture signal their presence. Like other vascular plants (flowers and trees), ferns have stems, leaves, and roots (rhizomes), but no flowers or seeds. Instead, ferns reproduce via spores; some produce spores on the underside of their leaves while others produce separate, spore-bearing leaves.

The forest floor in Turkey Run is covered by detritus or decomposing leaves, branches, bark, and dead animals that support large numbers of fungi, often called mushrooms and toadstools. The fungi help decompose the litter, adding nutrients to the soil that support the growth of the forest plants. Fungi may be found in all kinds of unusual and bizarre shapes, sizes, and colors. They seem to magically emerge from nowhere, often after a warm spring or summer rain. The main part of the fungus, the mycelium, is found underground. The weblike mycelium functions much like the roots, stems, and leaves of flowering plants. Fungi lack chlorophyll, so they cannot make their own food. Thus, the mycelium must absorb water and nutrients from the soil or dead plant and animal matter. Walk anywhere in the forest and you are likely to find fungi. Fungi can grow from soil, on dead tree trunks and branches, and from fallen logs. Lift up the fallen leaves and you may be surprised by what you will see.

Our journey through the flowers, ferns, and fungi of Turkey Run begins with the woodland wildflowers, followed by the ferns, and concluding with the fungi. The journey will only touch upon a few of the many flowers, ferns, and fungi of the park.

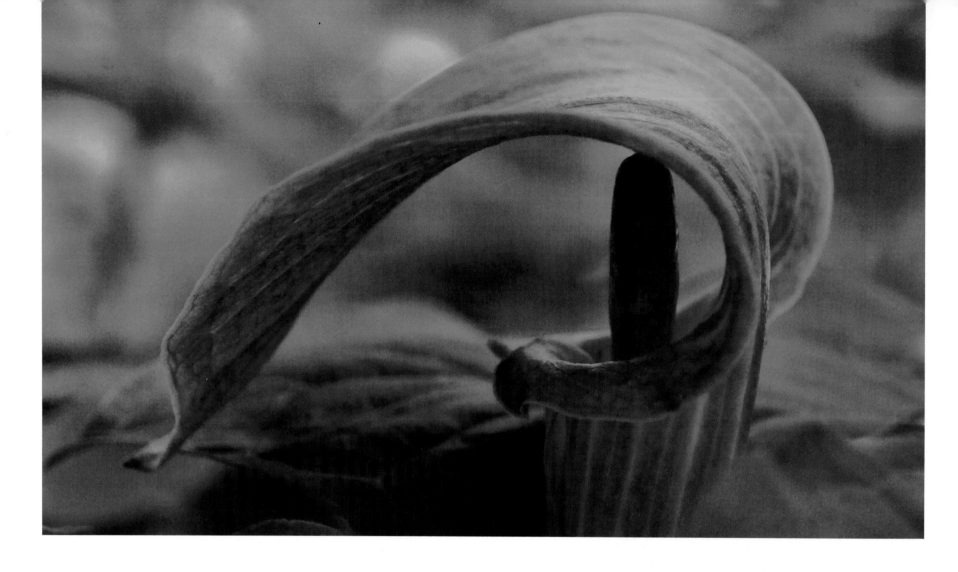

The presence of jack-in-the-pulpit (*Arisaema triphyllum*) indicates a damp woods or moist environment. The jack-in-the-pulpit is a member of the arum family, a group of herbs with fleshy, club-shaped spikes (the spadix) surrounded by a showy, curved bract or "pulpit" (spathe) beneath one or two large, long-stalked leaves. The spathe (flower) is green or purple in color, fading to yellow; a cluster of shiny red berries develops by summertime. The berries provide a food source for the park's wildlife.

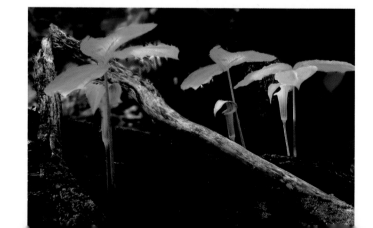

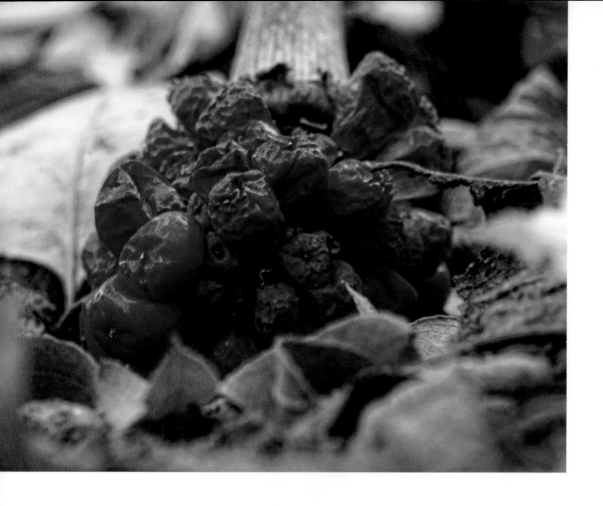

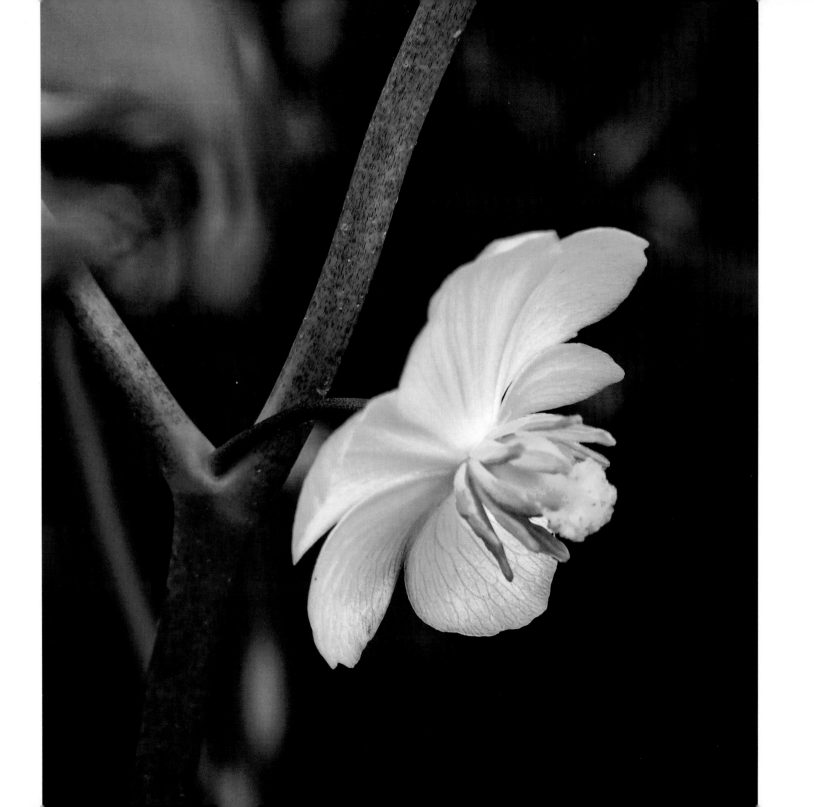

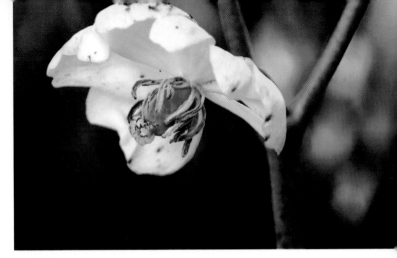

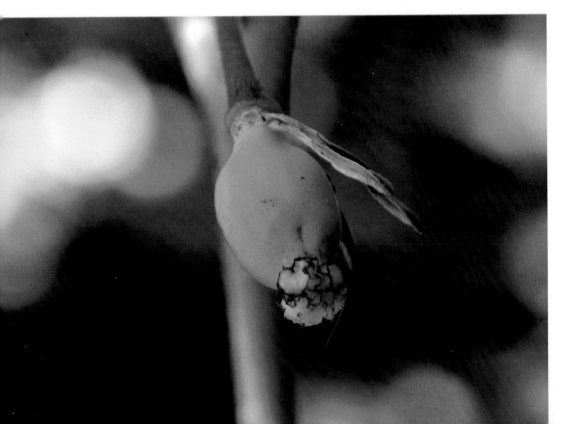

The mayapple (*Podophyllum peltatum*) is a large herbaceous plant found in rich woods and damp shady clearings. Mayapples produce a solitary, white nodding flower between a pair of large and deeply lobed leaves. Single-leafed plants do not produce a flower or a fruit. The name "mayapple" comes from the typical May-blooming time of the plant. Bees are the chief pollinators. As the flowers age, they bear fruit.

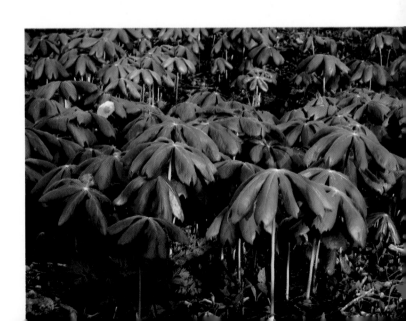

Three is the key number for trillium: three leaves, three green sepals, three colored petals, a three-chambered pistil, and three stigmas. In fact, "trillium" is Latin for "three parts." Two types of trillium found in Turkey Run are the red toadshade (*Trillium sessile*) and the white drooping trillium (*Trillium flexipes*).

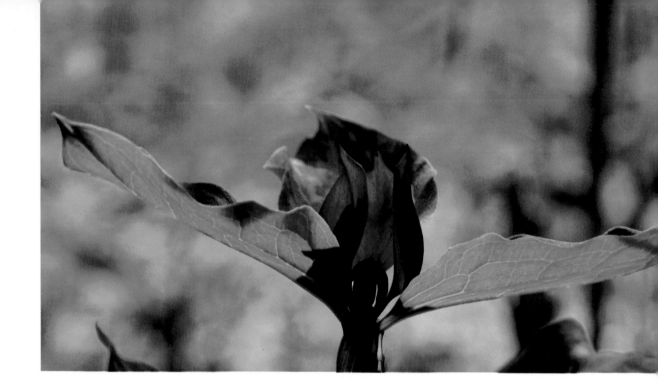

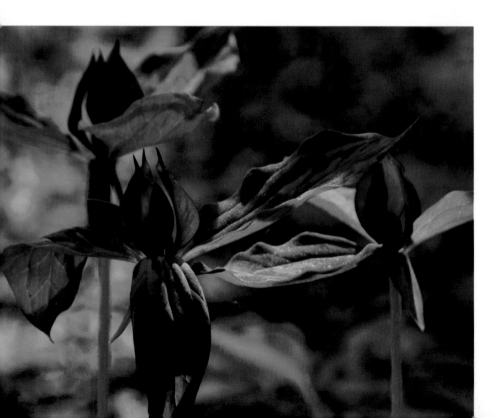

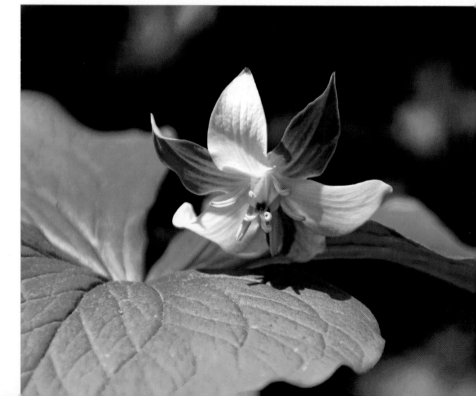

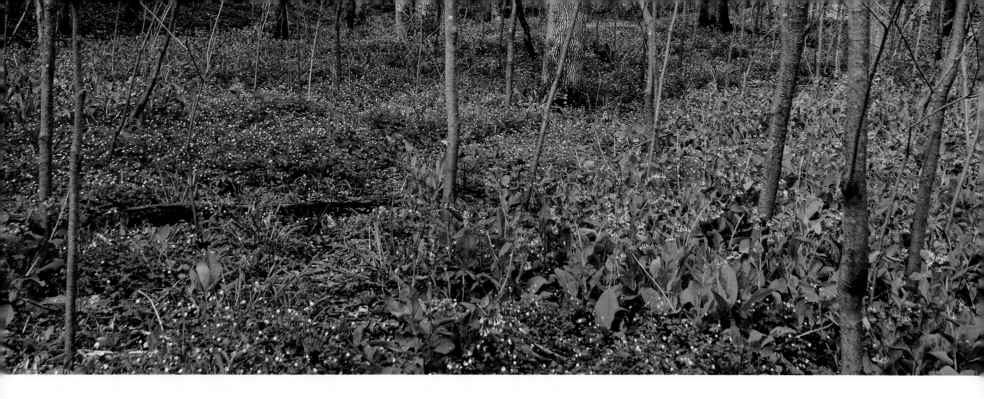

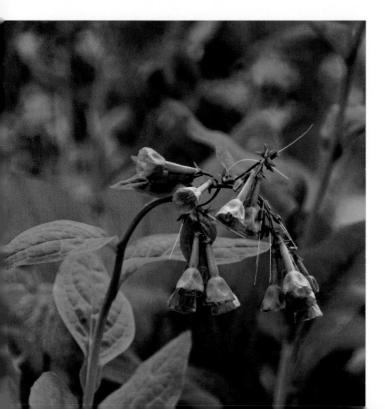

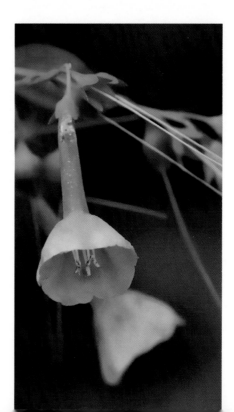

If you hike the bottomlands and flood-plains of Turkey Run in spring, you are likely to see Virginia bluebells (*Mertensia virginica*). Virginia bluebells prefer moist woods—in other words, wet soils. Rarely found in meadows, they are easily identi-fied by the cluster of nodding trumpet-like, blue flowers that are pink in color before blooming. Virginia bluebells often grow in masses, carpeting the forest floor, espe-cially along the Sugar Creek floodplain.

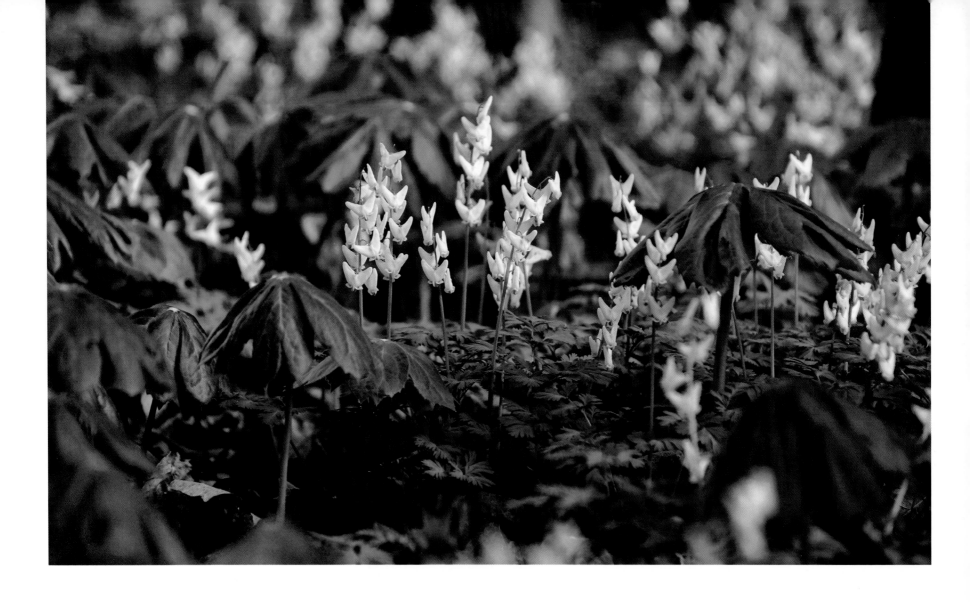

Dutchman's breeches (*Dicentra cucullaria*) are easily identified by their delicate, white, pantaloon-shaped flowers on a leafless, pink-colored stalk that protrudes above a mass of green and deeply divided leaflets. The yellow-tipped spurs add a touch of class to the flowers. An early bloomer and short-lived flower, it is pollinated by bumblebees and bees in general. You won't smell the flowers, for they are not fragrant. Dutchman's are found growing throughout the forest of Turkey Run. It presents a spectacular sight when growing in masses, carpeting the forest floor. Here, mayapples work their way up among the Dutchman's, unfolding like umbrellas at the beach. I was fortunate on one trip to the park to capture the early morning dew dripping from the flowers and leaflets (facing page).

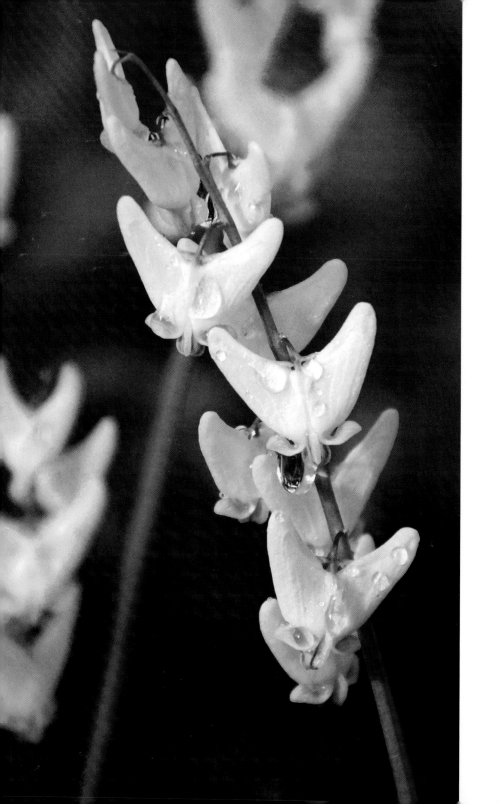
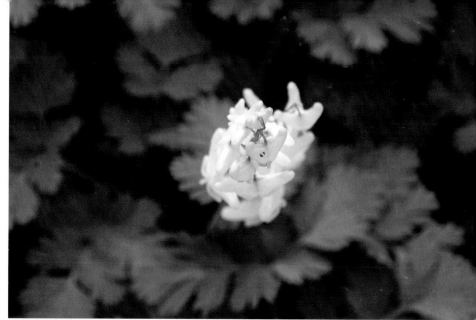
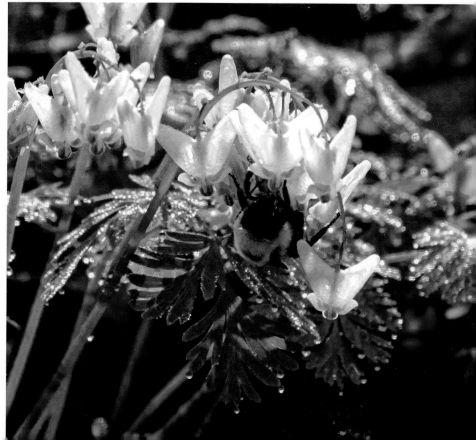

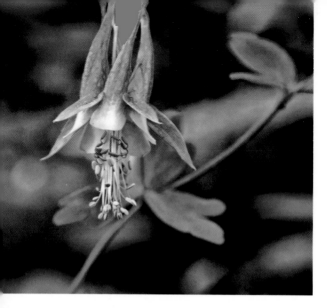

Look for wild columbine (*Aquilegia canadensis*) in the spring, growing on shaded sandstone ledges in the bluff and canyon areas of the park. The red and yellow nodding flower consists of five petals stretched backward to form a deep and slender spur. Nectar at the base of the spurs attracts hummingbirds and long-tongued moths, which serve as pollinators. The two perspectives here give us a sense of the structure and function of the columbine's flower.

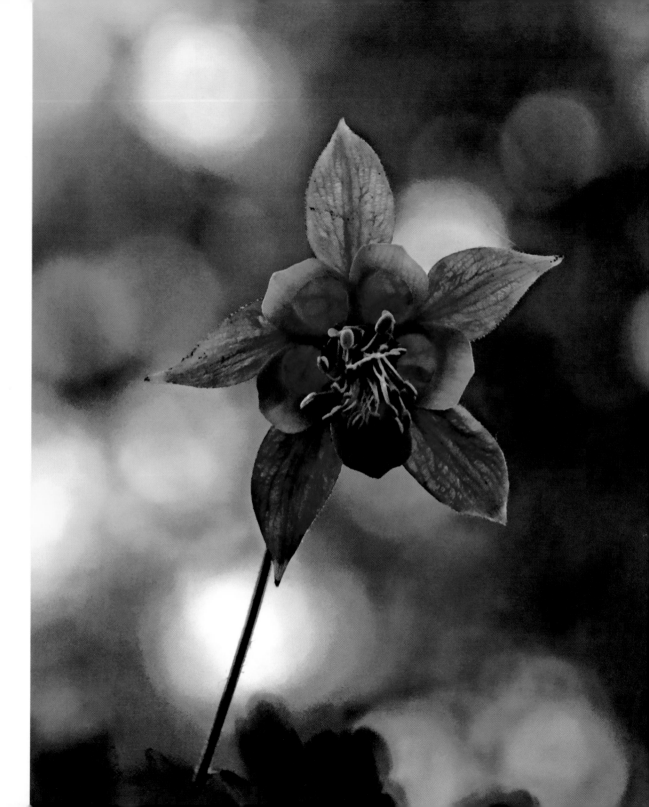

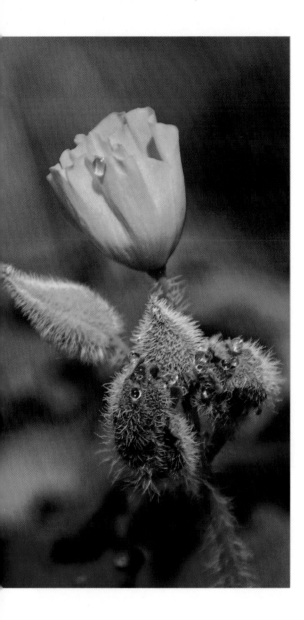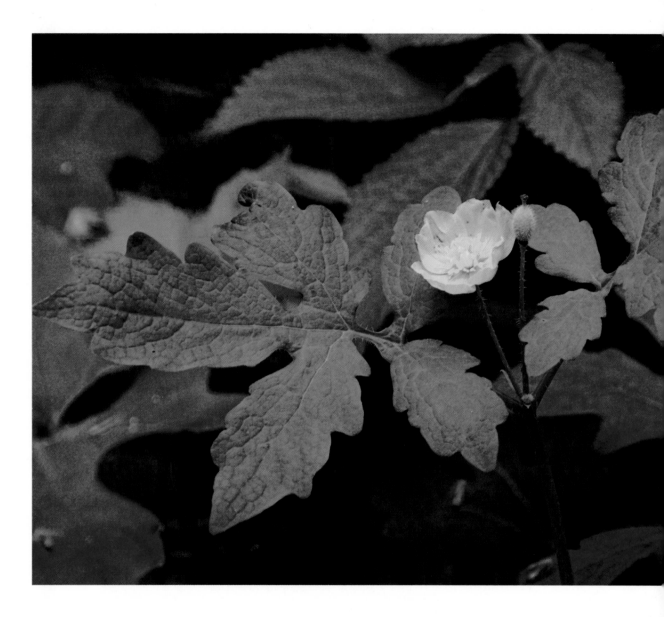

The yellow-flowered wood poppy (*Stylophorum diphyllum*) prefers moist, semi-shaded environments. In Turkey Run, look for them in the floodplains along streams and Sugar Creek, and in low-lying areas in the woods. In addition to its yellow flower, it produces yellow sap and has a hairy fruit. Like all poppies, its flower is short-lived.

Bloodroot (*Sanguinaria canadensis*) is a short-lived flower that displays a single eloquent, but fragile, white flower. The flower opens in full sunlight and closes at night. It has one large, lobed leaf that often curls around the flower stalk. They take up residence in moist areas in the woodlands, along floodplains and on slopes. Deer feed on the plant in early spring. Bloodroot is a member of the poppy family. Its name is derived from its red root sap. Native Americans used the root sap as a dye and as an insect repellent.

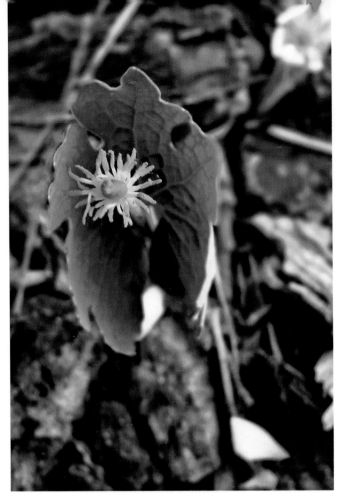

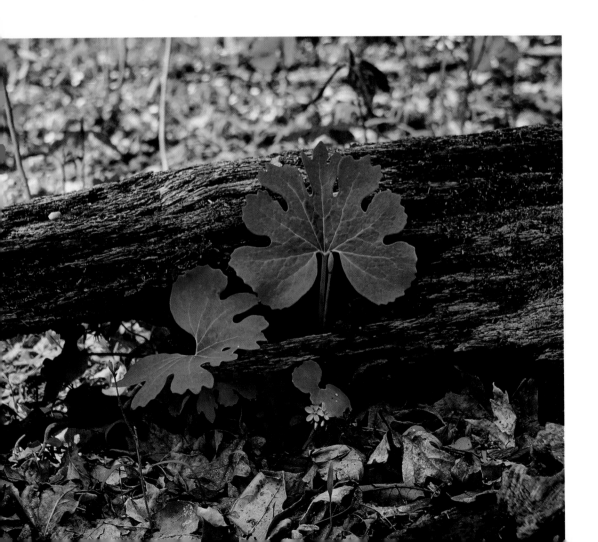

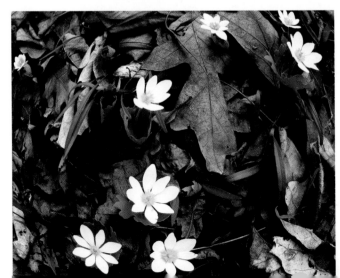

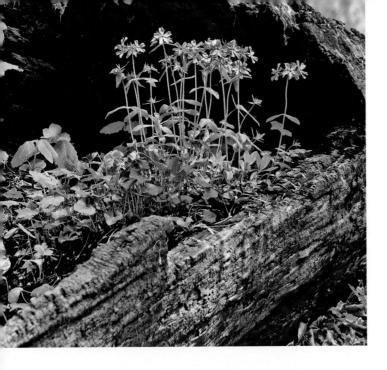

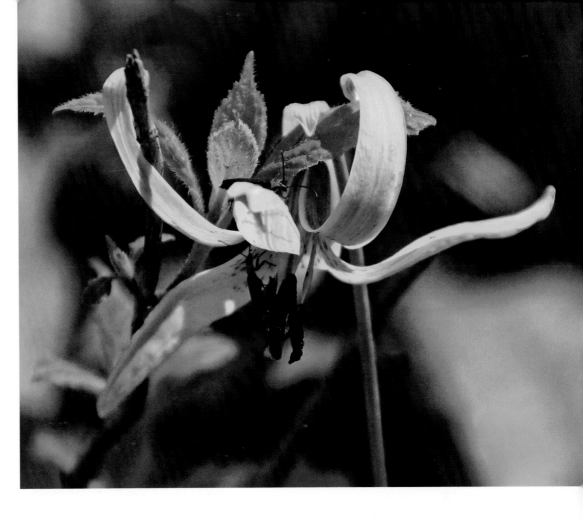

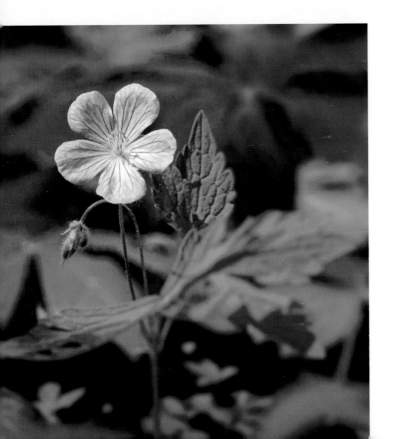

Wild blue phlox (*Phlox divaricata*) blooms in rich woods and is common to Turkey Run (top left image). Wild blue phlox is marked by its beautiful, dense cluster of light blue flowers atop leafy stems. The cluster of blue phlox growing in a log, along with violets (*Viola*), caught my attention. The wild geranium (*Geranium maculatum*) in the bottom left image is a leafy herb with showy flowers. The pink-to-white flowers cluster atop deeply toothed and lobed leaves. They provide an impressive display of color when found in patches on the forest floor. Trout lily (*Erythronium americanum*), with its stalked, yellow nodding flower, is a common spring bloomer (top right image). It is easily recognized by its two mottled leaves.

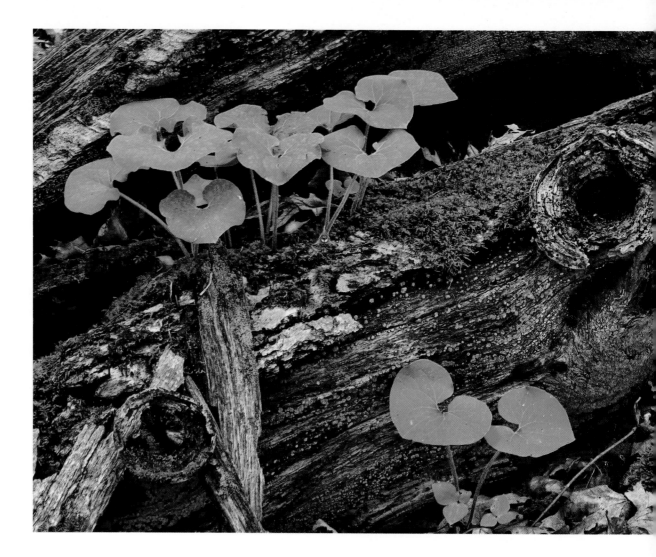

Wild ginger (*Asarum canadense*), with its distinctive large, hairy, heart-shaped leaves, often overshadows its ground level flower. Blooming from April to May, its flower has an odor of rotting meat that attracts flies as pollinators. Ants often carry away the seeds, distributing the plant to new locations. Wild ginger has an acrid taste that discourages plant eaters, like deer, from feeding on it.

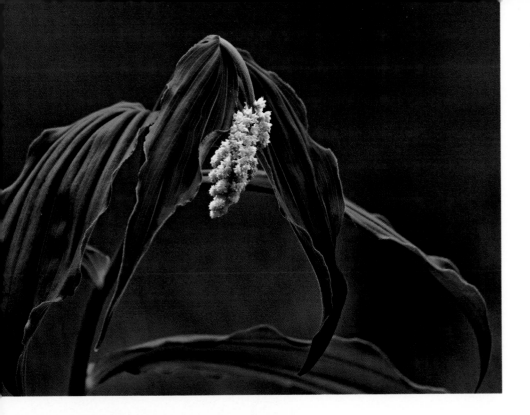

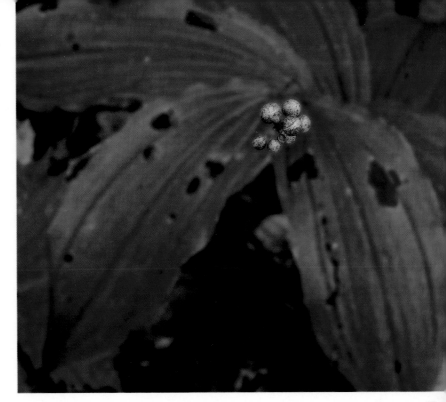

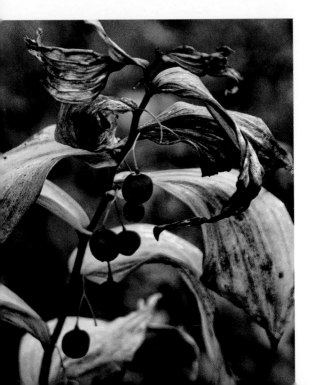

Though covered in colorful displays of spring wildflowers, the forest floor transforms to a green growth of shrubs and herbs in summer. False Solomon's seal (*Smilacina racemosa*), shown in the top images, and Solomon's seal (*Polygonatum biflorum*), shown in the lower image, spread their leaves to capture the diffuse and sparse sunlight, taking over where the spring beauties left off. Solomon's seal produces green-to-white, bell-shaped flowers that hang from its arching stem. The berries turn blue-black in fall. This distinguishes the plant from false Solomon's seal, which produces a mass of creamy white flowers at the tip of the stem. The berries, initially green, become speckled with red, and eventually turn bright red. Both plants may grow to over three feet tall and are found throughout the forest.

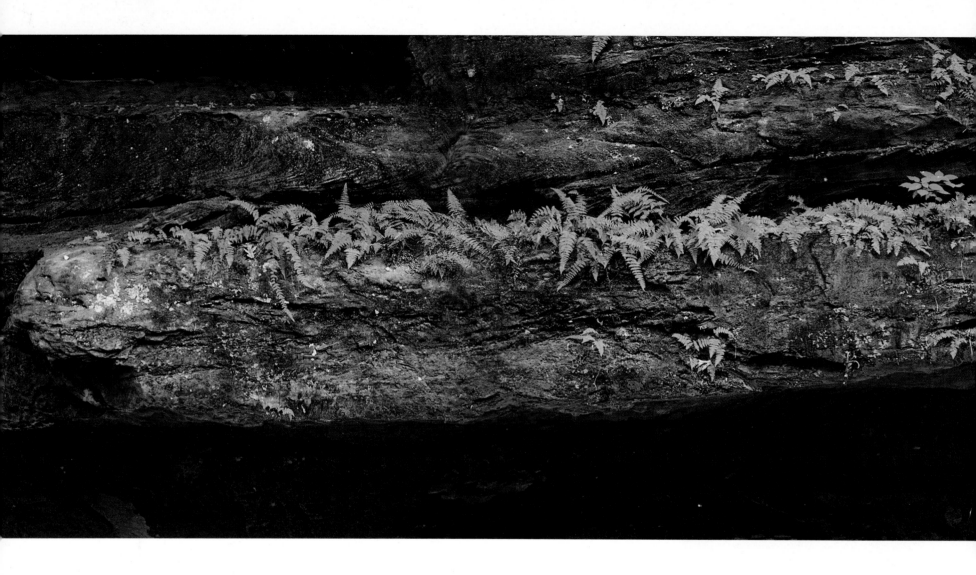

Ferns are known as simple plants because they produce spores instead of flowers and seeds. These plants grow throughout Turkey Run and are as common on the forest floor as they are on the rocky ledges that provide the shade and moisture they need to grow. Ferns often grow in those marginal areas where flowering plants struggle to survive. I always look to photograph ferns in their unique environments—sandstone ledges and fallen logs—found throughout the park.

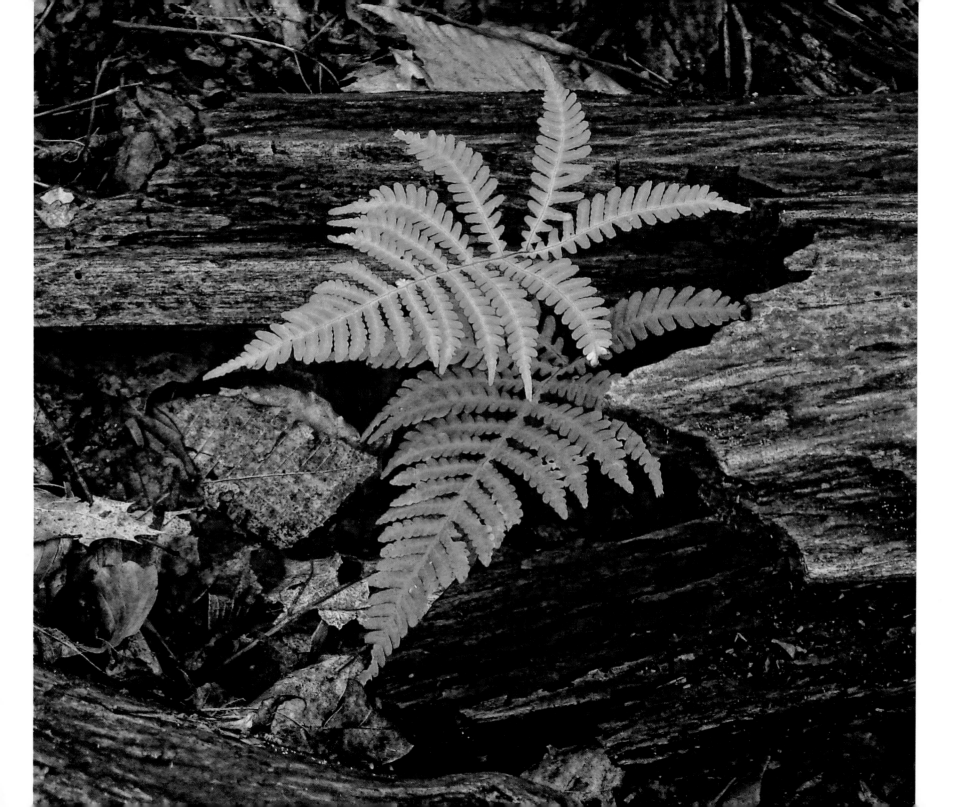

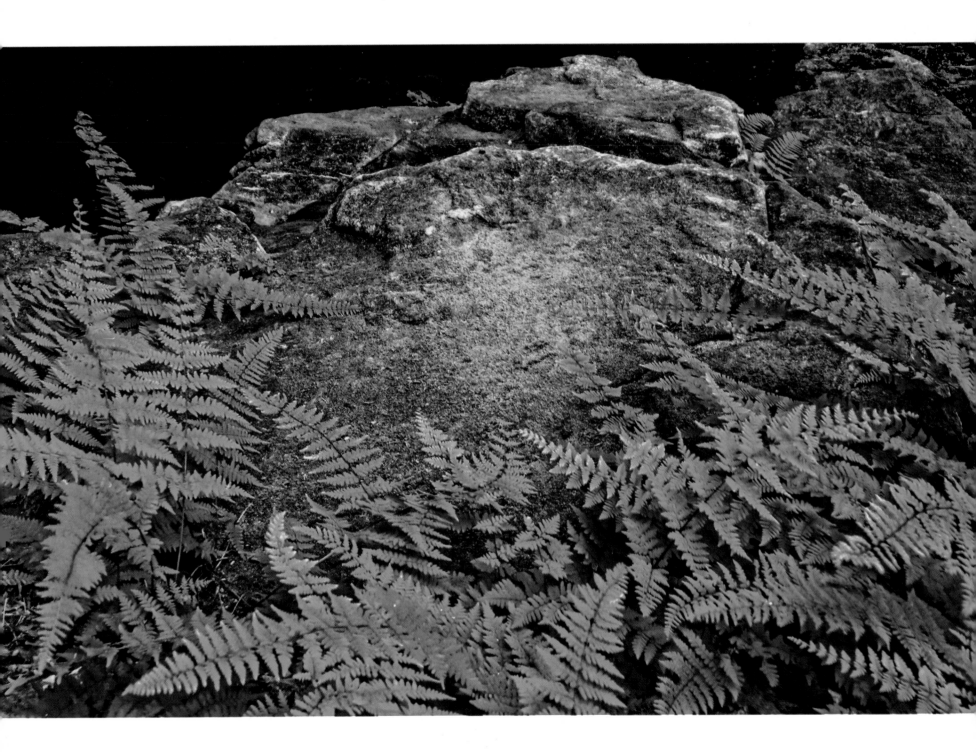

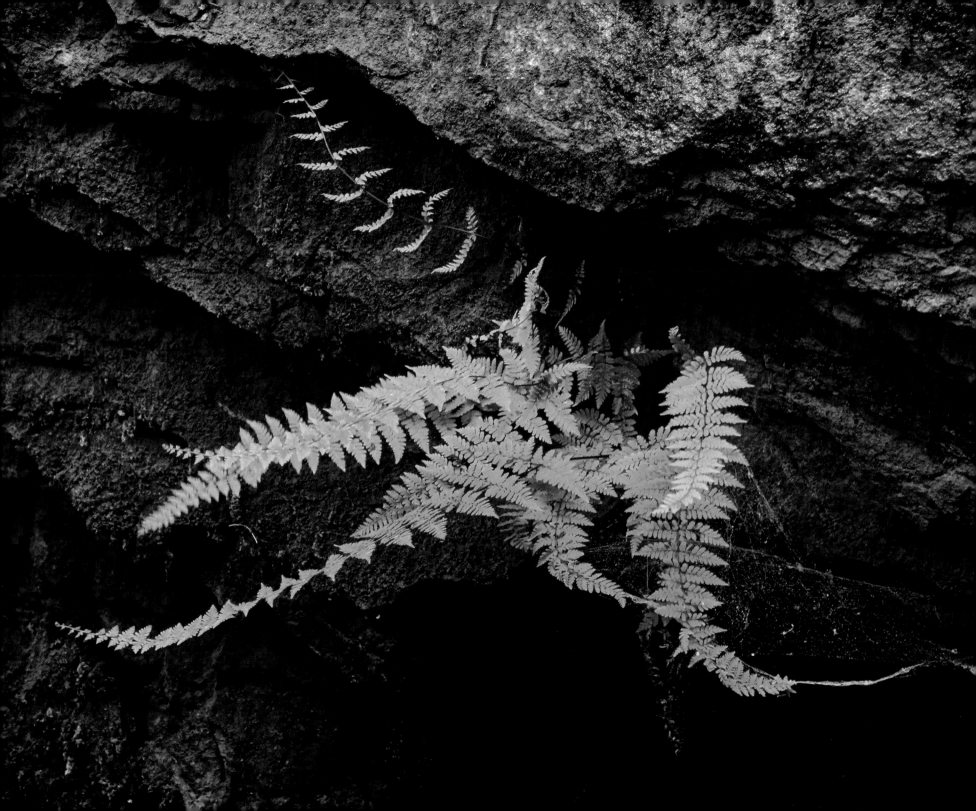

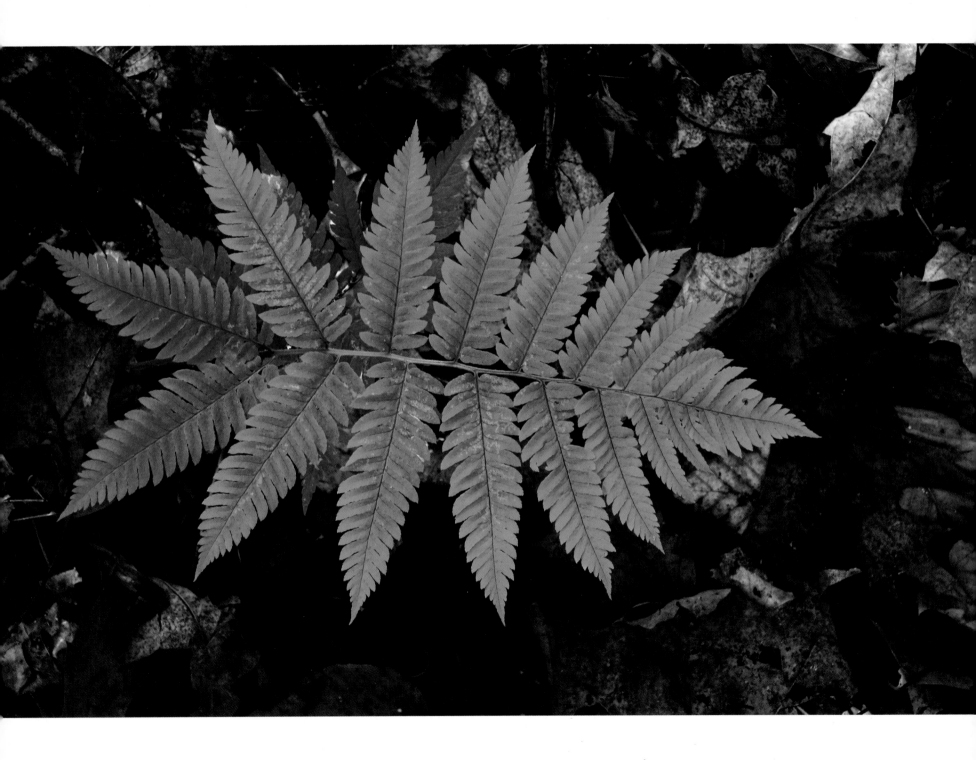

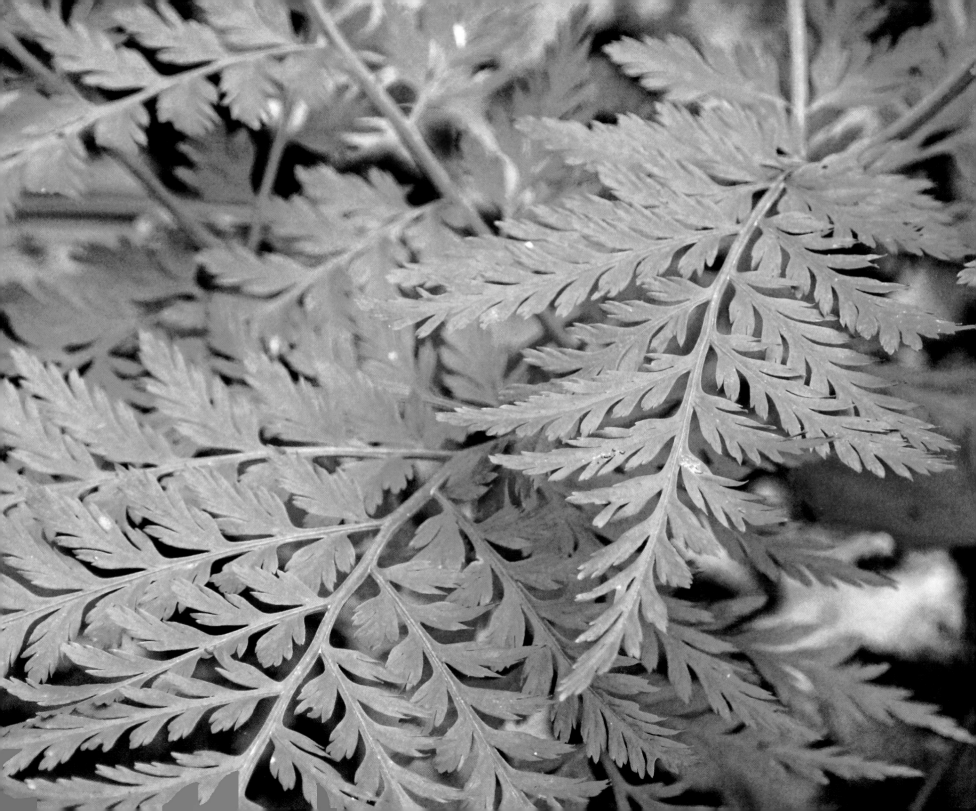

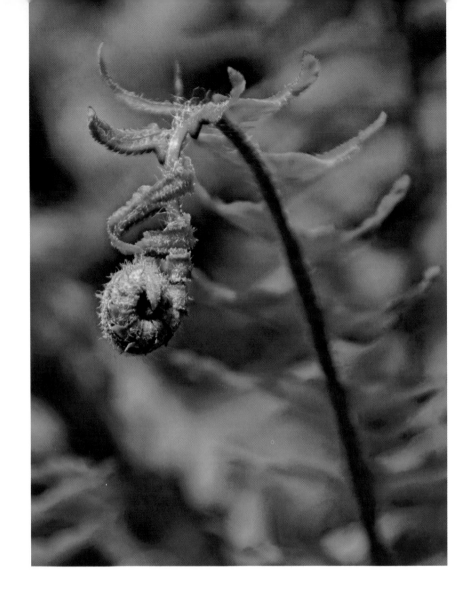
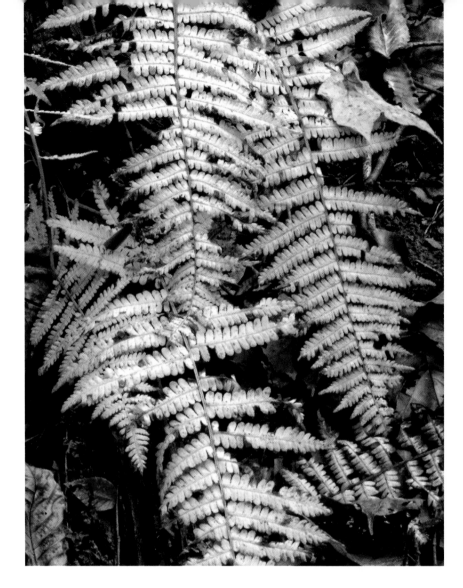

Spring and fall are juxtaposed on this page. Some ferns form "fiddleheads," new leaves (fronds) that unfold from soft, protective scales in spring. Although fern leaves are usually green with variations in tint and darkness, some turn bronze in fall. Others keep their green leaves throughout winter. Although ferns are difficult to identify, the maidenhair fern (*Adiantum pedatum*) on the facing page is easy to recognize with its fan-shaped whorls of leaflets and black stalks. It is this delicate form that draws me to photograph them. The subleaflets are toothed on one edge.

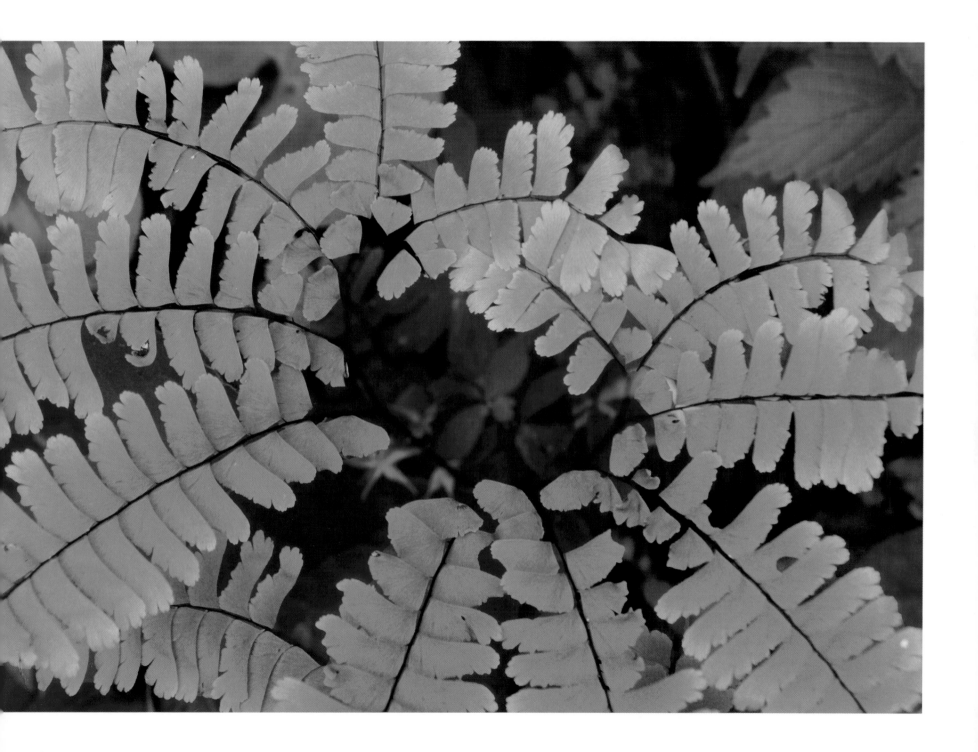

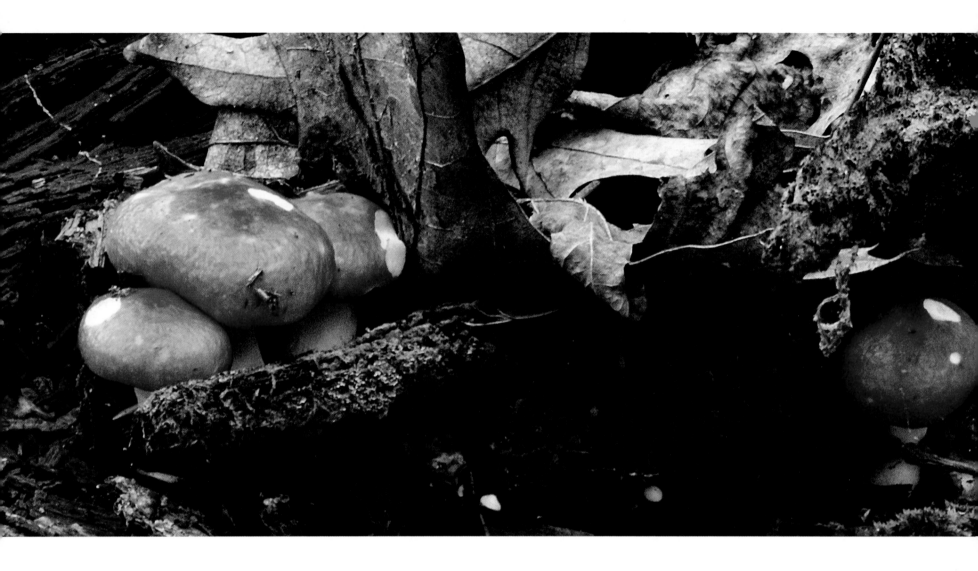

Fungi are diverse decomposers of the forest. Because fungi have no chlorophyll, they cannot produce their own food. Instead, the mycelium absorbs nutrients from organic matter. As the mycelium grows, it produces a bud that pushes upward. A stem forms and the bud unfolds like an umbrella. Gills on the underside of the umbrella release millions of microscopic spores. If a spore lands in a favorable spot, a new fungus will sprout, as shown in these images. A fair number of fungi are poisonous, so only experienced individuals should eat wild mushrooms.

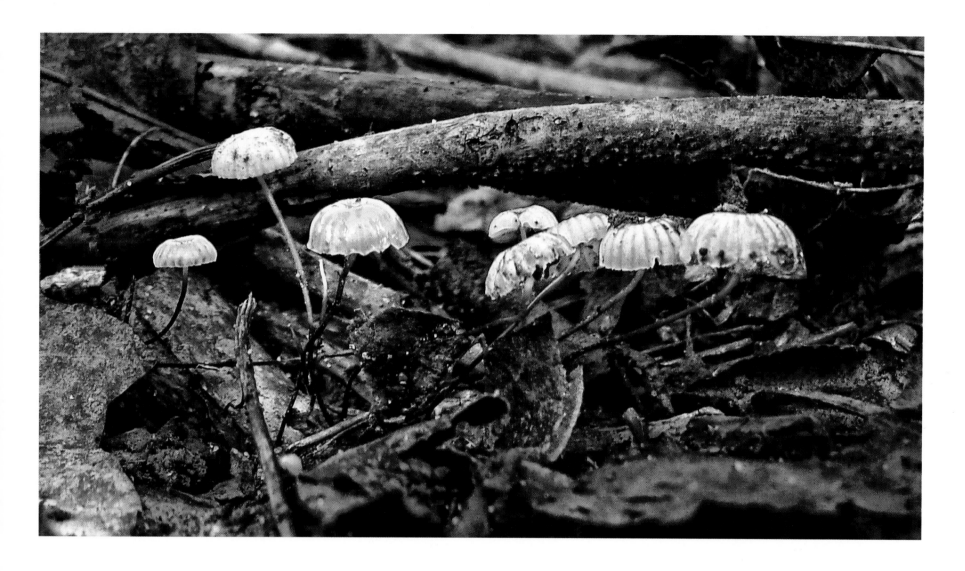

The images in this chapter illustrate the many shapes, sizes, and colors of the fungi found in Turkey Run. They also show their intricate and delicate lives, as revealed in the pinwheels (*Marasmius rotula*) shown in the image above. To take many of these images, I laid on my stomach to position the camera level to the fungi. I never strayed far from the trail to take these images, so with a keen eye you will be able to experience the many fungi found in the park, especially after a warm summer rain.

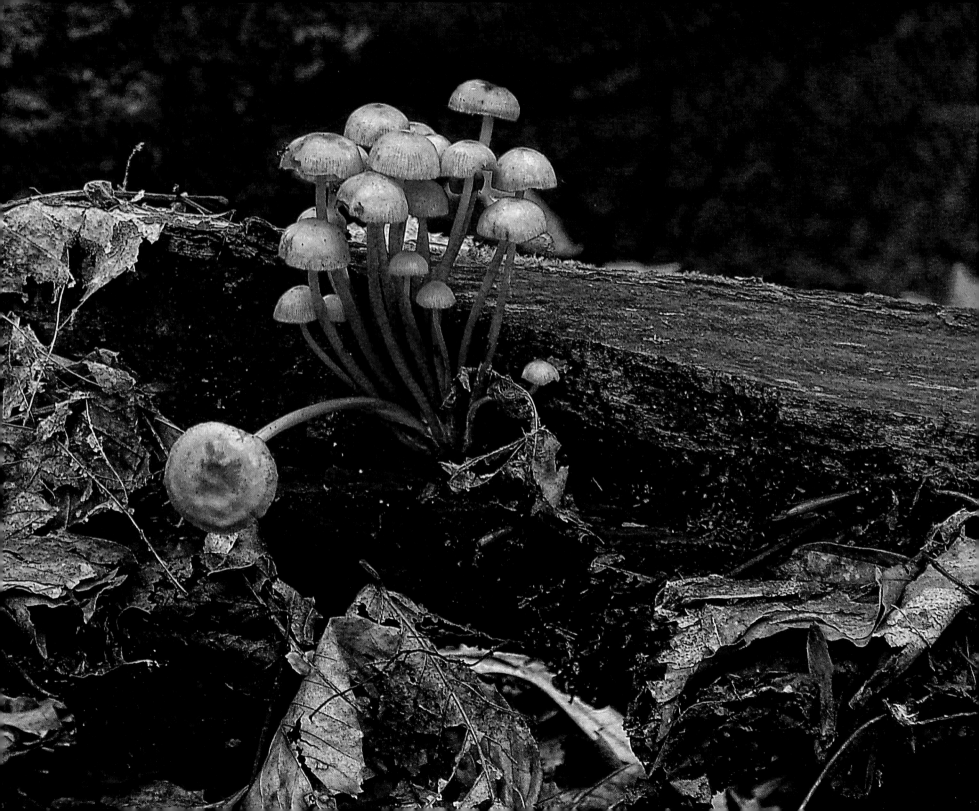

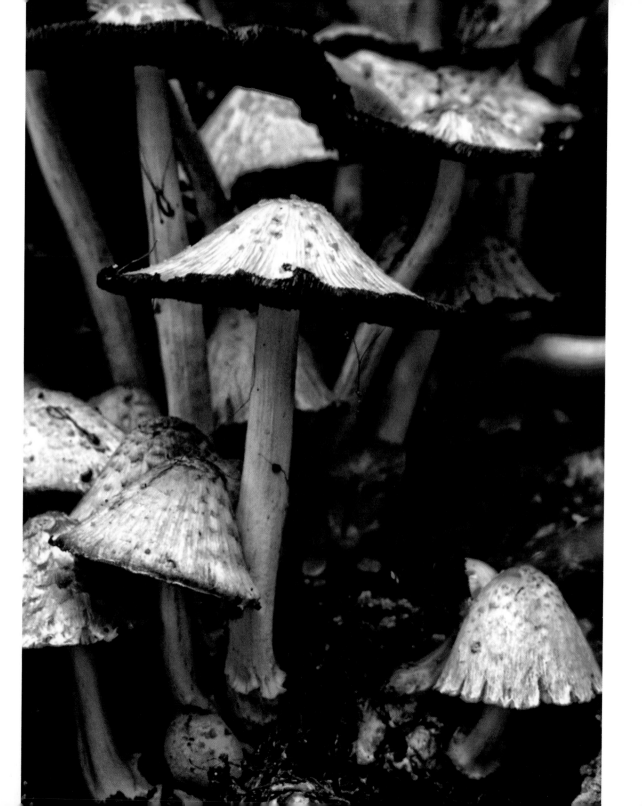
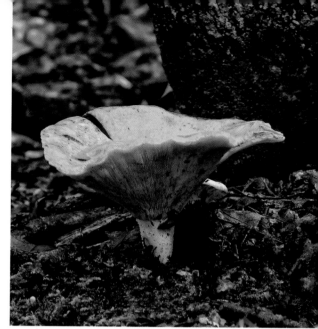
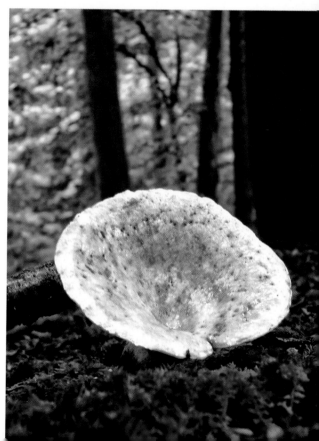

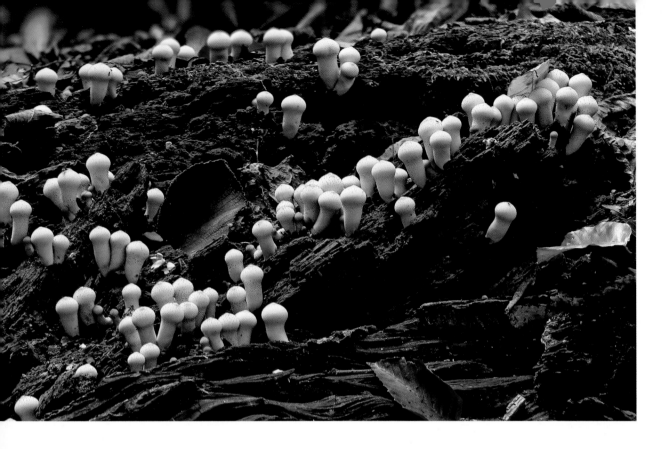

This cluster of white budding mushrooms on a fallen log caught my eye, standing tall like tiny fairy figures. It is easy to see where the coral fungi (*Clavariaceae*) in the bottom right image got their name. They grow under trees in the park, often near the trunk. Instead of spore-producing gills, spores form on the surface of coral fungi. The "typical" toadstool, emerging from the soil, is shown in the bottom left image. The scaly caps or umbrellas of the mushrooms growing on the log on the facing page show the umbrella like bud that rises up. The spore-producing gills are found on the underside of the umbrella.

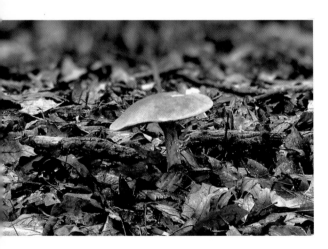

192

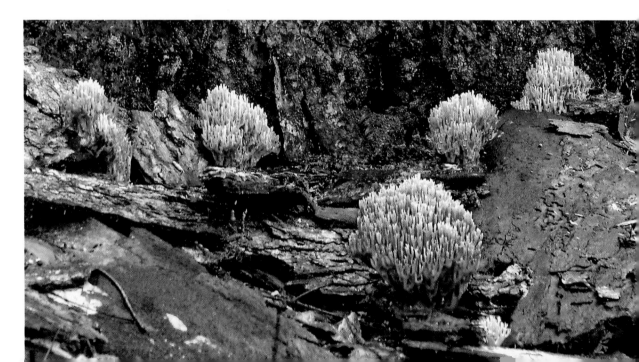

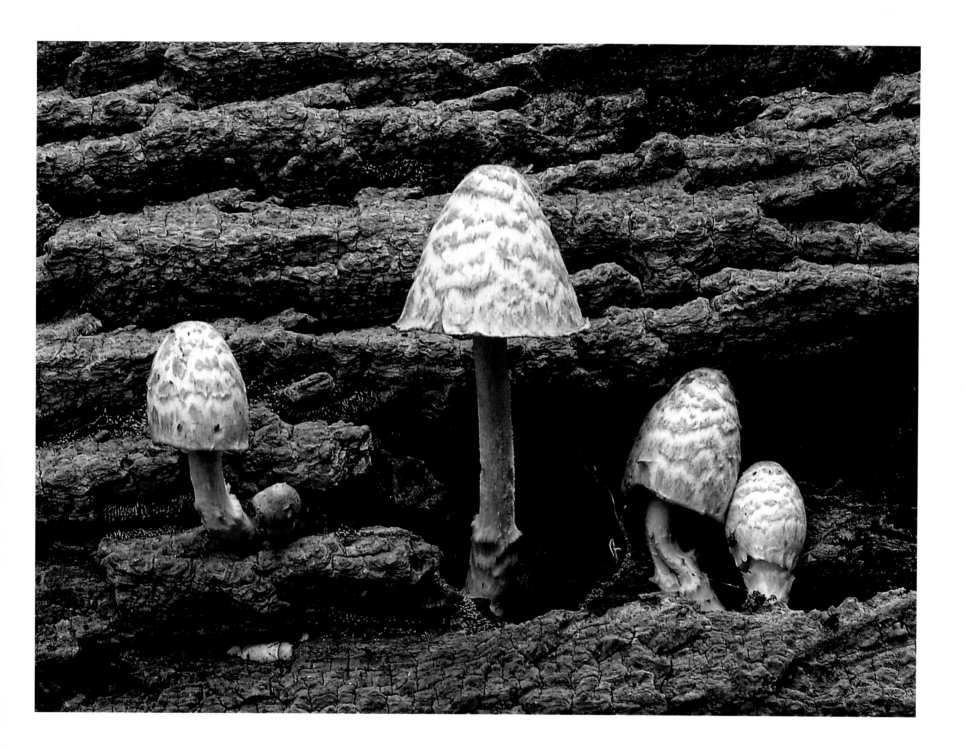

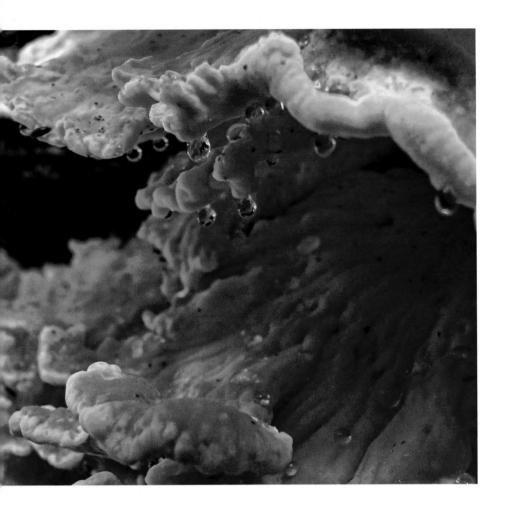

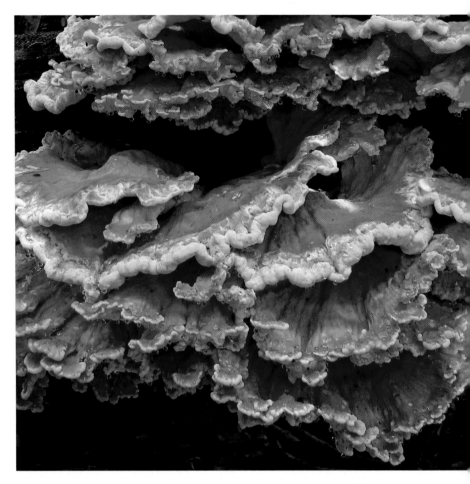

Bracket fungi, like sulphur shelf (*Laetiporus sulphureus*; images on this page), are easily spotted in Turkey Run because they form large shelflike protrusions on trees, stumps, and logs. Bracket fungi play an important role in the forest ecosystem, for they can easily digest and decompose the tough cellular material that makes up wood, returning the nutrients to the soil. The bracket that emerges is the reproductive structure of the fungi; spores are produced and released from the underside of the bracket. The large Dryad's saddle (*Polyporus squamosus*) bracket fungi on the facing page was attached to the injured trunk of a tree. Forest rodents find its meaty, fan-shaped cap to be tasty and quickly consume the fungi, leaving no trace behind.

Concluding Thoughts

In the year 2116, this book will be one hundred years old, and Turkey Run will be celebrating its two hundredth anniversary as a state park. But what will the park look like? How will it have changed since this book was published? Will Wedge Rock still stand tall, or will it have collapsed as its base is further eroded by flowing water? One thing is for sure: it is only a matter of time before it is toppled by the pull of gravity.

This book nicely documents the Turkey Run landscape as seen today, providing an opportunity for future generations to see what the park was like in 2016, and to see how it has changed over time. Although one hundred years seems long in human terms—more than a lifetime for most of us—it is not much in geologic time. Remember, it took thousands of years and melting glaciers to cut the canyons in the park. By 2116, the canyons may be an inch or two deeper and wider, but not noticeably different to the human eye, unless an extreme storm event washes the canyon rim to the bottom or undercuts the canyon walls such that the sandstone falls from the pull of gravity. I wonder if the glacial erratic, pictured in chapter 3, will have been transported to the canyon floor by 2116. Either way, it is a given that the Turkey Run sandstone will be weathered, shedding grains and particles, sediments that will be transported toward Sugar Creek.

Sugar Creek will still flow, having flooded and deposited sediments along its bank and in its floodplain hundreds of times by 2116, providing fertile soil for the Virginia bluebells and the tall trees that grow along the creek. At the same time, it will have further undercut the sandstone bluffs that tower above its flowing water. Migratory birds will still rely on Sugar Creek for water, food, and shelter as they travel south to north in the spring and north to south in the fall.

In 2116 the tall trees will be larger in diameter and reaching their maturity, having been protected from the saw. This second growth forest will slowly give way to the next generation of tall trees. The ashes, however, will likely be gone as a result of the emerald ash borer. And what new invasive species will be attempting to establish itself within the park? Will the sugar maples and beech trees begin to decline in number and begin to disappear as our climate warms and changes?

Between 2016 and 2116, one hundred million people will have likely visited and hiked Turkey Run's trails. I hope the generations to come not only see the park as a recreational place, but also as a place of natural beauty and wonder—a place where wildflowers bloom and wildlife roam, protected and preserved for their own right. In fact, I hope that future generations see the value in all of nature and recognize the importance to preserve and protect the precious few natural places on this planet, for our identity as humans is defined by our link to nature and natural places like Turkey Run State Park.

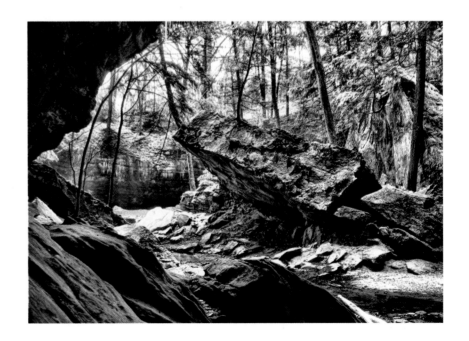